IMAGES

of America

WEST SEATTLE

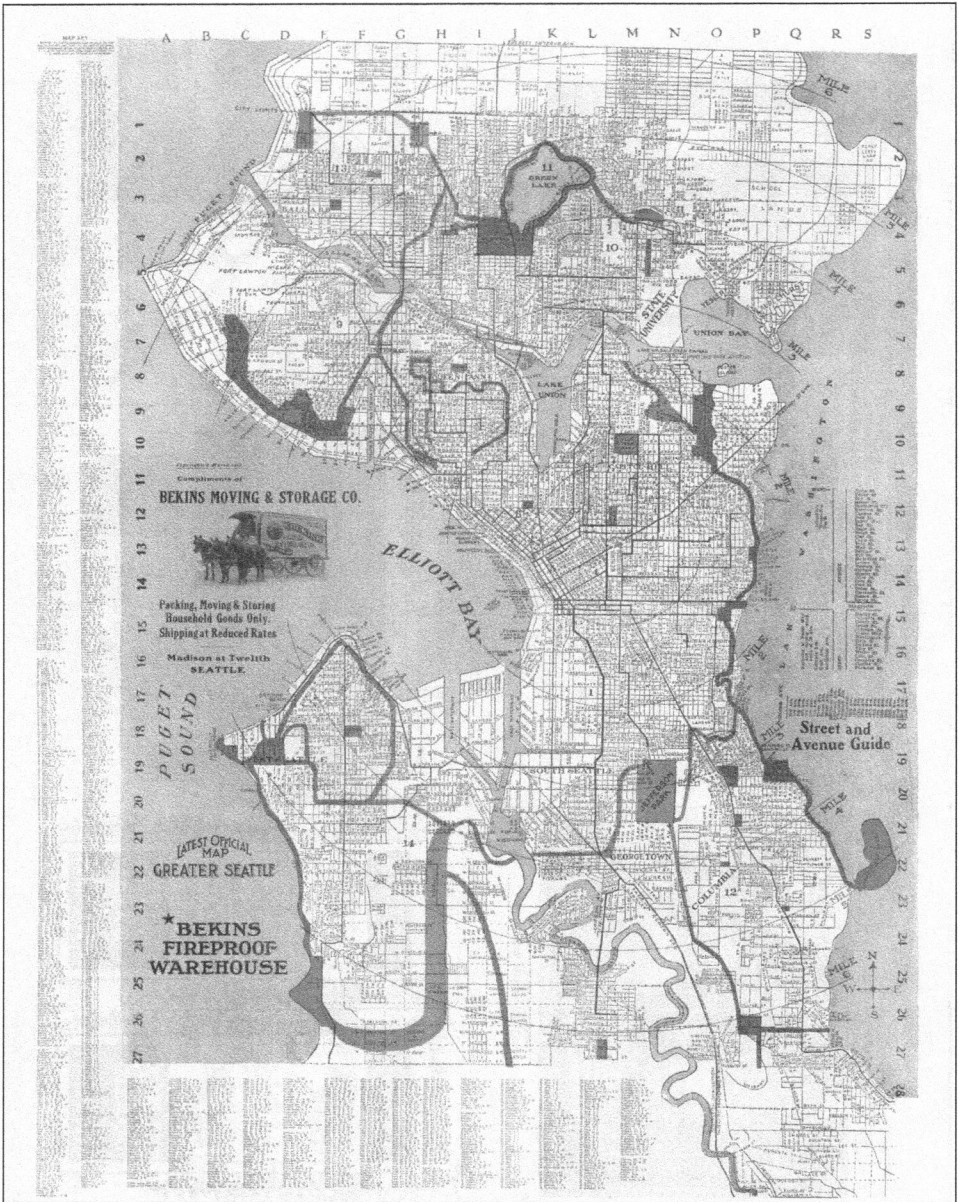

In 1913, Bekins Moving Company created this map highlighting a proposed vast park system connecting all of Seattle by greenbelts. An Olmsted design, it was also a "wishful thinking" map—the parks of Seattle exist today but are not connected. (Courtesy Southwest Seattle Historical Society/Log House Museum.)

ON THE COVER: William and Gladys Bernard and family camped at Alki in 1901, before their permanent home, the Fir Lodge, was built. Alki was a summer destination for vacationing families and Seattle residents. Tents like the one pictured had wooden floors raised off the ground and luxurious accoutrements such as oriental carpets and brass fixtures. (Courtesy Southwest Seattle Historical Society/Log House Museum.)

IMAGES
of America

WEST SEATTLE

Southwest Seattle Historical Society
Log House Museum

ARCADIA
PUBLISHING

Published by Arcadia Publishing
Charleston, South Carolina

Library of Congress Control Number: 2010926135

For all general information, please contact Arcadia Publishing:
Telephone 843-853-2070
Fax 843-853-0044
E-mail sales@arcadiapublishing.com
For customer service and orders:
Toll-Free 1-888-313-2665

Visit us on the Internet at www.arcadiapublishing.com

*This book is dedicated to the volunteers, donors, and staff who succeeded
in creating a wonderful community museum. Further gratitude
goes to individuals who have donated photographs, documents, and
artifacts to the museum. A picture is worth a thousand words!*

CONTENTS

ACKNOWLEDGMENTS

I would like to thank the following individuals and organizations: three longtime volunteers, Bob Carney, Don Kelstrom, and Alan Peterson pulled together the photographs and research found within these pages from the Log House Museum archives, the Museum of History and Industry (MOHAI), Seattle Municipal Archives, Puget Sound Maritime Historical Society, University of Washington Libraries Special Collections, Burien Library, Puget Sound Regional Archives, *West Seattle Herald*, John Kelly, Jackie Scott, David Chapman, Donald Kelstrom, Robert Carney, Patricia Filer, Alan Peterson, the Vann Brothers, Mike Butler, and the Miller family. Unless otherwise credited, all phographic images are from the collections of the Southwest Seattle Historical Society located at the Log House Museum. Museum collection manager Sarah Frederick navigated the project in her usual skilled, professional manner with a spark of humor. Jay Mora patiently waded through technologically challenged images and worked his own magic. John Kelly researched questions and solved mysteries so that Brandie Thompson Carlson, JoAnne E. Dyer, Sukie Juhan, Katie Meyer, and Todd Stephenson had rich source materials to craft the text within these pages. Waiting in the wings until the end of the project were Susan and Fred Madrid who stepped in to do finish work on digital images, layout, and the final edit. Their achievement is that this book is consistent and in order. The key ingredient to this project was Bob Carney. Without his endless volunteer hours, focus, depth of knowledge, and love of West Seattle and White Center history, this book would still be an idea, not in your hands. Finally, important to any project is the willingness to believe in one's staff and the ability to pay for the project. Thank you to the solid and consistent support of our museum donors, members, Judy Bentley, and the Southwest Seattle Historical Society board of directors, advisory board, and King County 4Culture for the special projects award. To quote a great Seattle bicyclist, "Holy Smokes, everyone, good job!"

—Andrea Mercado, Director
Log House Museum

INTRODUCTION

The tale of the birthplace of Seattle begins with a rainy, cold day in November 1851. Twelve children and 12 adults slogged their way toward an unfinished rough, little cabin at what was then called New York. A member of the party, Lee Terry, named the area hoping it would soon grow into a successful city like his hometown back east. Less than two years later, businessman Charles Terry, brother of Lee, remained alone in New York. All of the original members of that early group of settlers moved east across Elliott Bay and sited the current city of Seattle on the sheltered eastern shore. The beaches of West Seattle were notorious for the strong currents and storms, making driftwood of piers and the loading and unloading ships weather dependent. Once the settlers moved operations to protected Elliott Bay, the easily accessible timber was logged, and trade established with ship captains moving the lumber from Puget Sound to California and beyond.

While the city of Seattle grew rapidly, the Duwamish Peninsula slowly developed a few small shore settlements, New York being the first. Since Charles Terry now owned the large parcel of land left by the Denny, Bell, Boren, and Low families, he immediately platted and renamed it Alki.

"At this place on 13 November 1851 there landed from the Schooner Exact Captain Folger the little colony which developed into the City of Seattle." A pioneer monument placed in 1905 on Alki Beach wears this plaque recognizing the male settlers and children by name as the founders of Seattle. In 2001, two additional plaques were put in place recognizing the contributions of others who were unnamed and unrecognized in 1905—the people of the Duwamish tribe and the wives of the settlers. It took a determined West Seattle resident 150 years and societal changes for this full recognition to happen. A 100-year time capsule placed in 1951 and a piece of Plymouth Rock embedded in the monument finish out the site.

Another early community, Freeport, faced early Seattle along what is today Harbor Avenue SW. Industry began with a large sawmill, shipbuilder, and later, a salmon packing business. By 1877, Freeport was renamed Milton. On the hill above Milton, in what is now the Admiral District, the now familiar moniker "West Seattle" was first used by Uriah Niesz when developing 5-acre homesites in 1885.

The key to successfully building any town on the Duwamish Peninsula has always been access to transportation. It is not because of a favorable waterfront view that early settlements were close to the shore or river. Indeed, since this was the era before climate-controlled indoor heating, the farther from the water, the better. However, the first and quickest method of travel was by sea. It was much easier to move goods and people across water than through the heavy forests and underbrush that stood throughout those early years. The Duwamish Peninsula is also surrounded on three sides by water: the Duwamish River, Puget Sound, and Elliott Bay. The easiest and safest travel to the Duwamish Peninsula was by canoe, under sail, or by small steamship. The first scheduled ferry service ran across Elliott Bay in 1888. Used as a marketing tool to sell West Seattle property lots, the ferry service also linked Seattle residents and visitors to Alki Beach and in 1907, Luna Park. The amusement park was built over the water at Duwamish Head. Thousands

of white lights lined and illuminated the rides, luring visitors from Seattle to the daily and nightly entertainment. In 1913, after only six years of operation, the amusement park closed, and the rides were shipped to California, leaving behind the saltwater swimming pool.

As advances were made across and through the bogs and forests of the peninsula by streetcar and roads, commerce followed. The cable car brought early development and housing to the North Admiral neighborhood at the turn of the 20th century by moving people up the steep hill from the waterfront. As the streetcars extended, linking Seattle to Youngstown (Delridge) and south toward Fauntleroy and White Center, business and residential development followed. Farming increased in White Center, South Park, Alki, Seaview, and Fauntleroy by the late 1800s. Some communities were much more successful with farming than others. Marsh and boggy locations did not fare well. Property alongside the Duwamish River, such as South Park or Longfellow Creek, enjoyed fertile soil compared to the bogs and marshes of White Center or near the Junction. Logging increased, roads were placed, and these remote, separate communities became linked. Not all enjoyed their newfound community neighbors. The Youngstown neighborhood fought vehemently with words and brusque behavior to stay independent of the city of Seattle and West Seattle prior to 1907, and White Center also retained its spirit of independence and distinctiveness from West Seattle. The many hills, dells, rivers, and streams made neighborhood boundaries easy to define.

Today these boundaries encircle many distinct neighborhoods: Arbor Heights, Fauntleroy, Gatewood, Seaview, Fairmount Park, Genesee, Alki, North Admiral, North Delridge including Pigeon Point and Riverside, High Point, Roxhill, White Center, South Delridge, South Park, Riverview, and Highland Park.

The Duwamish Peninsula has always been a popular place to reside or visit with its lush Lincoln Park, historic Me-Kwa-Mooks, old-growth Schmitz Park, and the miles-long Alki Beach. What brings people here, and keeps them here, is a strong sense of place. Today the Duwamish Peninsula is no longer an isolated location next to a big city. Connected by bridges and roads, with transportation by ferry, foot, bicycle, auto, and bus, it is both tightly tied and separated from downtown Seattle. Graduates of Sealth and West Seattle High Schools proudly declare their graduating class, whether last year or decades ago. Families define themselves by what generation West Seattleite they are. Many community churches and service groups are enjoying centennial celebrations. This is not to say West Seattle and White Center are inhospitable to new residents. Placing value on longevity and a recognizable community does not mean they eschew newcomers.

In order to highlight a small corner of the culture and history bound by the borders of West Seattle and White Center, this volume is broken into eight chapters. Six are neighborhood pictorial histories: White Center, Fauntleroy, the Junction, Alki, Admiral, and Delridge. The book begins with "Getting to West Seattle" and ends with "Community."

Out of respect for the inhabitants of the Duwamish Peninsula for thousands of years before 1851, this book does not interpret their history. Descendents of Chief Seattle and the indigenous people of this area are still here and able to tell their own history both at the Duwamish Longhouse and Cultural Center in West Seattle and the Suquamish Museum and Cultural Center on the Port Madison Indian Reservation across Puget Sound. A visit to their museums will clarify that this book shares location and settlement information that is recent history. For every neighborhood or prominent geographic point in this book that a visiting sea captain, settler, or explorer named, chances are these locations already carried a native name. Welcome to the Duwamish Peninsula.

One

GETTING TO
WEST SEATTLE

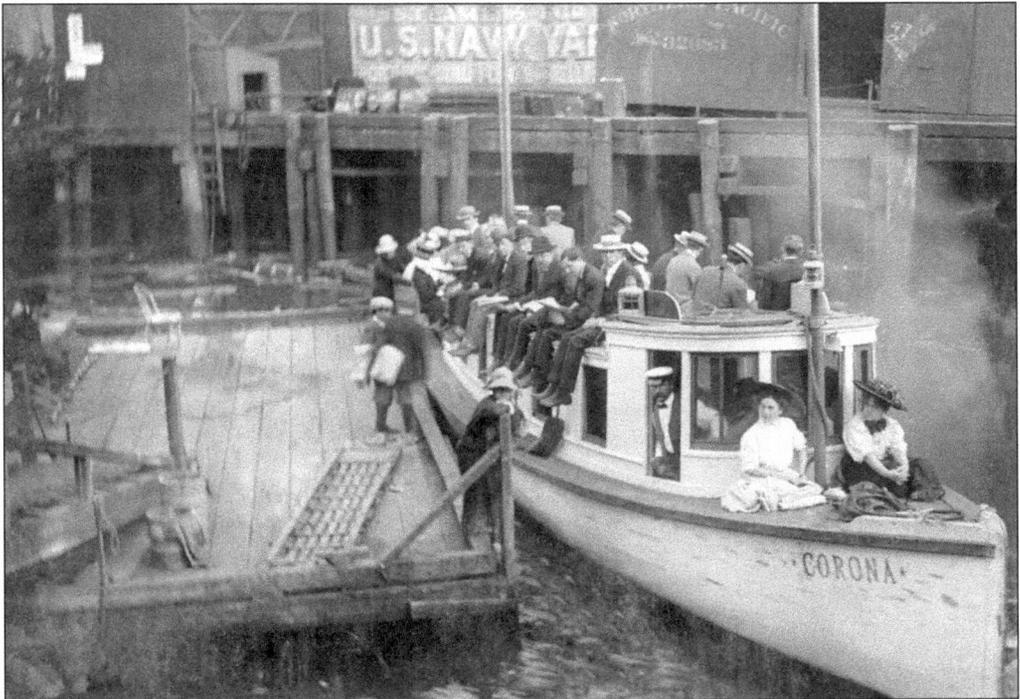

Since roads were rough or nonexistent, a vast fleet of small steamships, known collectively as the "Mosquito Fleet," transported passengers and freight to hundreds of small docks over Puget Sound. The Mosquito Fleet ships were so nicknamed because they were small and quick, flitting from one side of the sound to the other. Their heyday of operating was 1880–1920. In 1908, the *Corona* readied to launch from downtown Seattle for Alki Beach with a full deck of passengers. Capt. C. C. Guntert piloted it daily, excluding Sundays. That same year, the steamship fleet transported $15.6 million in cargo and two million passengers over Puget Sound waters.

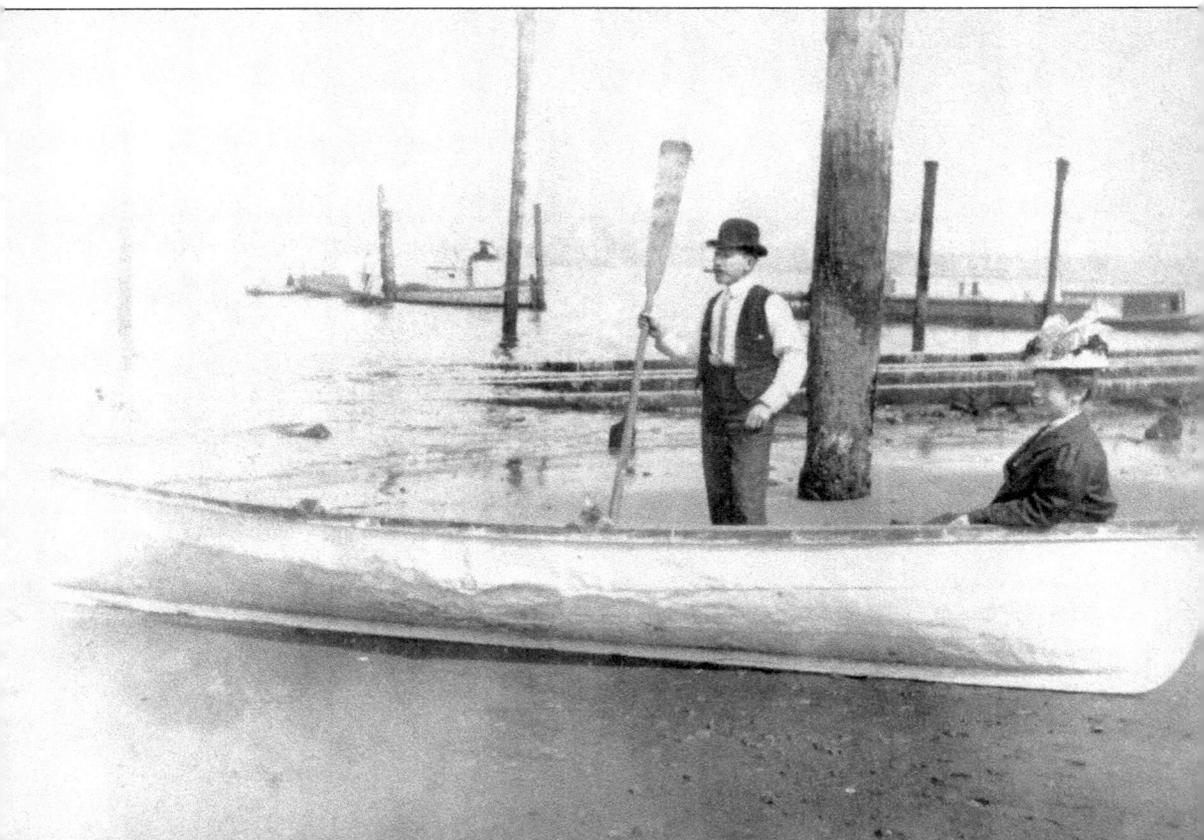

Ida and Claude Outland are pictured in their boat at low tide near Bonair Drive SW in 1909. The ramp in the background was used for launching larger vessels after repairs. Many waterfront residents had their own small boats for fishing and transportation.

FOR

ALKI· POINT

Favorite Bathing Beach, Camping and Picnic Grounds

Str LADY OF THE LAKE

FROM COLUMBIA DOCK

LEAVE SEATTLE	LEAVE ALKI
6:30 7:40 and 10 A. M.	7:10, 8:15 and 10:30 A. M.
1, 2, 3, 5:10 and 6:15 P. M.	1:30, 2:30, 4:30, 5:40, 7 P. M.

SUNDAYS EVERY HOUR FROM SEATTLE

HOTEL ALKI NOW OPEN FOR THE SEASON

Rates $1.oo Per Day

Around 1900, the steamship *Lady of the Lake* was in business competition with the *City of Seattle* ferry and mysteriously burned during a rate war for Seattle-to-West Seattle run passengers. The ticket advertises lodging at the Alki Hotel for $1 a day next to the "favorite bathing beach, camping, and picnic grounds."

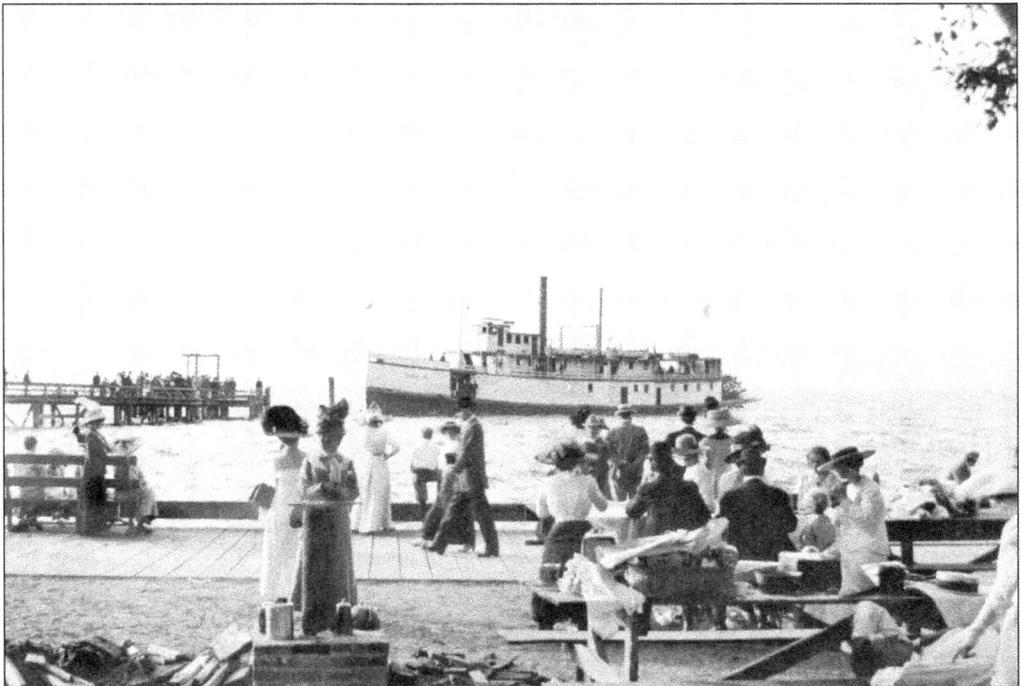

On the Alki boardwalk, finely dressed picnickers and beach strollers enjoy the view as the stern wheeler *Fairhaven* arrives at one of the docks on Alki Beach around 1900. The dock is located near the present-day Birthplace of Seattle monument. Mosquito Fleet steamers were a very common method for delivering passengers and cargo to West Seattle. The 130-foot-long *Fairhaven* was built in Tacoma in 1889 and served until its demise in 1918.

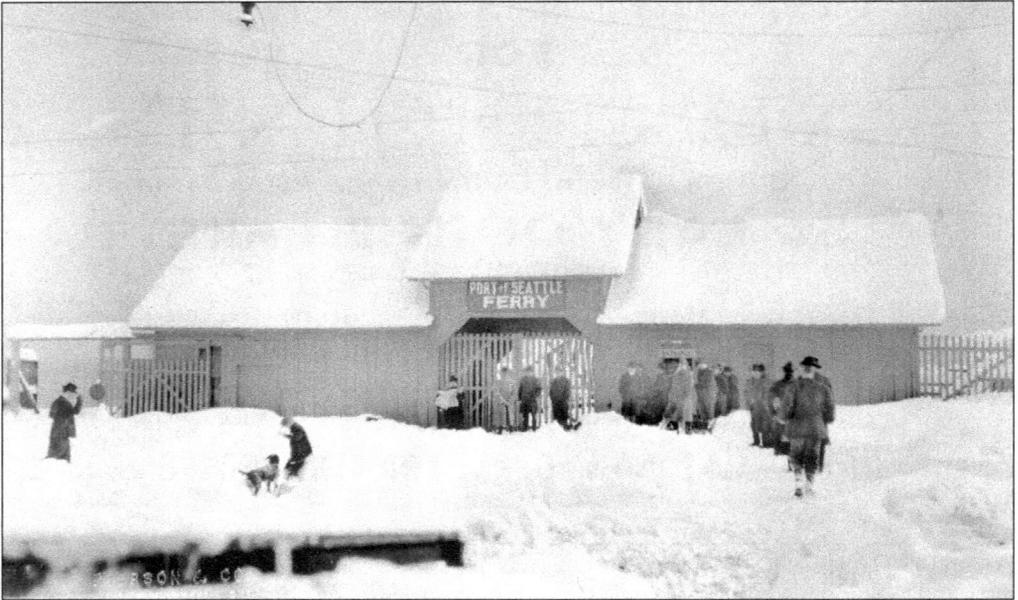

The West Seattle ferry terminal on Railroad Avenue (now Harbor Avenue SW) is shown around 1915. Ferry travel was advertised in the *Westside Press* (the precursor to the *West Seattle Herald*) as "more convenient and safer than by streetcar–besides it cuts the time of travel in half." While crowds of travelers were typical during the summer months, far fewer of them opted for the ferry during the winter. The terminal was located near the present-day Don Armeni boat launch.

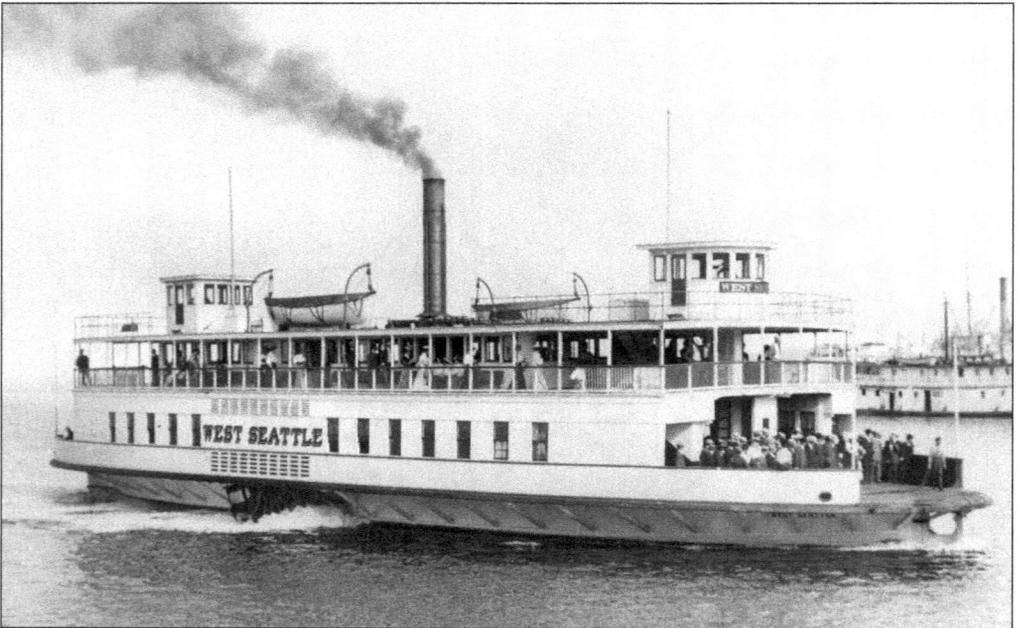

The ferry *West Seattle* heads across Elliott Bay to the West Seattle ferry terminal around 1910. Replacing the *City of Seattle* on the West Seattle-Marion Street run in 1907, the *West Seattle* was lauded as the largest and finest ferry north of San Francisco. A 145-foot-long steam-powered side-wheeler, she remained in service until 1920.

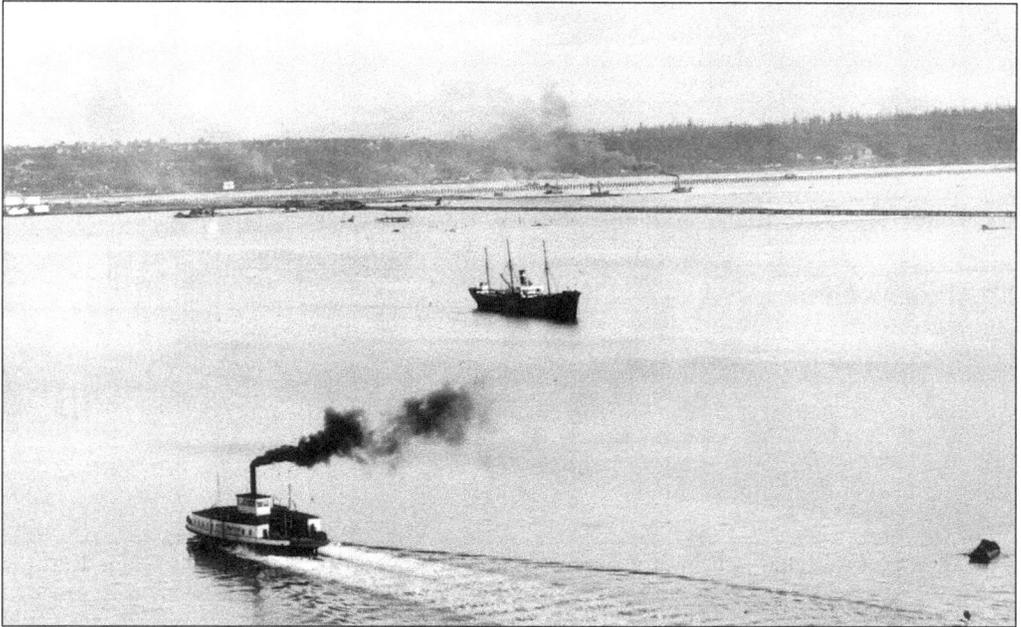

The *City of Seattle* heads east toward the Marion Street Pier in downtown Seattle in 1901. Ferry service between West Seattle and downtown Seattle began on December 24, 1888, with a fare of 15¢ and a crossing time of eight minutes. Note that the tide flats of the Duwamish River extend all the way to the base of Beacon Hill and that Harbor Island does not yet exist.

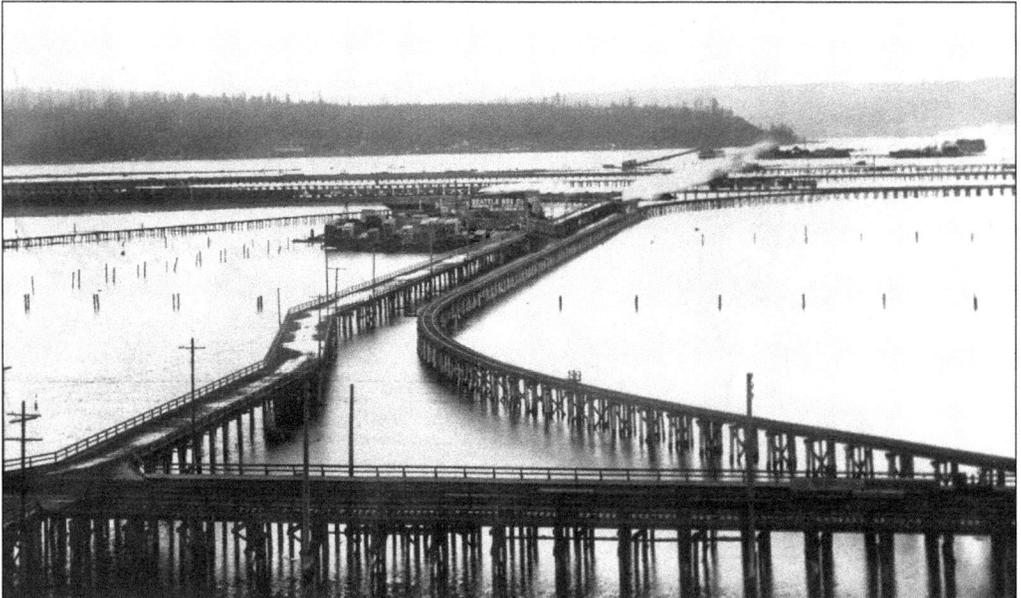

This view from Beacon Hill looks east toward Pigeon Point and West Seattle by train trestle. In 1902, Spokane Avenue led to the Seattle Box Factory and planing mills built over the tidal flats of the Duwamish River. Before Harbor Island was created and the flats filled, all of this area was underwater at high tide. The current West Seattle bridge and elevated freeway carries traffic in almost the same location.

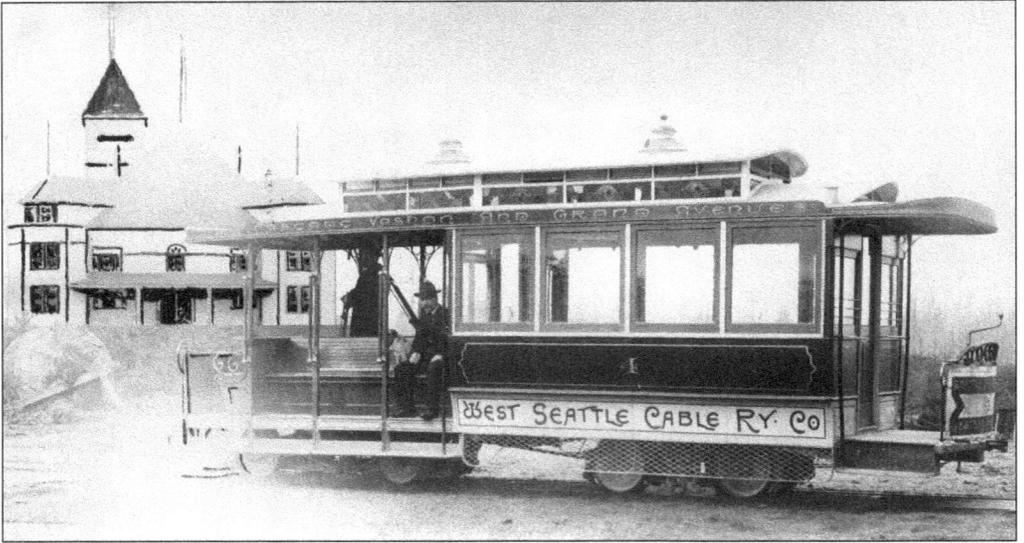

The West Seattle Land and Improvement Company started the West Seattle Cable Railway line, shown here in the Admiral District, about 1895, to augment the ferry service they founded in 1888. The intent was to promote property sales and growth in West Seattle. The cars would descend Grand Avenue (now Ferry Avenue) to the ferry dock. Financial setbacks closed the line in 1897. (Courtesy Seattle Municipal Archives, No. 66239.)

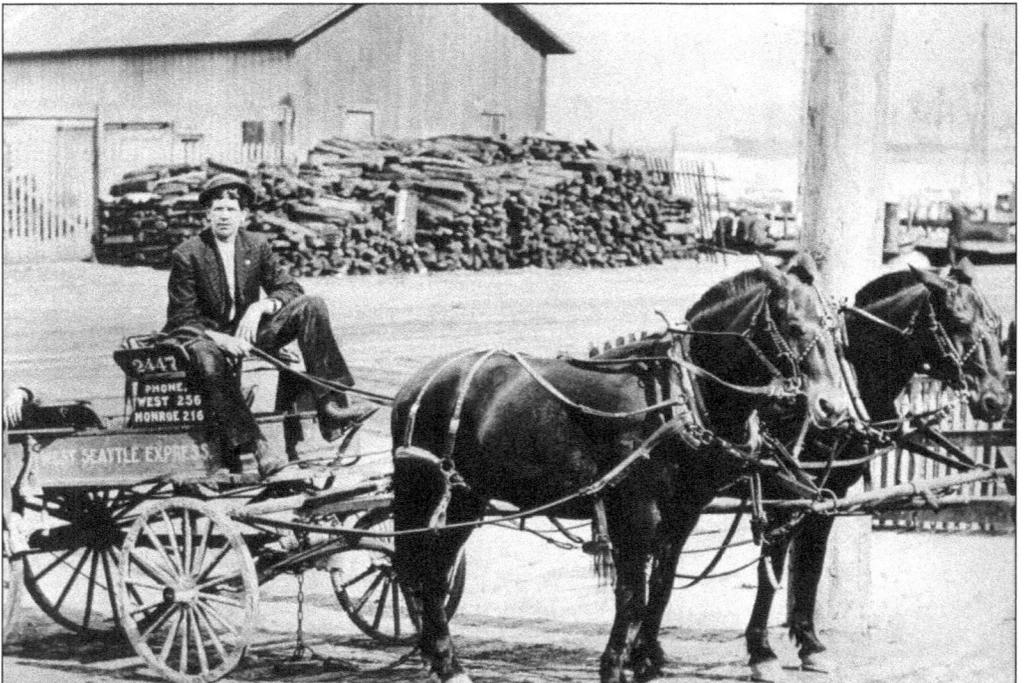

The West Seattle Express waits for the *City of Seattle* ferry around 1904. The proprietors were Darryl and Erik Mellencamp, shown with their horses Diane and Heidi. Delivery services like the West Seattle Express were vital to Duwamish Peninsula residents unable to carry oversize items purchased from downtown businesses.

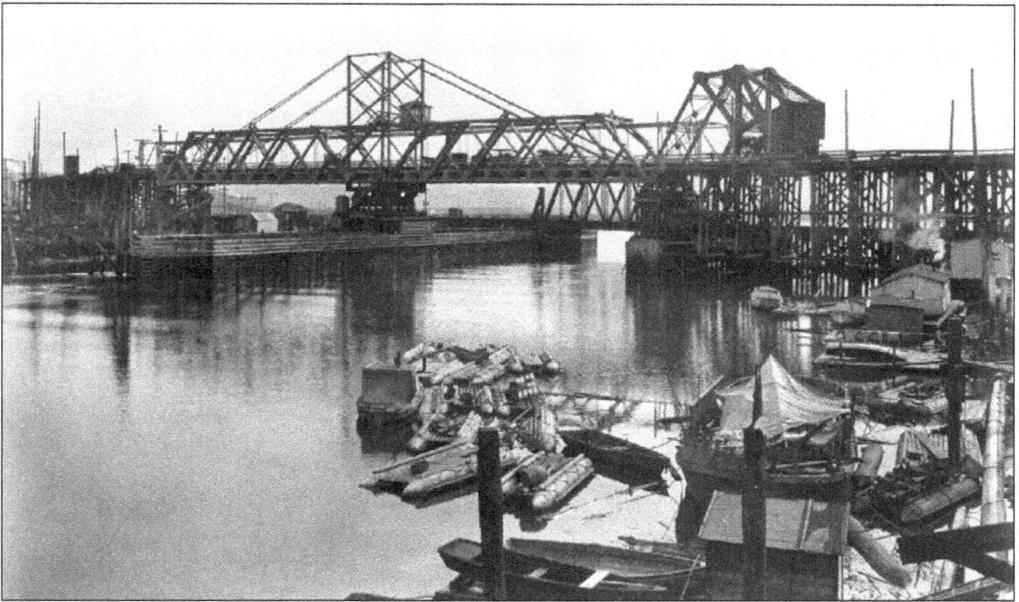

With a higher clearance of 28 feet, the new 1917 Spokane Street swing bridge replaced a temporary bridge over the Duwamish River. Per the 1913 City Engineers Annual Report, the 1910 low bridge was "constantly making traffic over Spokane Avenue more dangerous and subject to greater delays and interference" because it opened for all marine traffic. Swing bridges open horizontally as opposed to Seattle's more common bascule bridges that rise.

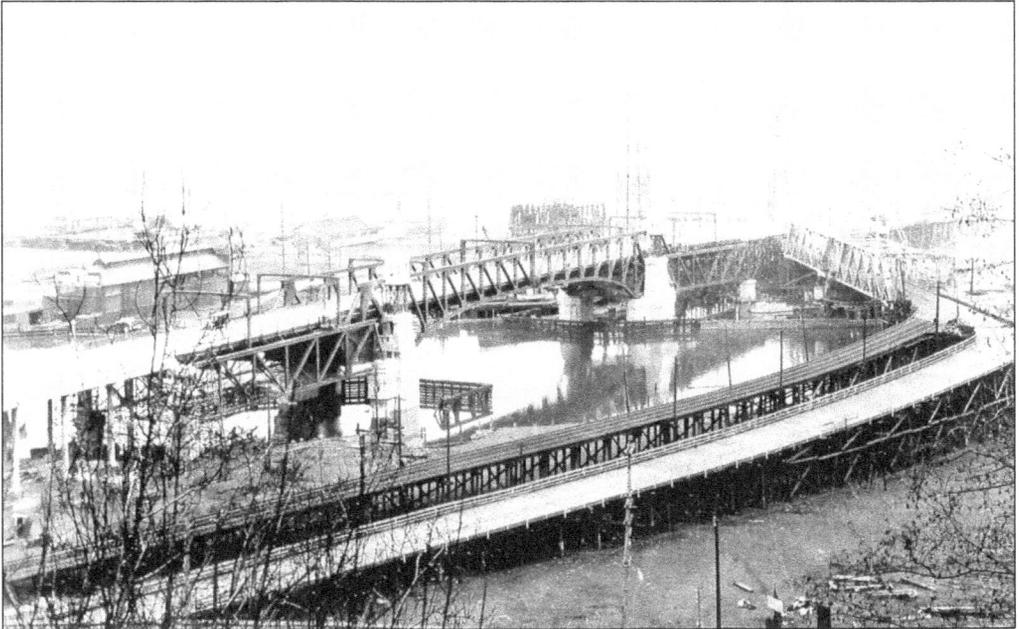

In October 1925, the *West Seattle Herald* stated, "The completion of the new (bascule) bridge has removed some of the greatest transportation difficulties, and no residence district in greater Seattle can surpass this district in any of the features which make living enjoyable." All streetcar traffic was diverted to the old swing bridge on the right.

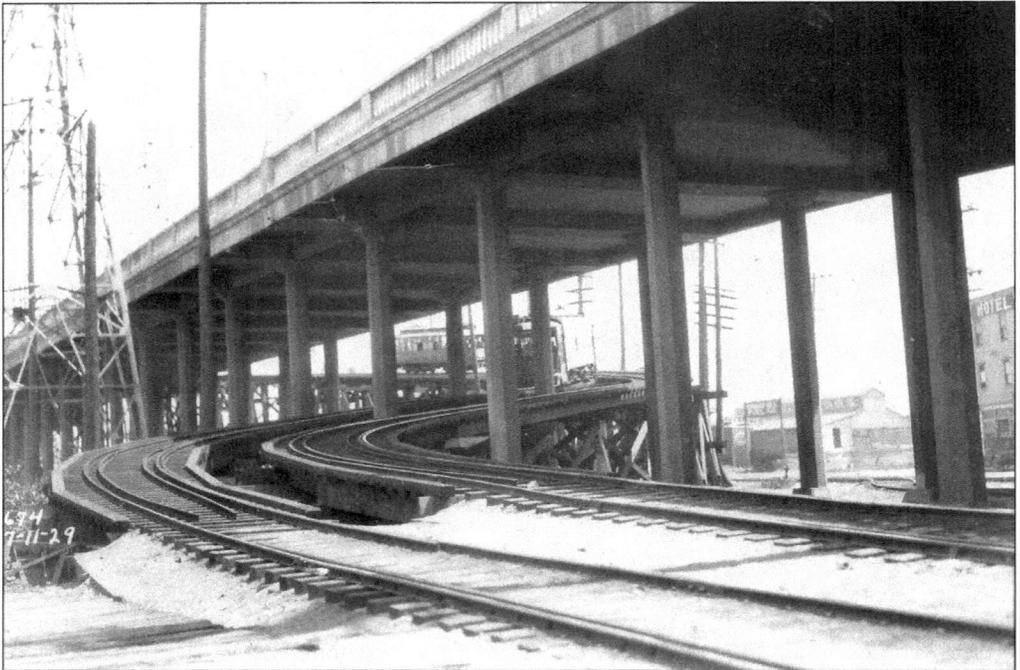

The temporary "shoo-fly" trestle was erected to route streetcars to the first Spokane Street bascule bridge in July 1929. The old 1917 vintage swing bridge had been condemned because of extensive teredo mollusk damage to the structure in January 1928. The S-shaped trestle carried streetcars up to the first bascule bridge while the second bridge was under construction.

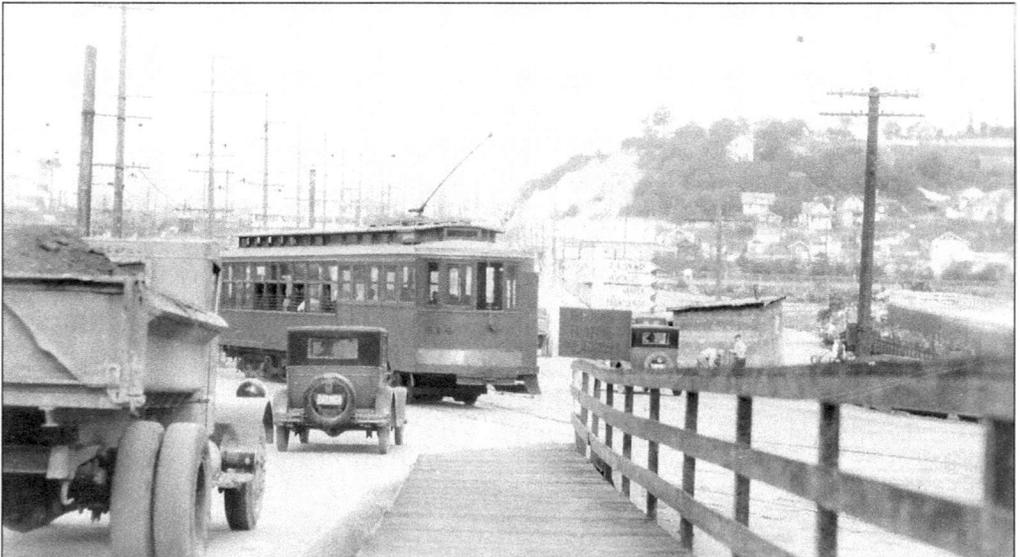

In 1929, traffic congestion at SW Admiral Way, SW Spokane Street, and SW Avalon Way was caused by streetcars, trucks, automobiles, and a few horses. This merge of three arterial streets made for many traffic challenges until improvements were made a year later in 1930. Pigeon Point is visible on the right above Youngstown. The directional signs point to Fauntleroy, Avalon Way, Harper Ferry, and Vashon Island.

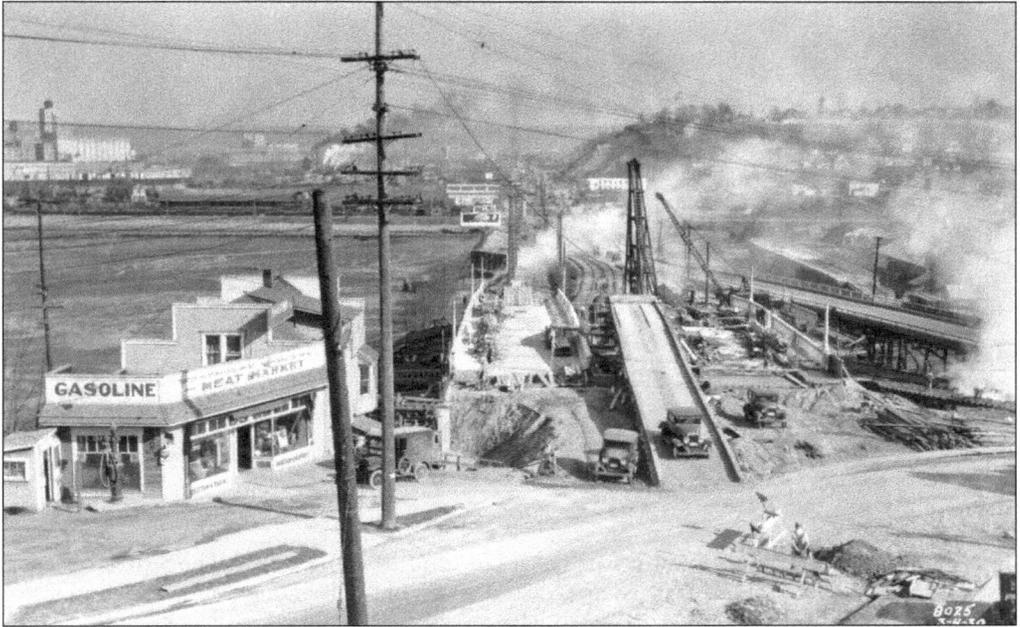

This view is looking east at construction on the concrete viaduct connecting SW Admiral Way and SW Avalon Way to SW Spokane Street on March 4, 1930. The area just north of SW Spokane Street was still tide flats. Fisher Flouring Mills is off to the left in the background, and the Pacific Coast Steel Mill is to the right.

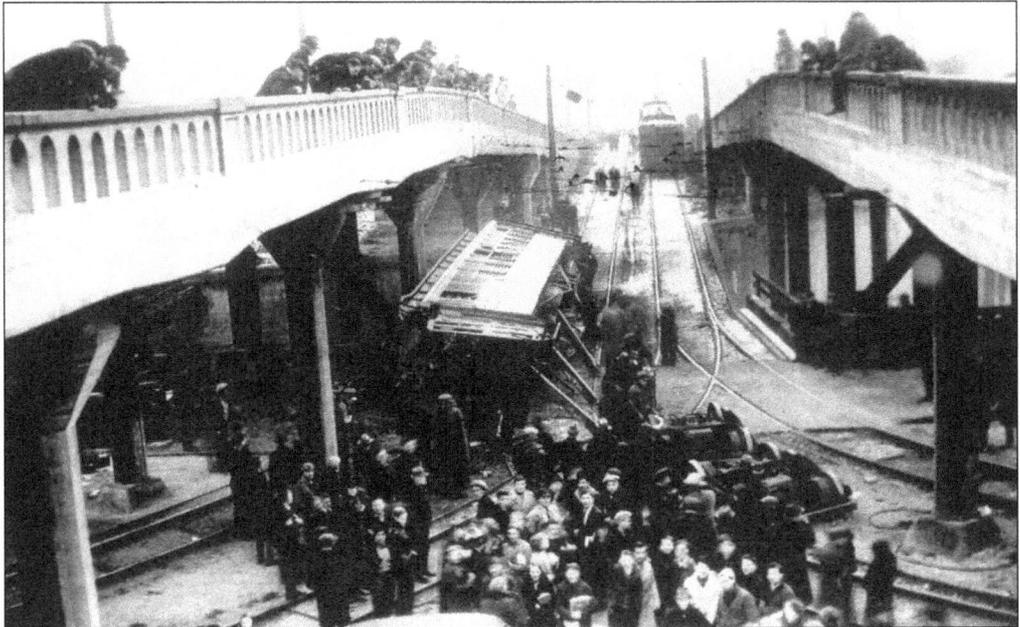

The worst streetcar accident in Seattle history occurred on January 8, 1937, when car No. 671 lost its brakes and jumped the tracks as it came down SW Avalon Way and turned east onto SW Spokane Street. The car struck a concrete pillar and was left teetering over a ravine; three passengers were killed and 59 were injured. (Courtesy MOHAI, 1986.5.12163.2.)

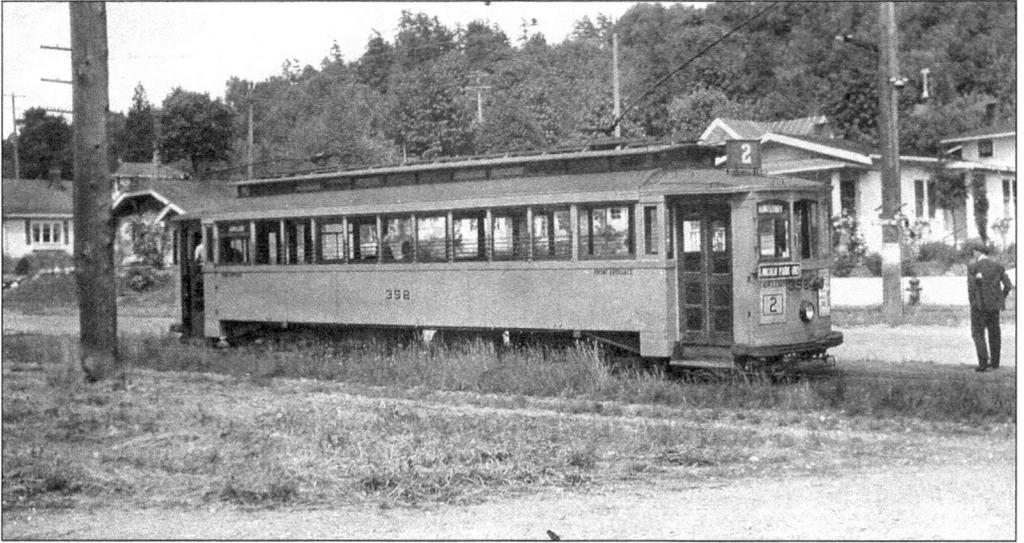

The No. 2 Fauntleroy streetcar was stopped near Lincoln Park in June 1939. The Seattle streetcar system was in poor condition by this time, due to a lack of funds and maintenance. Service to Fauntleroy began in 1907, and the last Fauntleroy streetcar ran in August 1940. From this point, the tracks continued to Endolyne in the Fauntleroy area, which was the end of the line.

This postcard image shows a new Seattle Transit "trackless trolley" approaching the Belvedere viewpoint on SW Admiral Way in 1941. Streetcars were phased out in West Seattle in 1940, with the last one running on Alki Avenue SW in November. These electric buses were better adapted for climbing Seattle's steep hills. The city marketed its new vehicles by distributing this card for a free transit ride to the public and tourists. Seattle ordered 235 of these buses after receiving a $10.2-million federal loan from the Reconstruction Finance Corporation.

18

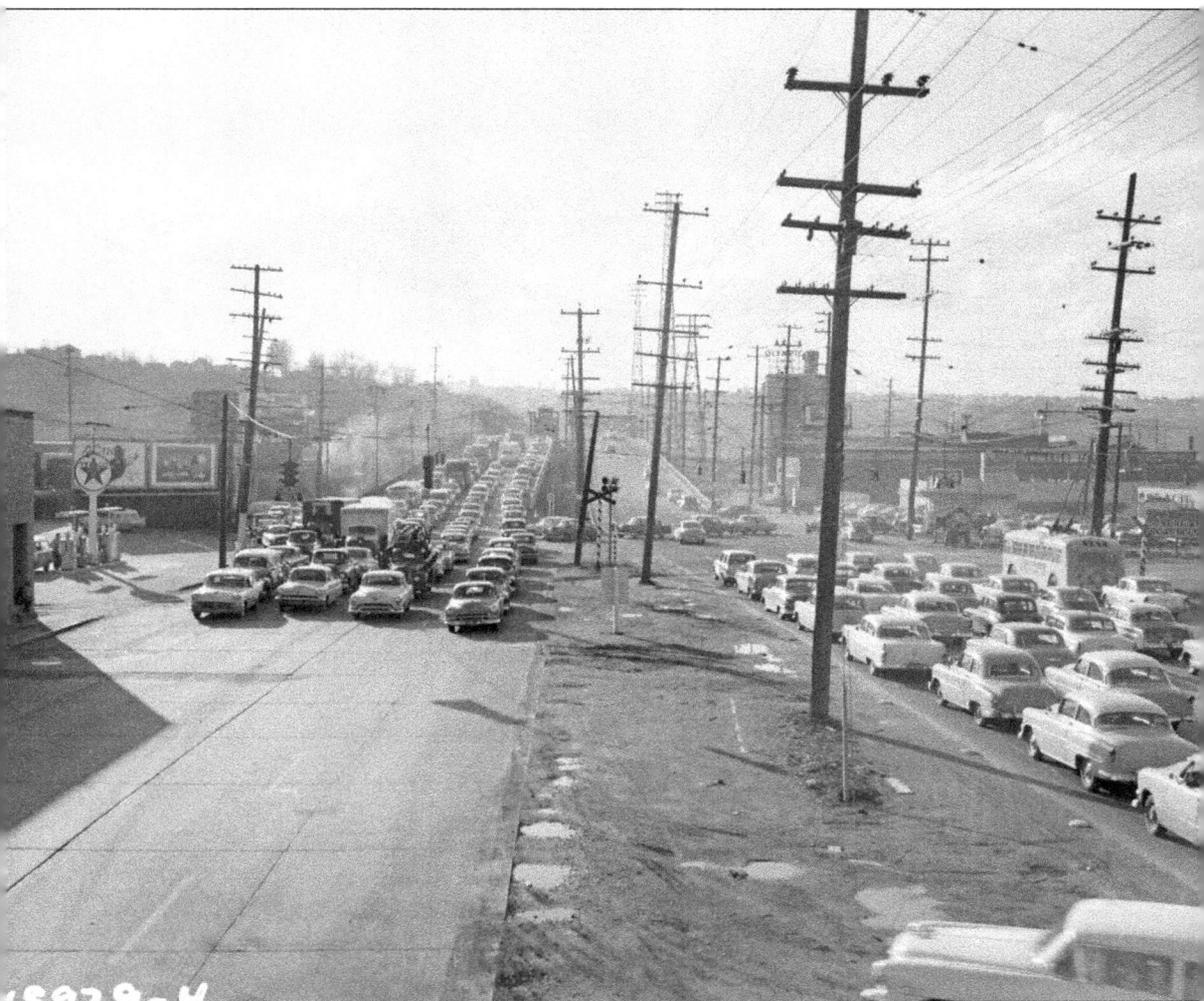

This 1956 view is looking west on SW Spokane Street from Harbor Island. It was difficult accessing West Seattle prior to the construction of the first elevated West Seattle freeway. Often after a bridge opening, a train would cross SW Spokane Street, causing further traffic delays. Nifty's Restaurant on the right, a Harbor Island landmark for many years, advertised "Good Food Always—Payroll Checks Cashed—We Never Close." When the flow of traffic was moved to the elevated freeway in 1965, the once-thriving business district of Youngstown gradually disappeared. (Courtesy Seattle Municipal Archives, No. 54247.)

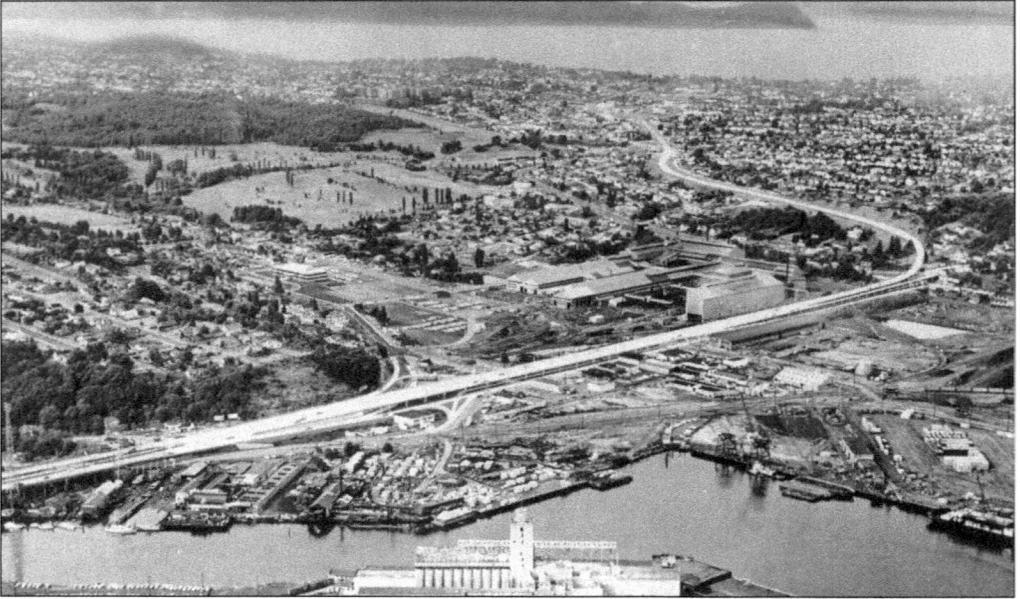

An aerial view looks southwest at the West Seattle Freeway around 1965. Originally called the Fauntleroy Expressway, it connected the two bascule bridges at West Marginal Way SW to SW Admiral Way and Harbor Avenue SW to the west, as well as Thirty-fifth Avenue SW and Fauntleroy Way SW to the south. The area remained a bottleneck. (Courtesy Frank M. Anderson.)

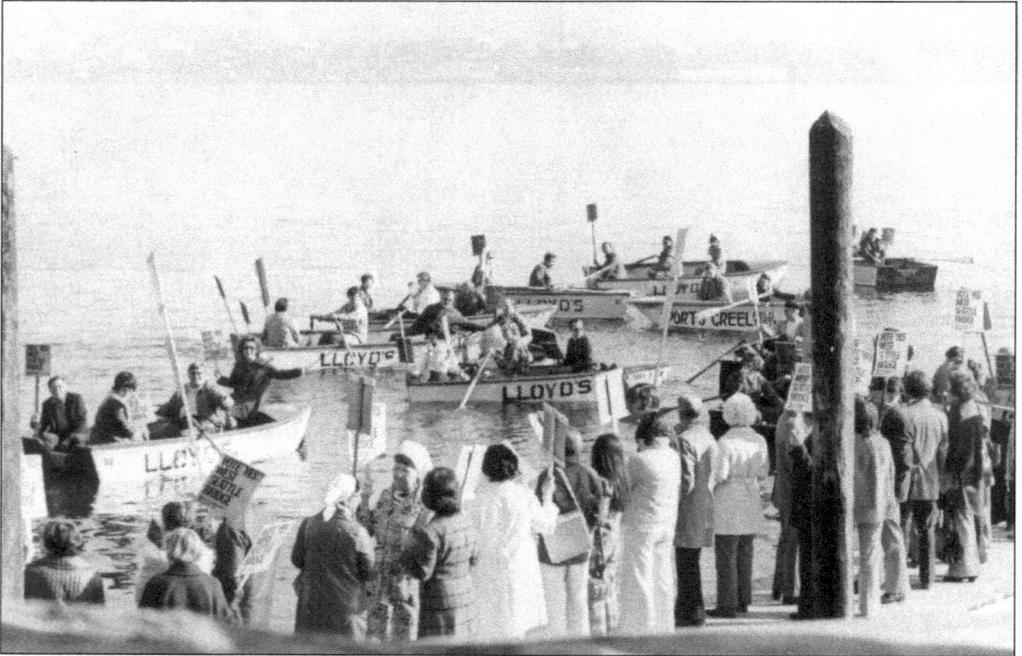

Holding signs that read "Vote Yes West Seattle Bridge," enthusiastic residents staged a flotilla of rowboats in support of the West Seattle Bridge Referendum, which was approved in March 1974. New bridge proposals in the 1970s sprang from increased traffic congestion on SW Spokane Street, the second-busiest roadway in the state by 1972.

The northern span of the Spokane Street Bridge is shown stuck in the open position after the freighter *Antonio Chavez* struck the bridge on June 11, 1978, rendering it inoperative. Westbound traffic had to be routed over the southern span, which made traffic much worse; eight lanes were reduced to four. Duwamish Peninsula residents resigned themselves to the commuting nightmare, some with humor. A T-shirt commemorating the accident queried, "Where were you when the ship hit the span?" The damage was extensive. Structural steel that helped to bind the span to the structure was ripped out of the concrete piers, the counterweight pivot bent, and the driving gears and motors used to raise the bridge were pushed out of alignment. (Below courtesy Melvin Fredeen.)

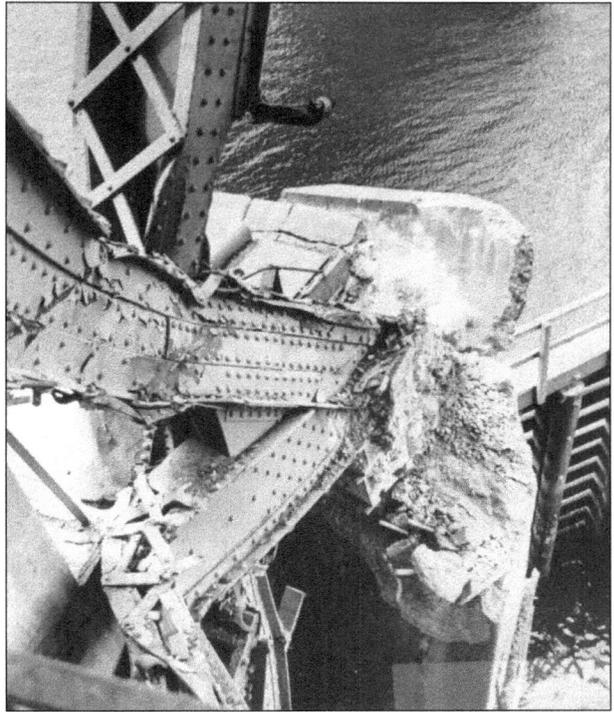

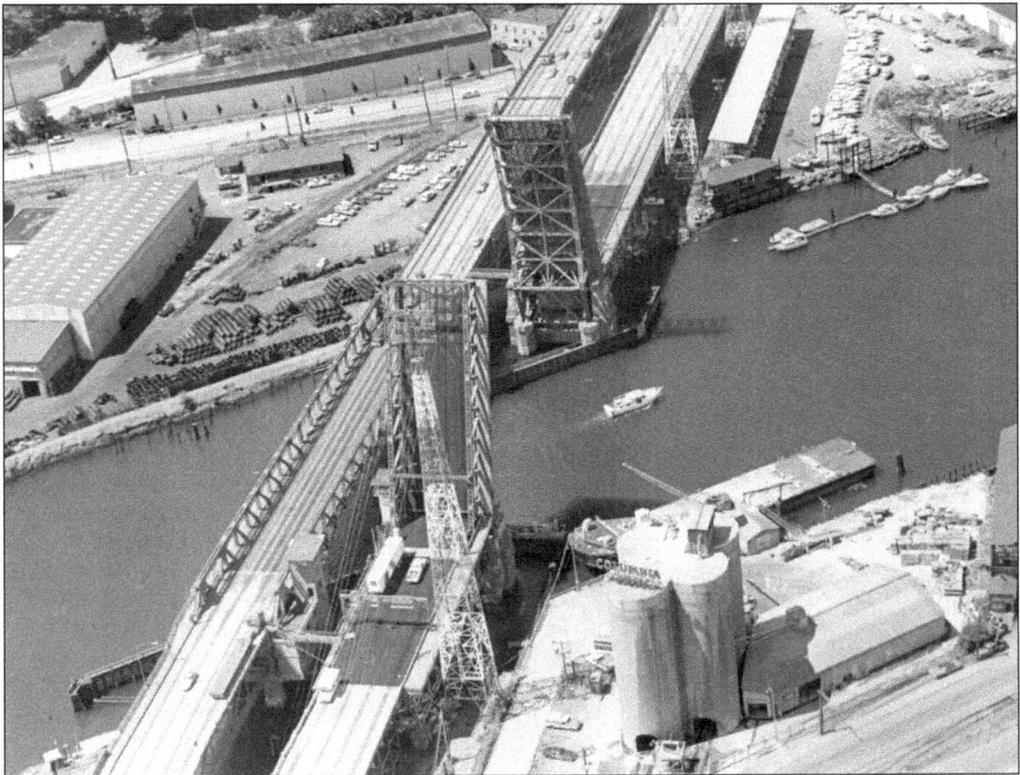

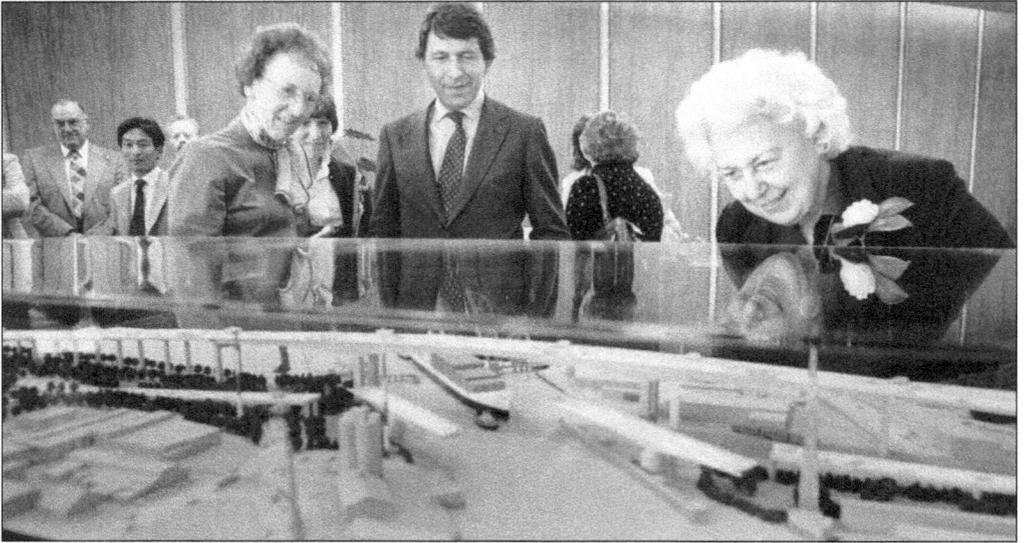

Seattle mayor Charles Royer and city council member Jeanette Williams view a scale model of the proposed high-level West Seattle Bridge around 1979. Williams chaired the transportation committee and played a key role in getting the bridge built. Various agencies raised $172 million to fund the bridge. In recognition of Williams's efforts, the bridge was also named the Jeanette Williams Memorial Bridge in 2009.

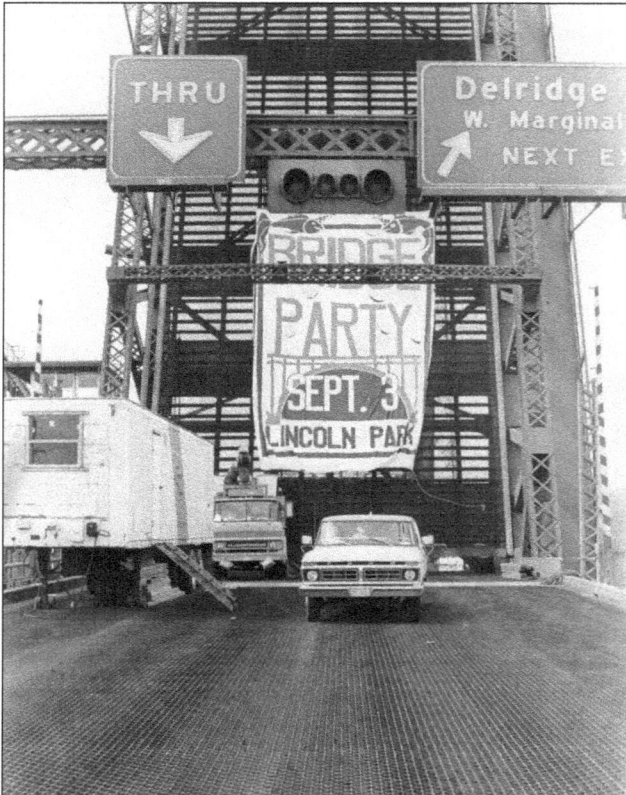

A banner on the defunct bridge advertises the "bridge party" for the new bridge held in Lincoln Park on September 3, 1978. Despite the rain, over 1,000 people showed up for the "Bashed Bridge Bash" to celebrate the funding obtained to build a new bridge. U.S. senator Warren G. Magnuson, guest of honor, was a key sponsor of the appropriations bill. Sports celebrities, live music, and the Seafair Clowns added to the bash. (Courtesy Chris Styron.)

The much-anticipated West Seattle Bridge nears completion as drivers negotiate a myriad of detours and temporary routes along the corridor of the future high-level bridge. Construction began in 1980, and the two ends were joined in the middle on July 13, 1983. The four-lane bridge opened on November 10, 1983, and all eight lanes were completed in July 1984.

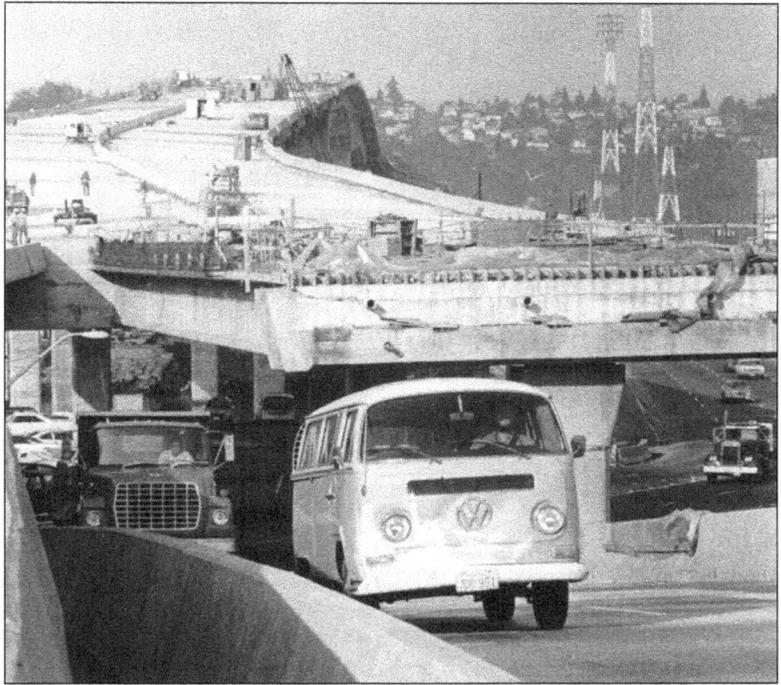

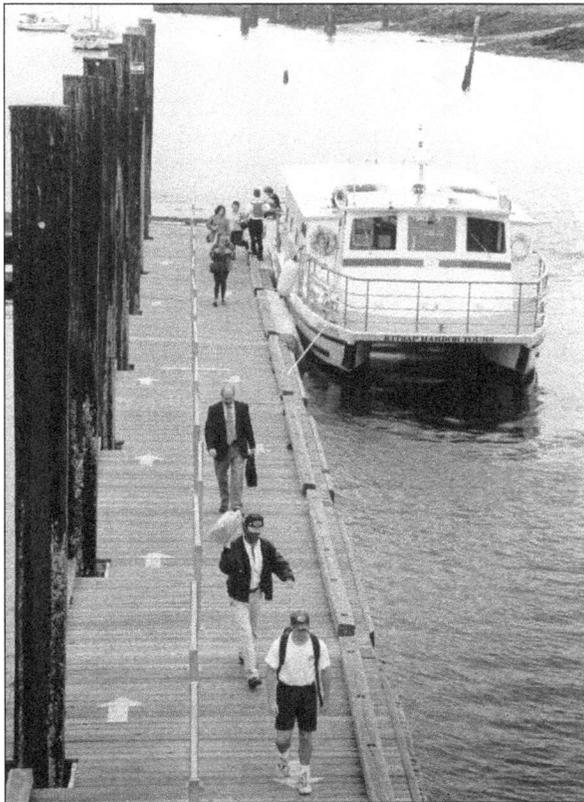

The West Seattle water taxi *Admiral Pete* is shown at the Seacrest Boathouse pier in August 1999. Water transportation between West Seattle and downtown Seattle was revived in 1997 on a trial basis and proved so popular that it is now in continuous operation from April through October. The crossing time is about 12 minutes. (Courtesy Bruce H. Savadow.)

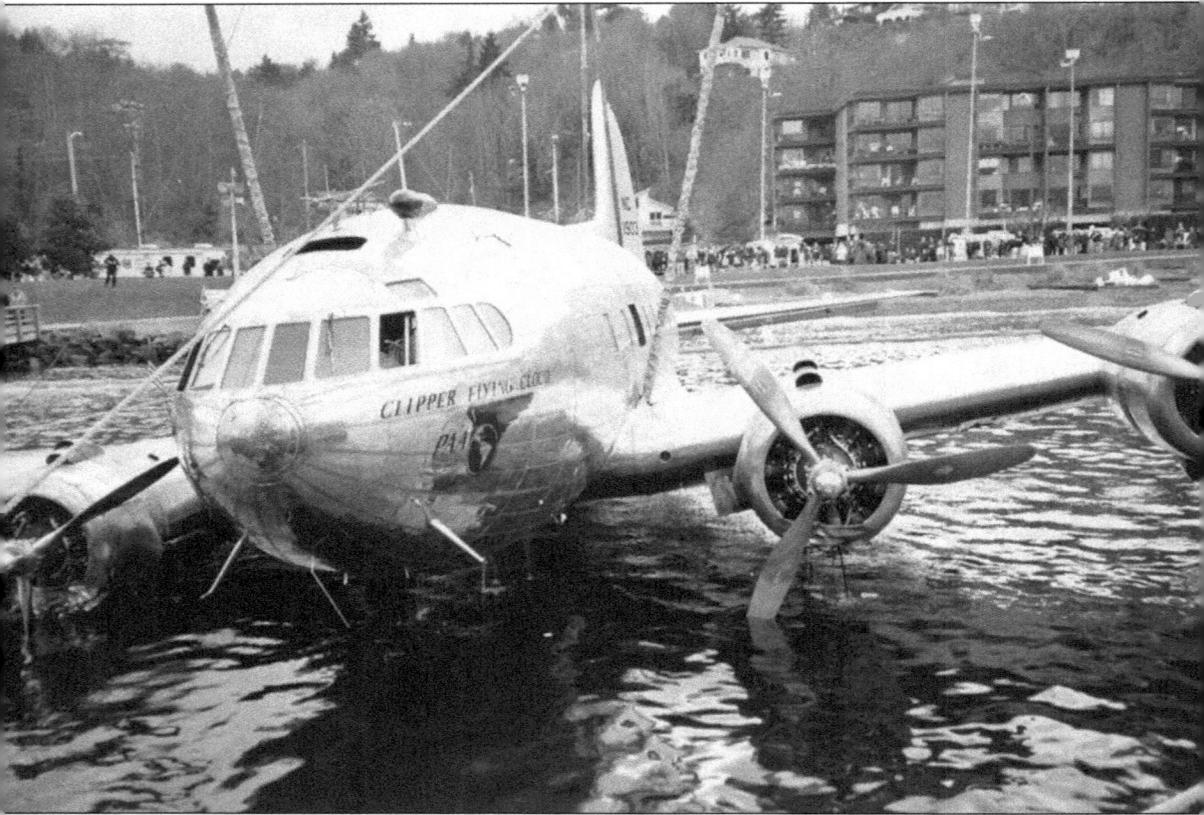

This is how not to get to West Seattle. A Boeing 308 Stratoliner is recovered after it plunged into Elliott Bay off West Seattle on March 28, 2002. The newly restored airplane was returning to Boeing Field from Everett's Paine Field when a landing gear malfunction delayed the landing. The airplane ran out of fuel and then ditched in the water. The airplane has since been restored and is part of the Smithsonian Collection. It is the last surviving Stratoliner. (Courtesy Gary Dawson.)

Two

ALKI AND
HARBOR AVENUE

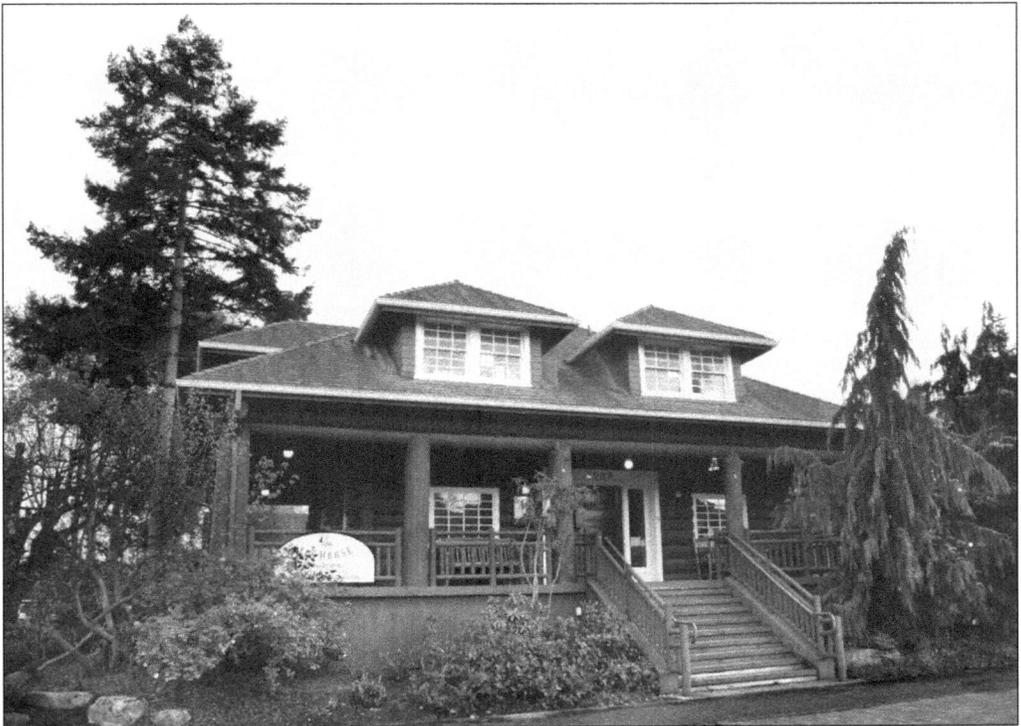

The history of the Duwamish River stretches from longhouse to log house. In 1997, the Southwest Seattle Historical Society restored and opened the Fir Lodge carriage house as a public museum called the Log House Museum. This log structure was built during the 1903–1904 winter as part of the estate of Seattle's Bernard family, and it later became a private residence. In 2009, the Duwamish Longhouse and Cultural Center opened in West Seattle near Kellogg Island. It houses the Duwamish tribal offices, public meeting space, and exhibits.

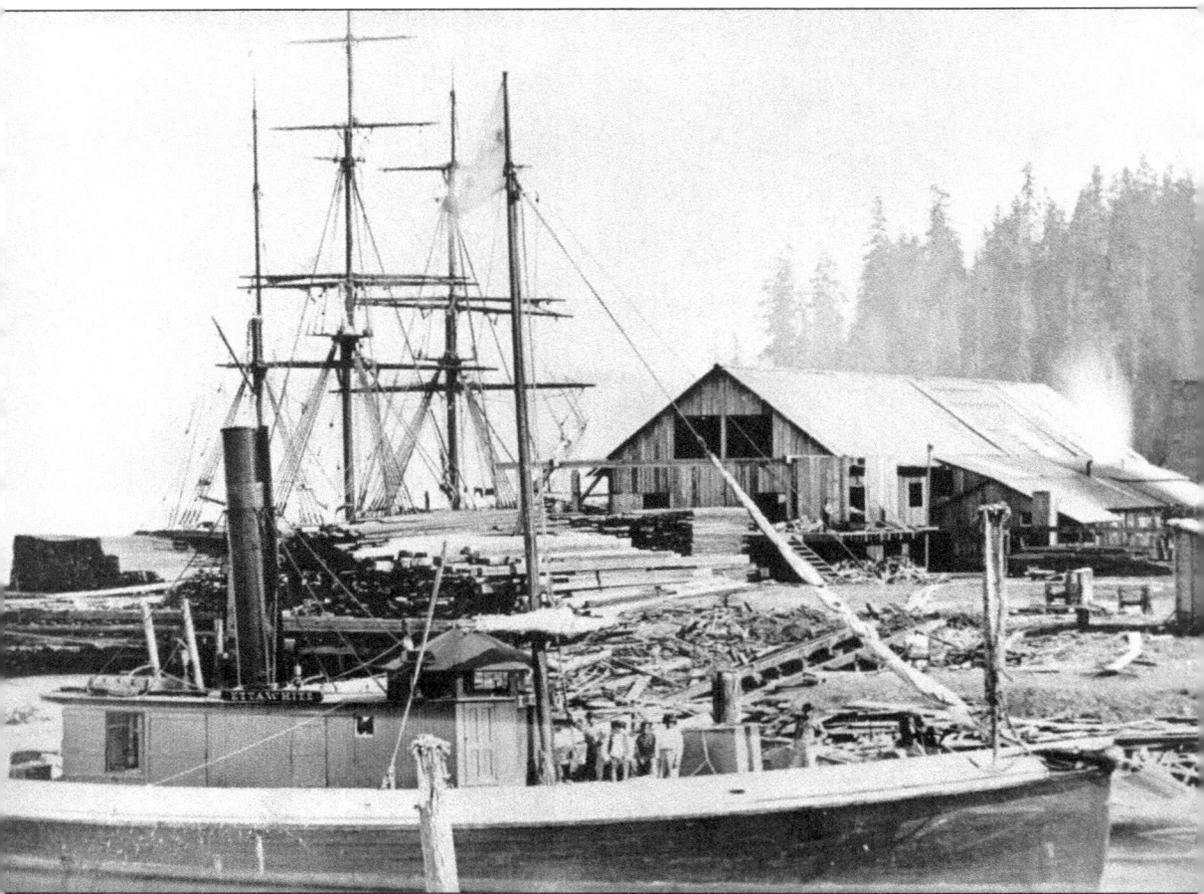

The Williamson, Phillips, and Plummer sawmill, southeast of Duwamish Head, was built in 1864 along what is now Harbor Avenue SW. It was one of the largest mills in the northwest. The surrounding community was named Freeport and by 1877, Milton. When the West Seattle Land and Improvement Company applied for incorporation in 1888, the east side of Duwamish Head was renamed West Seattle. (Courtesy Puget Sound Maritime Historical Society.)

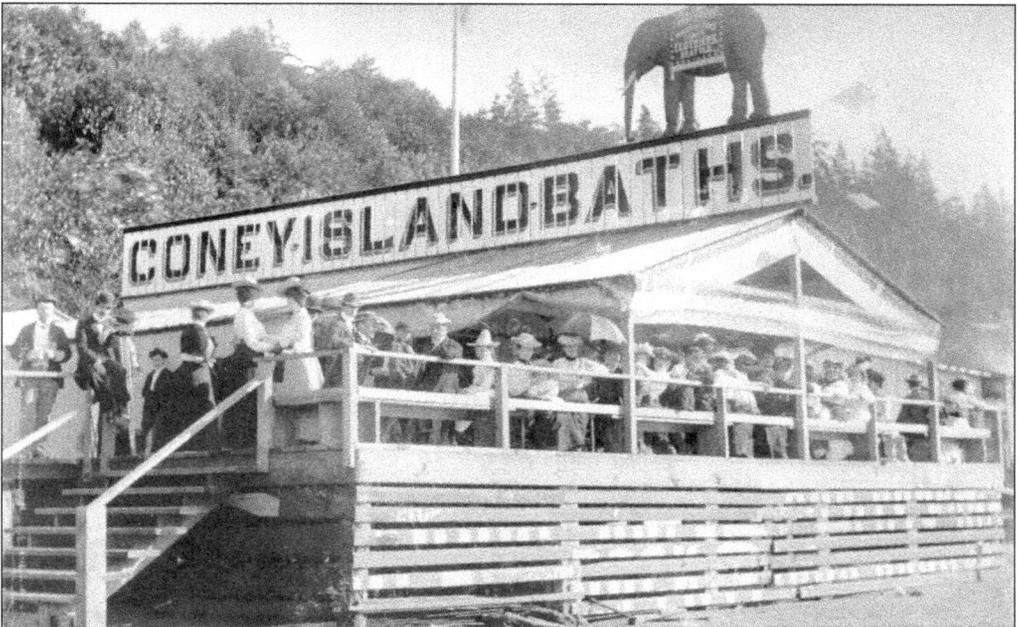

Arthur Stretch and William J. Hainsworth II opened the Coney Island Baths in 1899, west of Duwamish Head. An advertisement for the baths highlighted "running fresh water" for washing off sand and saltwater and "special care of private suits" as a convenience for those who spent their summers at Alki Beach in tents or cabins.

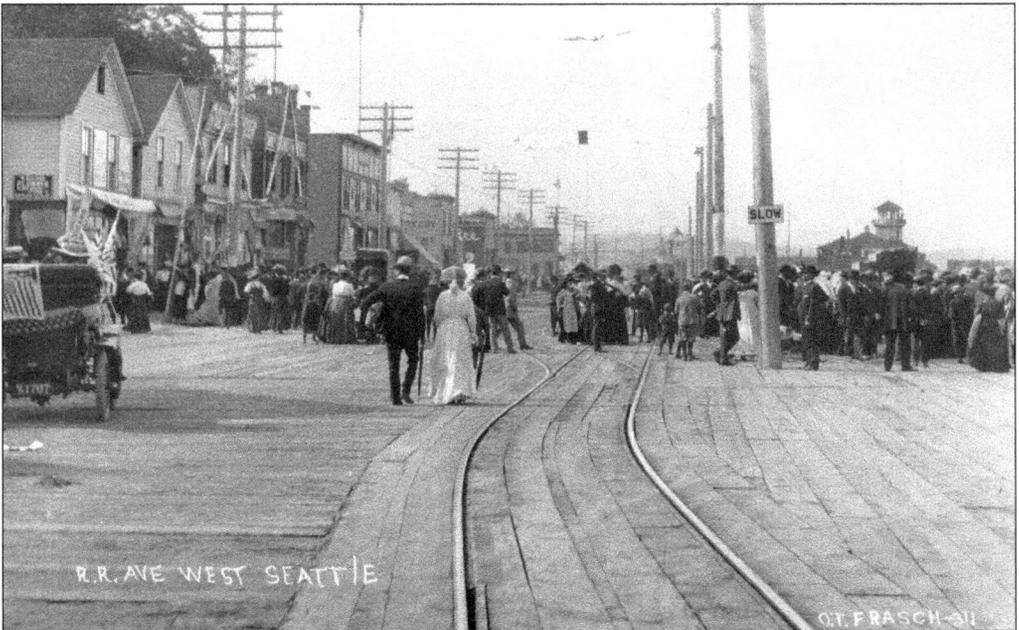

In 1908, ferry passengers visiting the Harbor Avenue business district from Seattle could ride the streetcar or walk to Luna Park and Alki beach. The tower on the right belonged to the first Seattle Yacht Club, just east of Luna Park.

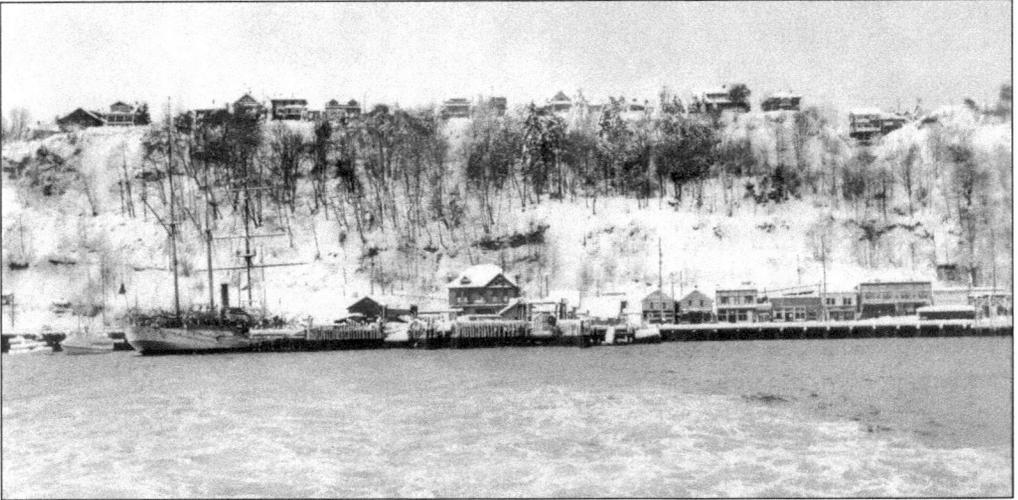

This winter scene shows homes and the West Seattle business district along the east side of the peninsula viewed from Elliott Bay around 1910. The large, two-story building at center is the West Seattle Land and Improvement Company office, which sold lots in the Admiral District. The West Seattle ferry dock is just right of center.

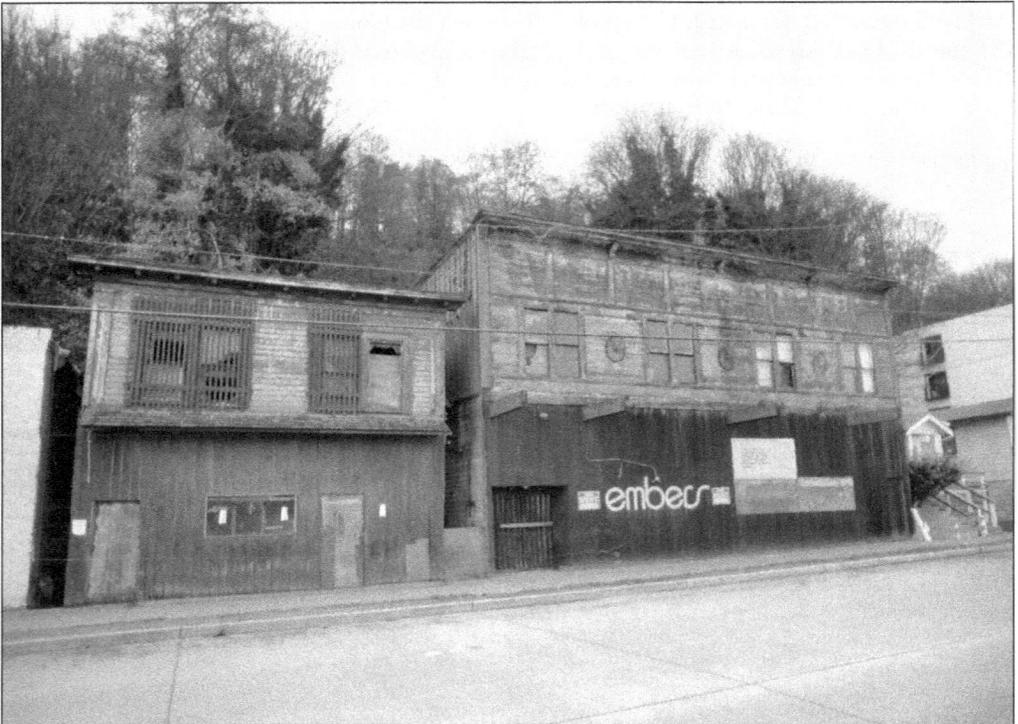

West Seattle's famous nightspot, The Embers, 1317 Harbor Avenue SW, is shown in the 1980s. The building dates to 1907 when it was constructed as the Dakoglou block in the Railroad Avenue business district. The Embers opened in 1964 as a jazz club. It hosted many famous bands and personalities including the Kingsmen Jr. Cadillac, Quincy Jones, Dyan Cannon, Robert Culp, and Bill Cosby. It closed in the 1980s and was demolished in 2003.

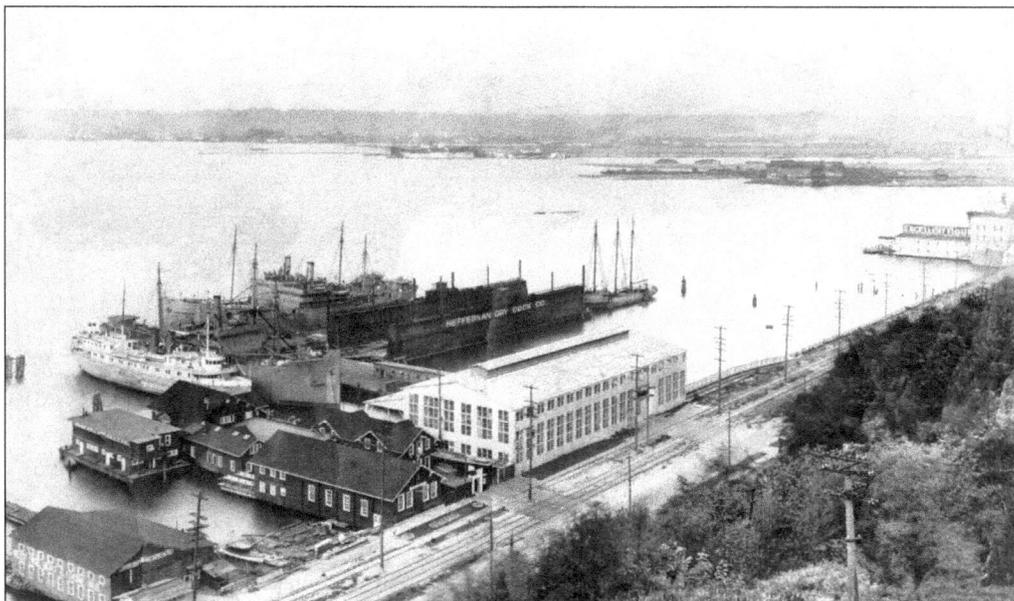

The Heffernan Dry Dock Company was located on Railroad Avenue (now Harbor Avenue SW) around 1918. The large white building was the machine shop, which became Haury's Marina and later Seacrest Marina. Located in the building cluster to the left was an early home of the Seattle Yacht Club. The Novelty Flour Mill on the right stood as a visible landmark from 1893 to 1956 next to Harbor Island in the center.

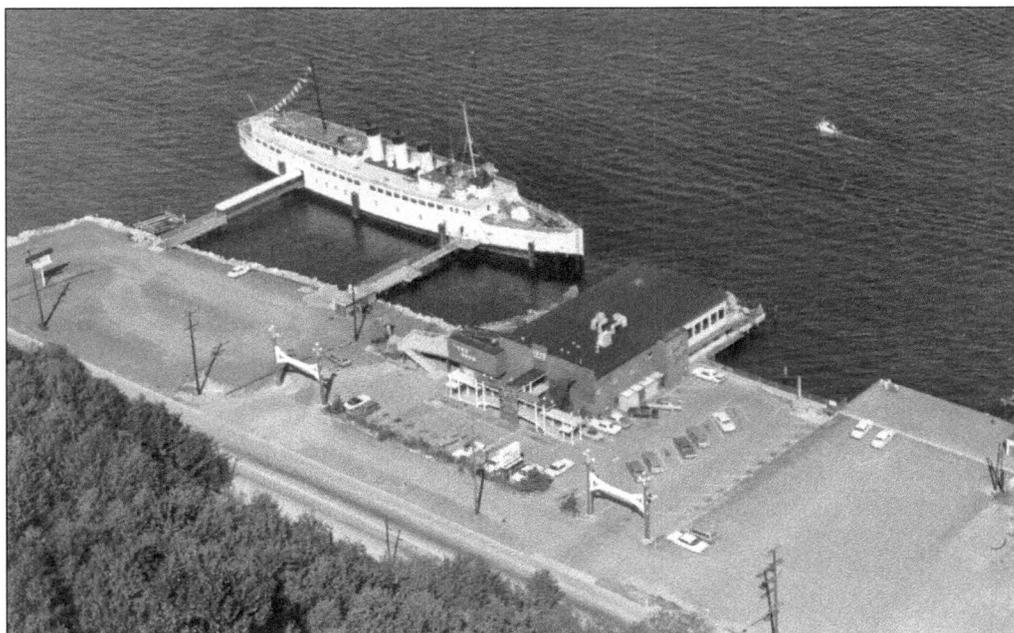

The steamship *Princess Elaine* is moored on Harbor Avenue SW next to the Beach Broiler restaurant around 1960. The retired Canadian Pacific liner was conceived as a floating restaurant, but it never succeeded, and the vessel was scrapped in the early 1970s. The Beach Broiler was sold in 1985 and is now Salty's on Alki.

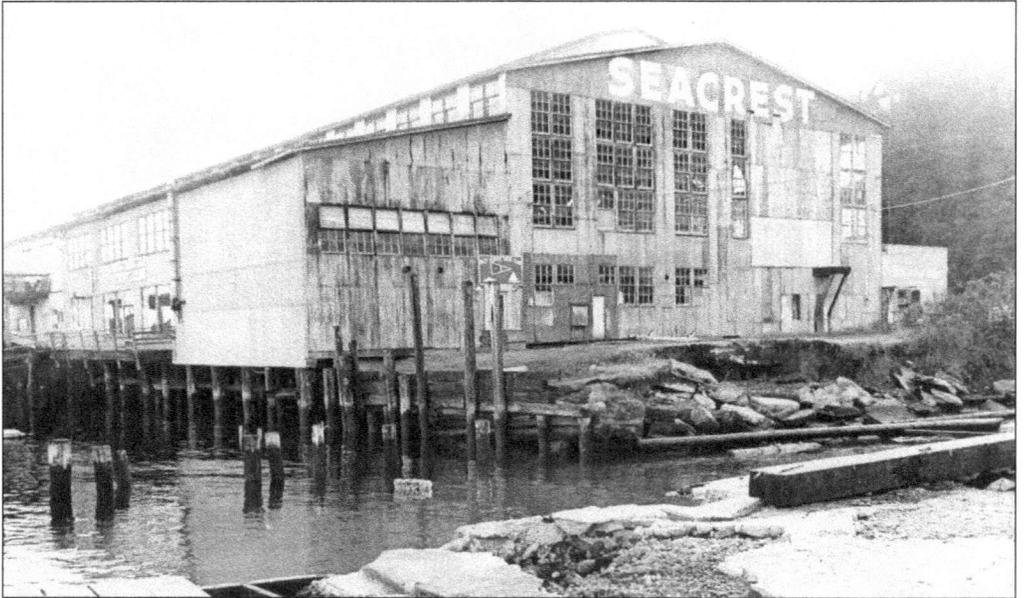

Seacrest Marina was demolished in February 1984. This structure housed both the successful Heffernan Dry Dock Company in 1907 and later the popular boat rental facility Haury's Boathouse. Located at 1660 Harbor Avenue SW, Seacrest Marina was home to the West Seattle Yacht Club, chartered in 1963. The area is now Seacrest Marina Park with boat launch facilities but no permanent moorage.

A proud young fisherman and his catch pose in front of a West Seattle boathouse rental boat on Harbor Avenue SW in the 1940s. Other West Seattle boathouses along Harbor Avenue SW providing boat rentals included Haury's, Lloyd's, Ernie's, Healy's, and Scotty's.

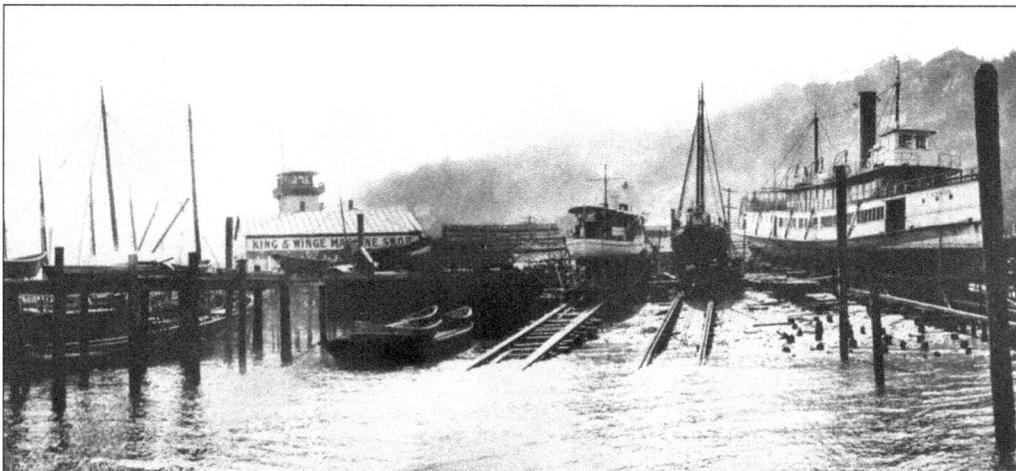

Around 1910, the King and Winge Shipyard was located directly southeast of the Luna Park Amusement Park at Duwamish Head. In 1899, Albert Winge, an immigrant from Norway, and Thomas King, a Boston-trained shipbuilder, founded one of the most successful shipyards in Seattle. Pictured behind the King and Winge sign is the tower for the original Seattle Yacht Club.

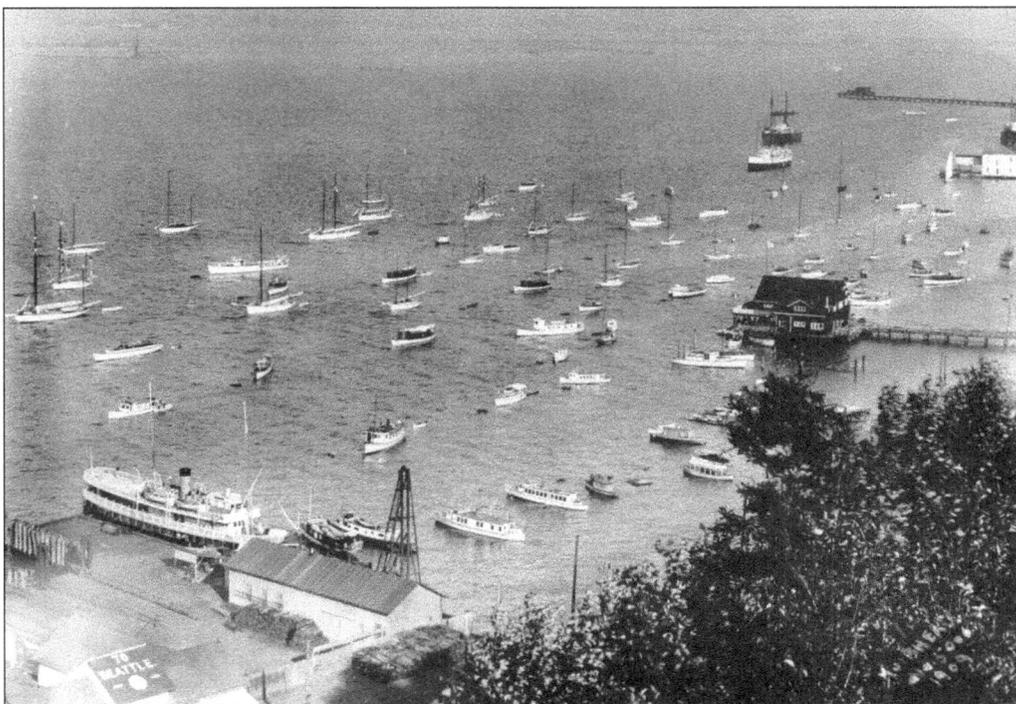

The second Seattle Yacht Club anchorage around 1892 was located southeast of Duwamish Head. Originally founded in 1892, the club merged with the Elliott Bay Yacht Club in 1909, and a new clubhouse was built along Railroad Avenue (now Harbor Avenue SW). In 1918, the clubhouse was taken over by the U.S. Shipping Board for officers' training. The club was without a facility until they moved to Portage Bay in 1920.

The Anchor Park viewpoint at Duwamish Head in 2007 provided spectacular views across Elliott Bay to Seattle. Anchor Park visitors could see remains of Luna Park's (1907–1913) pilings exposed at low tide and a memorial to the 1906 steamship *Dix*, the worst maritime disaster on Puget Sound. Anchor Park was built in the early 1950s over the filled-in concrete ruins of the Luna Park swimming pools. In 2005, the former swimming pools were replaced with a pier.

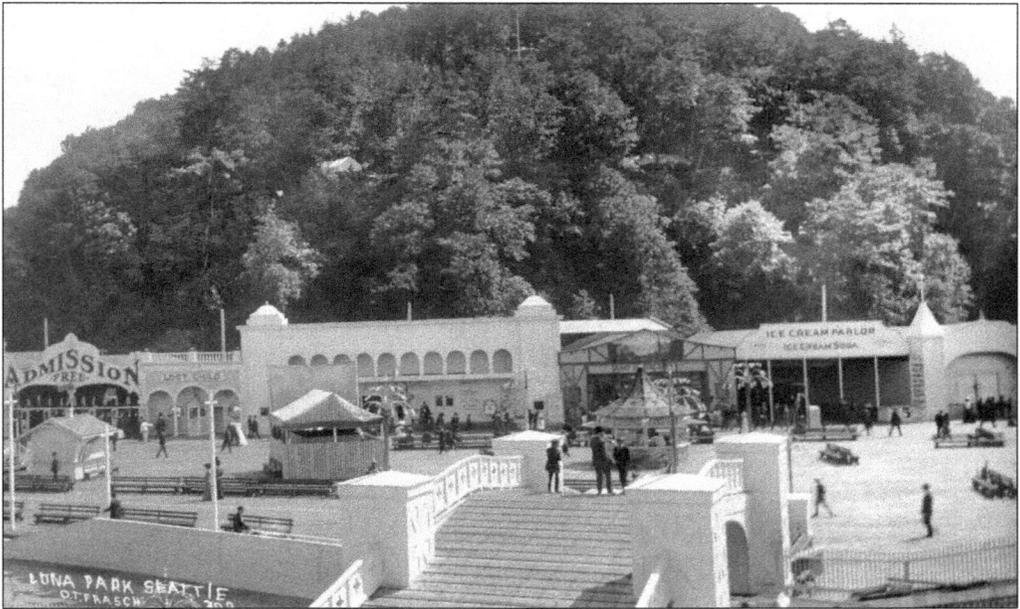

Charles I. D. Looff opened the Luna Park amusement park at Duwamish Head in 1907. The park, popular in the summer months, was short lived and closed in 1913. The Alaska Pacific Yukon Exposition kept it busy in 1909, but visitation dropped off during the colder months in Seattle. Having the "longest bar on the bay" did not enhance its reputation with the local residential community. After closing, the rides went to Playland-at-the-Beach near San Francisco, California. In 1998, the carousel was purchased and restored by the City of San Francisco and moved to Yerba Buena Gardens.

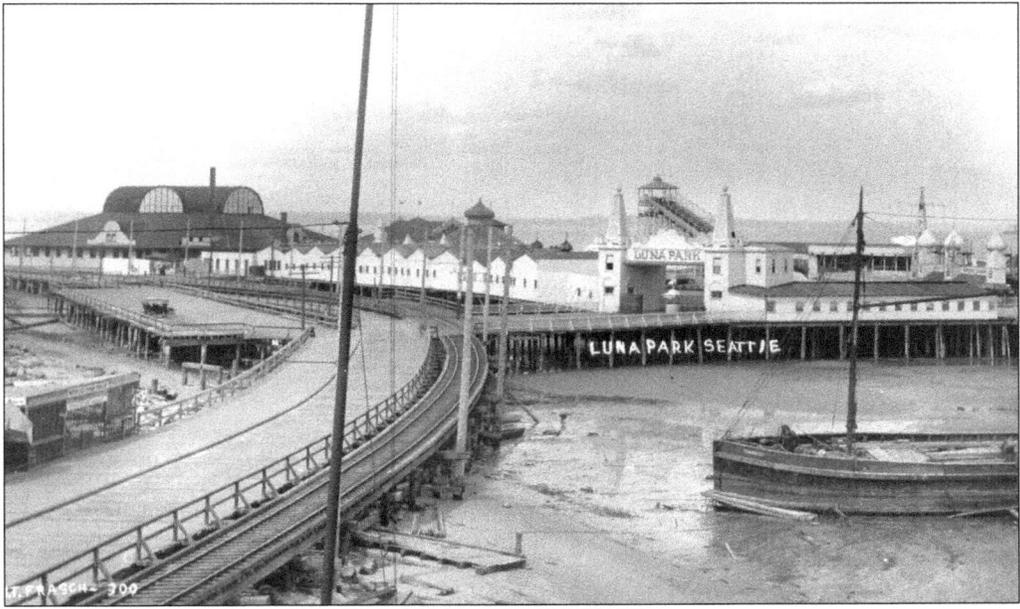

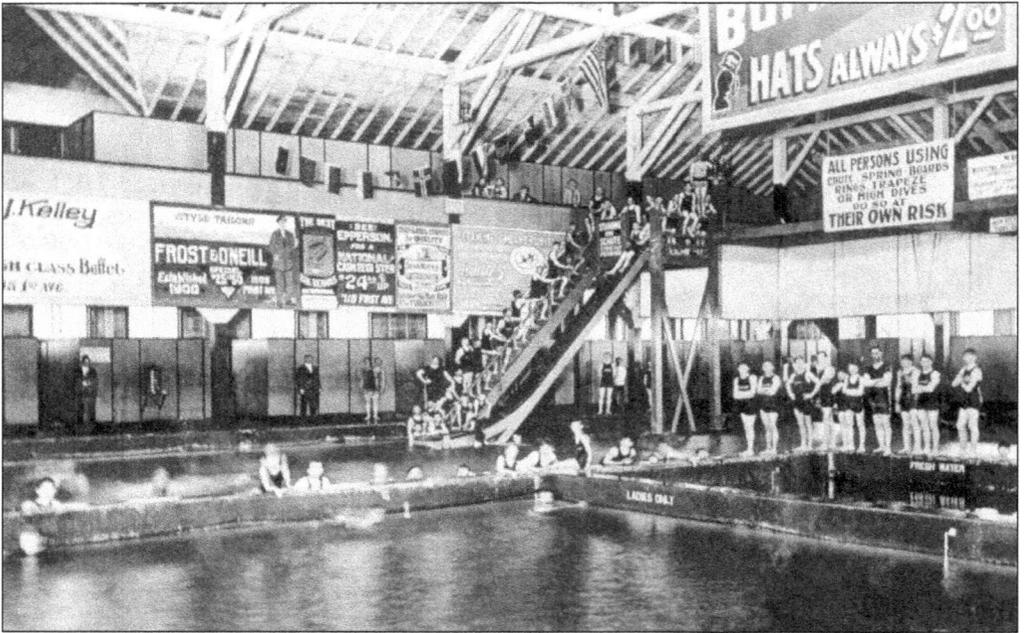

When the amusement park opened in 1907, this pool was known as the Luna Park Natatorium. Renamed "Luna Pool" after the rides closed, it continued to operate until burning down in 1931. An ad in the *Southland News* in 1916 announced "Outdoor Sport Inside, Heated Seawater, Separate Tanks for Ladies and Children, Water Changed Daily."

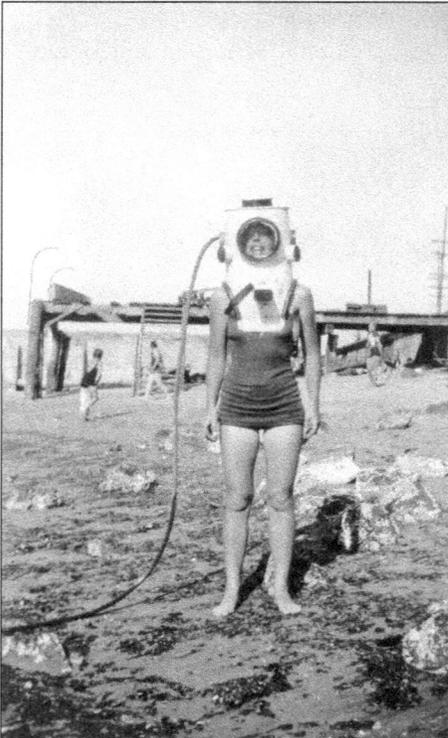

In 1933, Bernice Petty was growing up on Alki. Standing in front of the remains of Luna Pool, in a homemade diving helmet, Petty recalled when she and a friend dove off the seawall of former Luna Park. The helmet was built out of an old hot water heater.

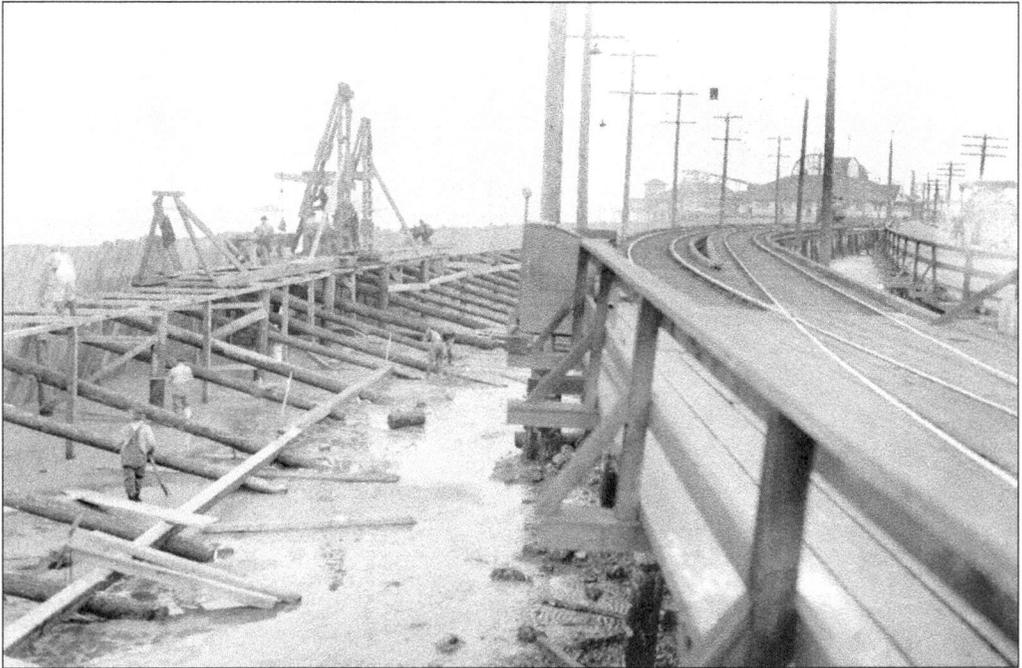

Workers are shown building a seawall and filling in the shoreline north of California Place along Alki Avenue SW in September 1915. The fill behind the seawall established the present-day shoreline. Oceanic threats of wood-eating teredos, undertow, and tidal erosion forced repairs on this work as early as 1921. Luna Park buildings are visible in the background on the right.

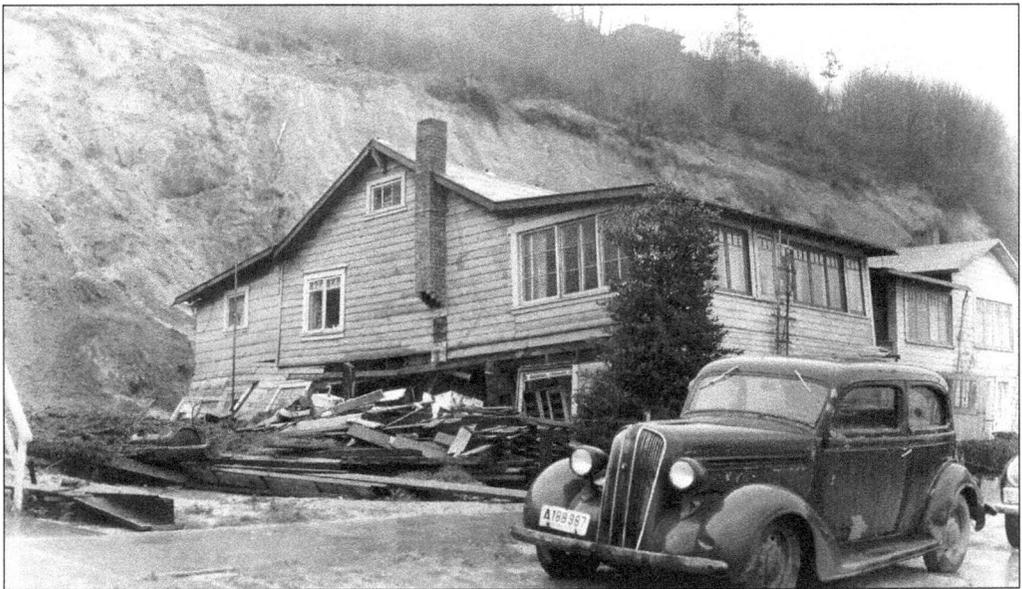

The landslide damage in this photograph occurred on Alki Avenue SW in February 1951. Landslides were common along the unstable hills and bluffs of the Duwamish Peninsula. Underground springs and heavy rainfall exacerbated the instability, and some early-day residents dug tunnels into the bluffs to create needed drainage.

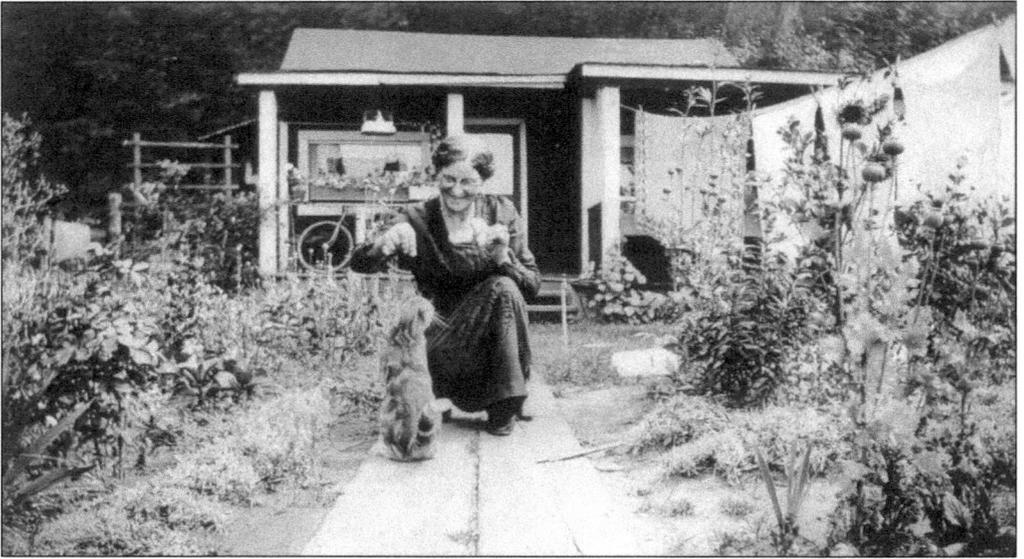

Wilhelmina Ringens is shown in her front garden around 1920. Ringens moved from Seattle proper to Alki Beach sometime after 1901. She lived in one of the many small beach houses, of typical construction of that period, which originally lined Alki Avenue.

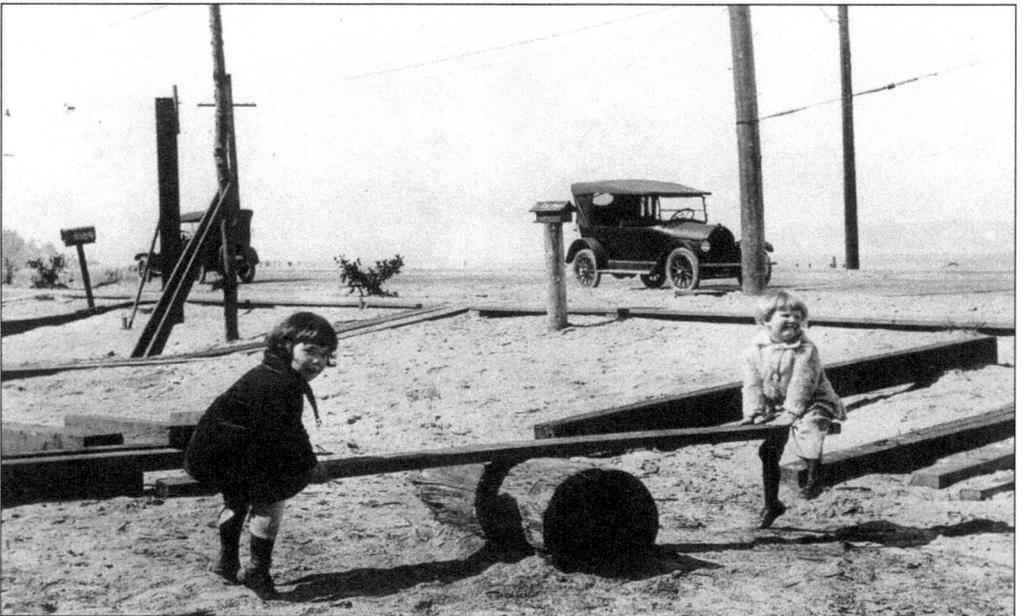

Alki resident Bernice Petty plays on the homemade log teeter-totter around 1921. The photograph was taken in front of her grandmother Wilhelmina Ringens's beach house. (See photograph above.)

This photograph shows the Alki Beach Bathing Pavilion entrance on Alki Avenue SW around 1911. Three finely dressed young women stand on the street side of the pavilion. In 1910, the city paid $75,000 for 2,500 feet of waterfront between present-day Fifty-seventh Avenue SW and Sixty-fifth Avenue SW on which the bathing pavilion was built. It opened on July 4, 1911.

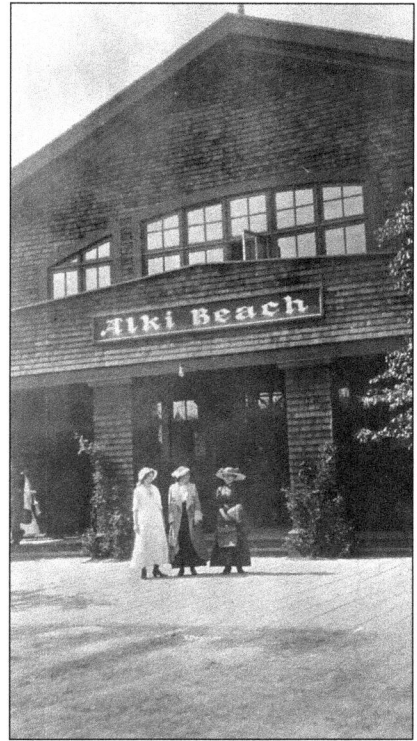

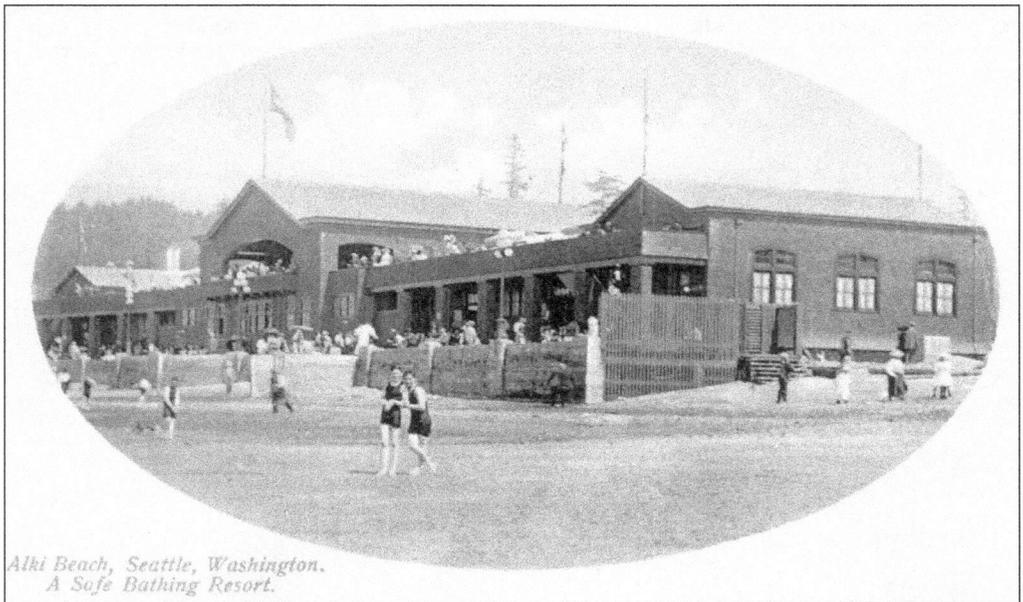

Alki Beach, Seattle, Washington.
A Safe Bathing Resort.

The Alki Beach Bathing Pavilion was located on Alki Beach. The pavilion was also known as the "Fieldhouse." The facility served the area as a community center, providing sources of entertainment and a home for community activities that included dances, Boy Scout events, sports such as volleyball and basketball, and Halloween haunted houses. The Fieldhouse rented swimsuits to adults for 10¢ and provided them free for children.

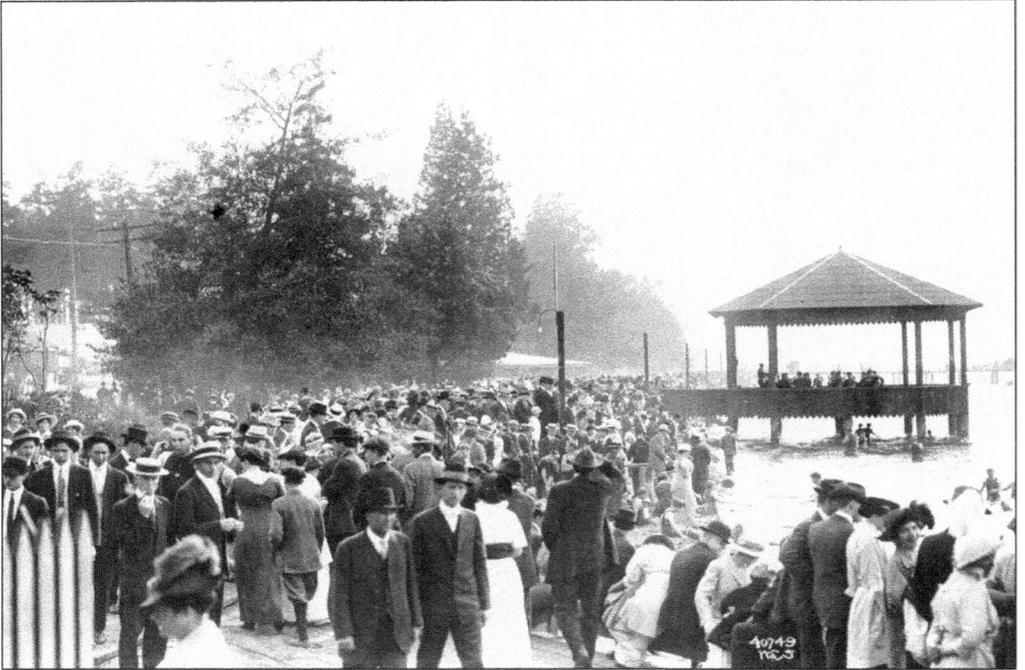

Crowds throng the Alki Beach Park promenade just southwest of the bathing pavilion. The bandstand over the water was completed in 1912, a year after the pavilion opened. More than 103,000 people attended the 75 concerts performed that year. Beachgoers arrived from Seattle by ferry and streetcar. The Alki Mosquito Fleet ferry pier is in the background.

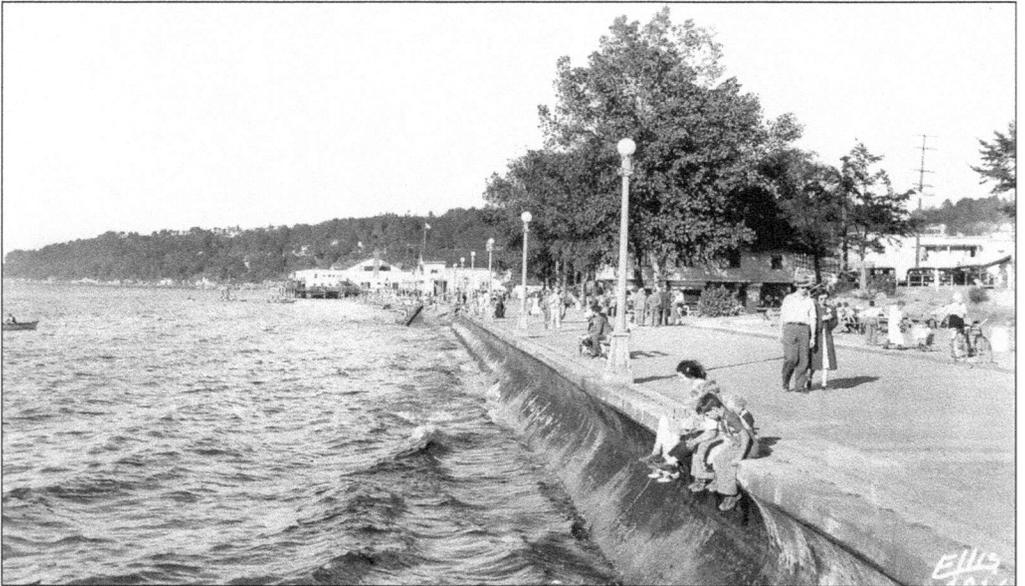

This section of the Alki Beach promenade and seawall looks much the same today as it did when this picture was taken in the early 1940s. The Alki Natatorium is visible in the far background. The seawall was poured in curved sections in 1925 by the Seattle Engineering Department to stabilize the bank and deflect the force of wave action.

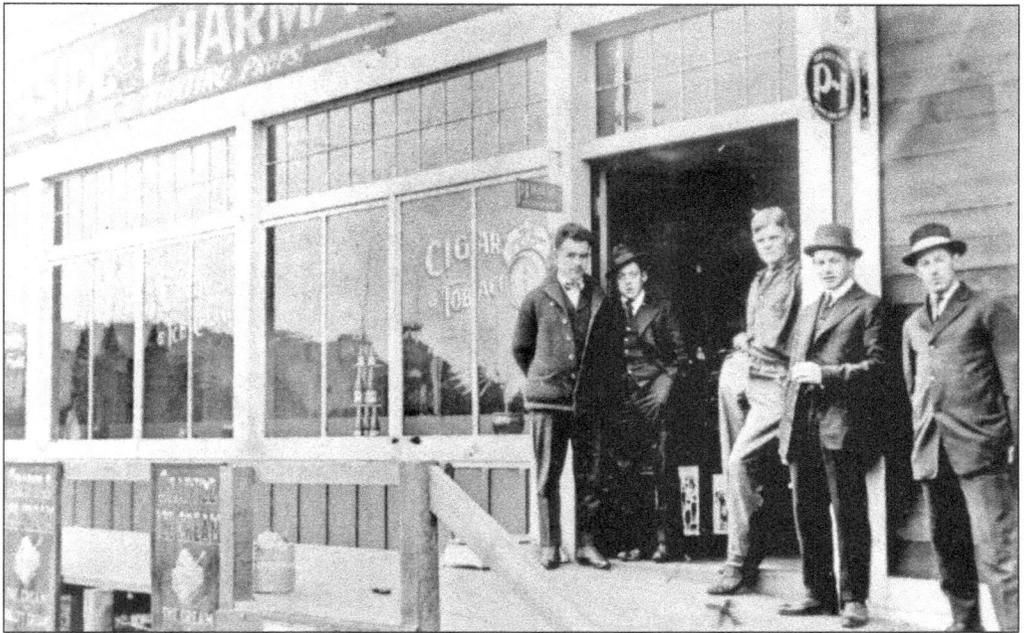

A group of men stand outside the Seaside Pharmacy located at the southeast corner of Sixty-first Avenue SW and Alki Avenue SW around 1910. The business later moved across the street, and Charles A. Richey—nicknamed the "Mayor of Alki"—purchased it in 1922. Richey's Seaside Pharmacy was a beloved local hangout. Today the Alki Bakery occupies the building.

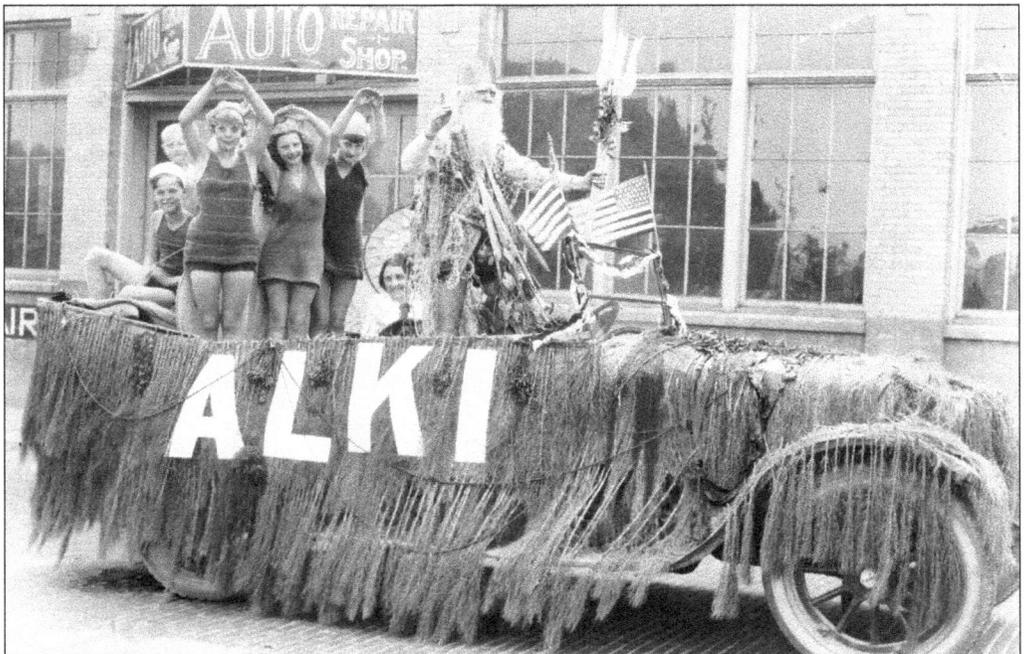

Around 1920, King Neptune and mermaids pose aboard the Alki parade float, an elaborately disguised Auburn touring car. West Seattle has participated in many local parades, such as the original Potlatch Parade in downtown Seattle and the later Seafair parades.

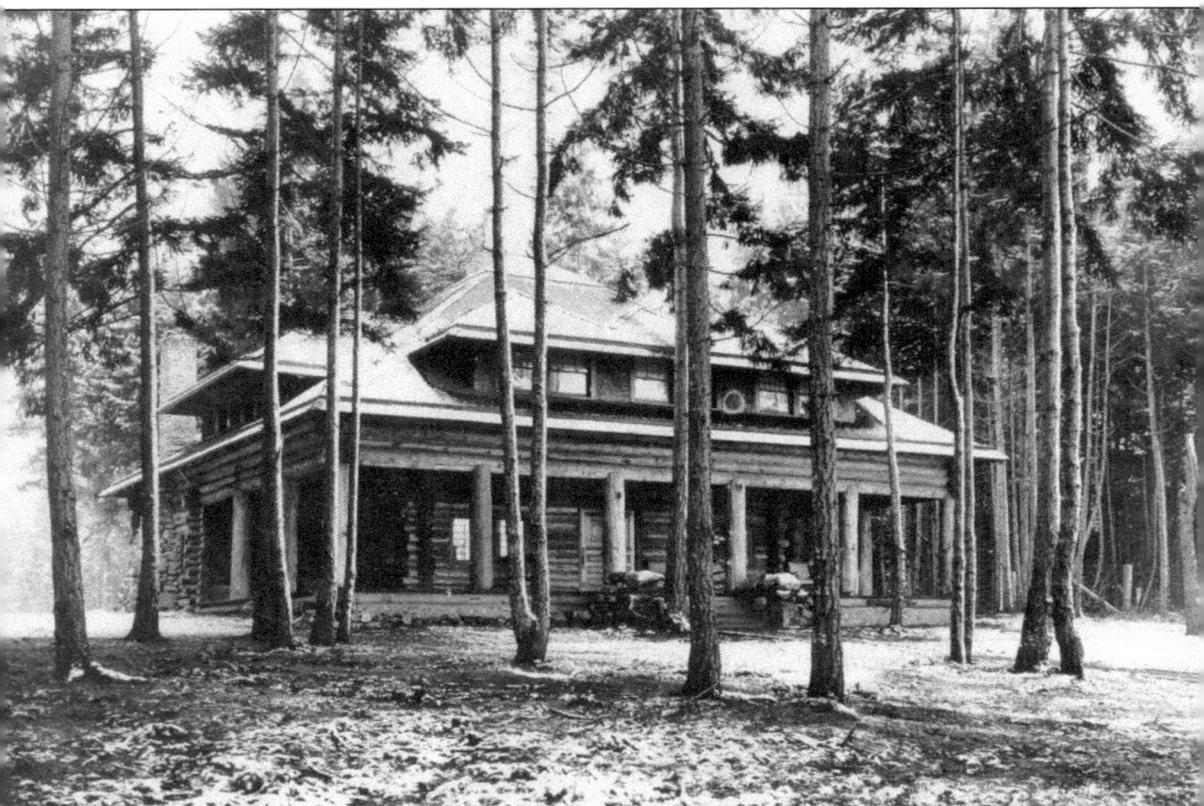

The Fir Lodge, 2717 Sixty-first Avenue SW around 1905, was one of the earliest year-round residences built in the Alki Beach area. In 1950, it became the Alki Homestead restaurant. Doris P. Nelson and her family owned the restaurant for 44 years until her death in 2004. Designated a unique Seattle landmark in 1995, it sustained fire damage in January 2009 and awaits restoration.

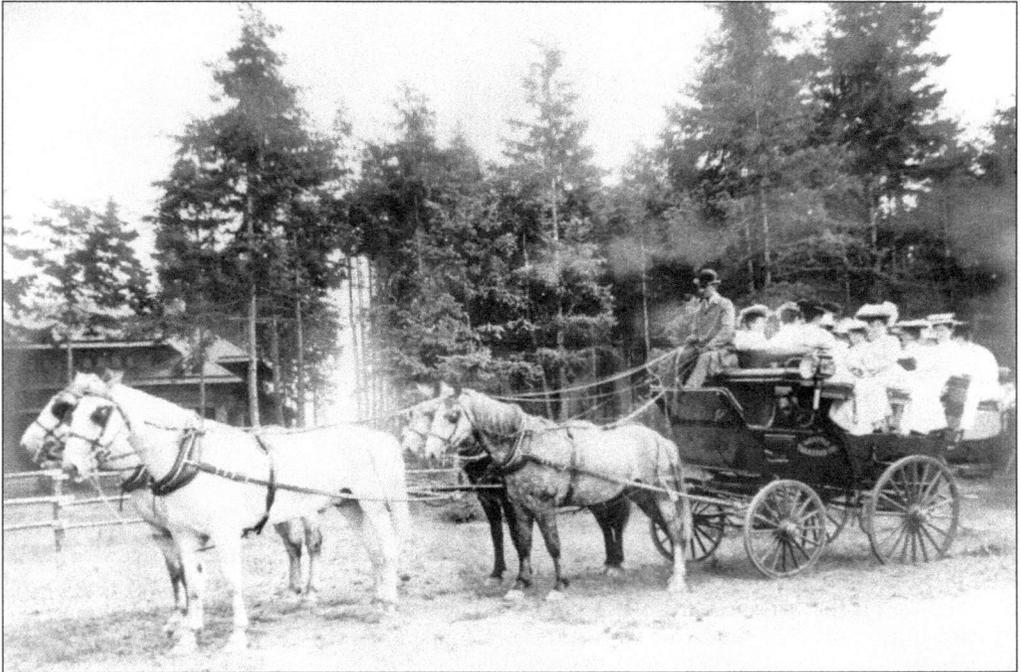

A group of ladies enjoys an Alki adventure aboard a West Seattle Transfer Company omnibus shown in front of the Fir Lodge around 1905. Before streetcar service began in 1907, visitors to West Seattle traveled by ferry or mosquito fleet vessels and walked or rode around the point. Horse-drawn carriages transported visitors from the docks to their destinations.

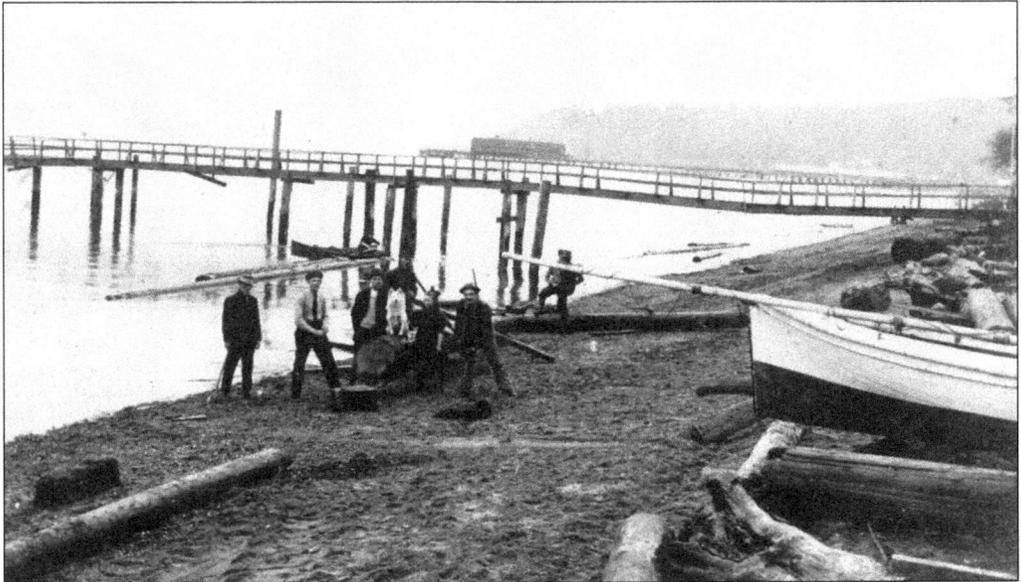

A group gathers driftwood on Alki Beach around 1909. This image is from a postcard sent to a Mrs. C. C. Lewis. The sender identifies the two men wielding the saw as Cal Meeker and Will Gary. The picture shows several docks that once existed along the beach. The King and Winge Dock, with its fish-packing plant, opened in 1905 and is visible in the far background.

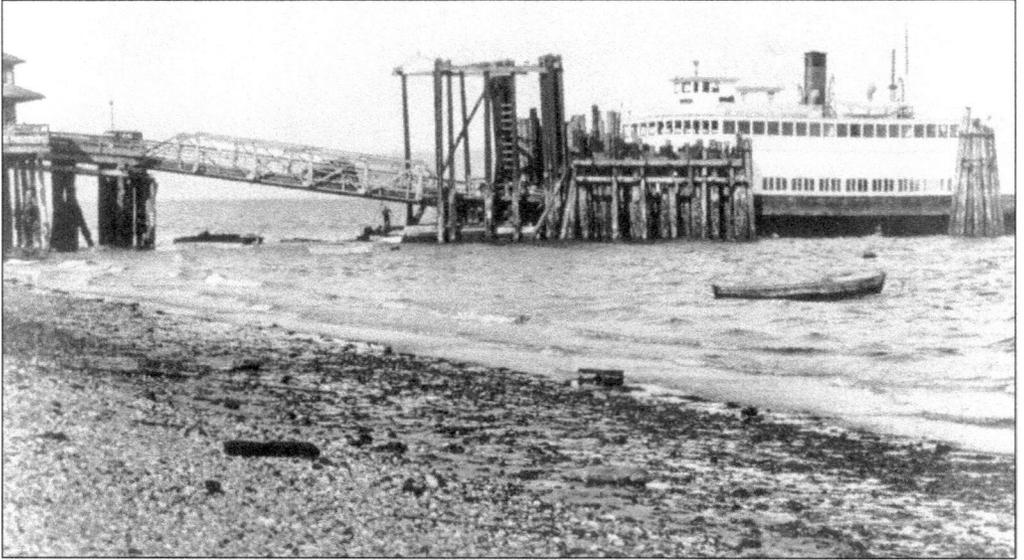

The ferry *Crosline*, around 1930, ran between Alki Point (just south of the lighthouse) and Manchester on the Kitsap Peninsula. The *Crosline* was 142 feet long and could accommodate 65 cars. It was built by the Marine Construction Company on the Duwamish River. The Alki-Manchester route ran from 1925 until 1936 when a storm washed out the Alki Point dock.

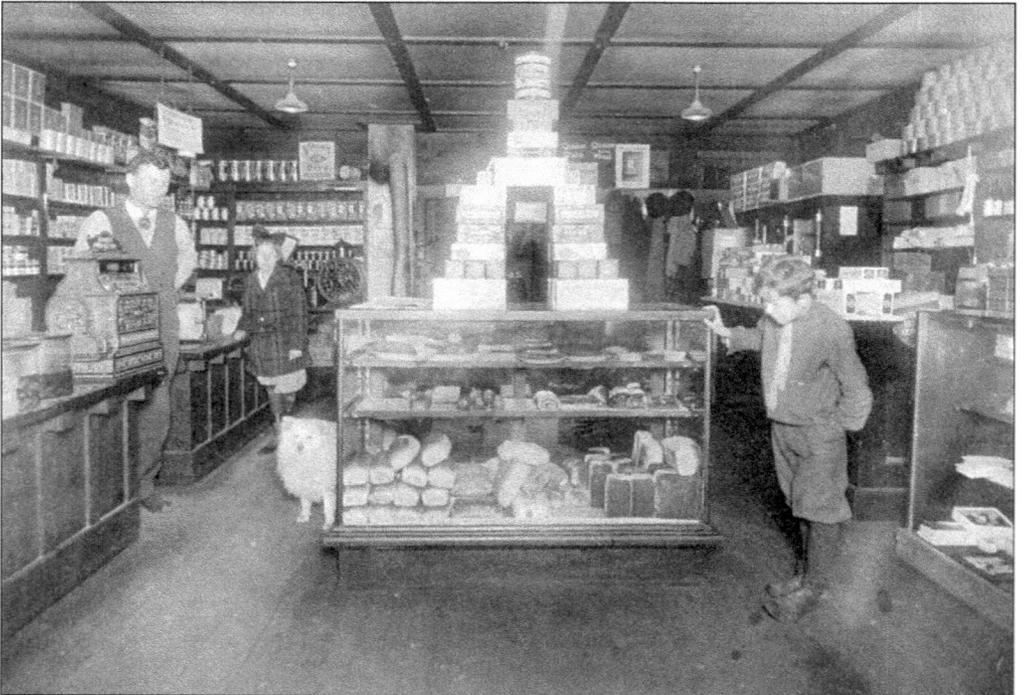

The Bonair Grocery store, around 1917, was just north of the current Alki Beach business district on Alki Avenue SW at Bonair Drive SW. It was typical of the small family-owned groceries that were in business throughout the city neighborhoods. The owners were Martin and Mattie Sherman. Their son Arthur is at the right.

Klint's Alki RentaBike, shown here around 1940, started as a bicycle repair and rental shop in the garage behind Chas Klint's house on Alki Avenue SW in 1937. As bike riding has always been popular along the beach, he had more than 40 bikes that he rented for 10¢ an hour. The operation, renamed Alki Beach Cycle, moved to the corner of Alki Avenue SW and Fifty-ninth Avenue SW in 1943.

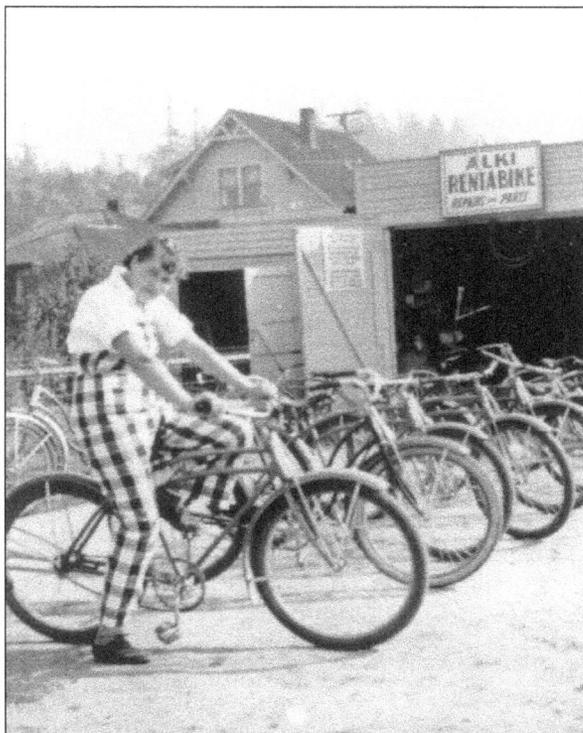

Zoe Richey poses on the Alki Beach seawall in front of the shell of the Alki Natatorium. Just north of the Alki Beach Bathing Pavilion, also visible and built by a private developer, is the natatorium that opened in 1934. Five years later it went bankrupt and closed. In June 1941, the city claimed the property and renovated the neglected structure, reopening it in 1942.

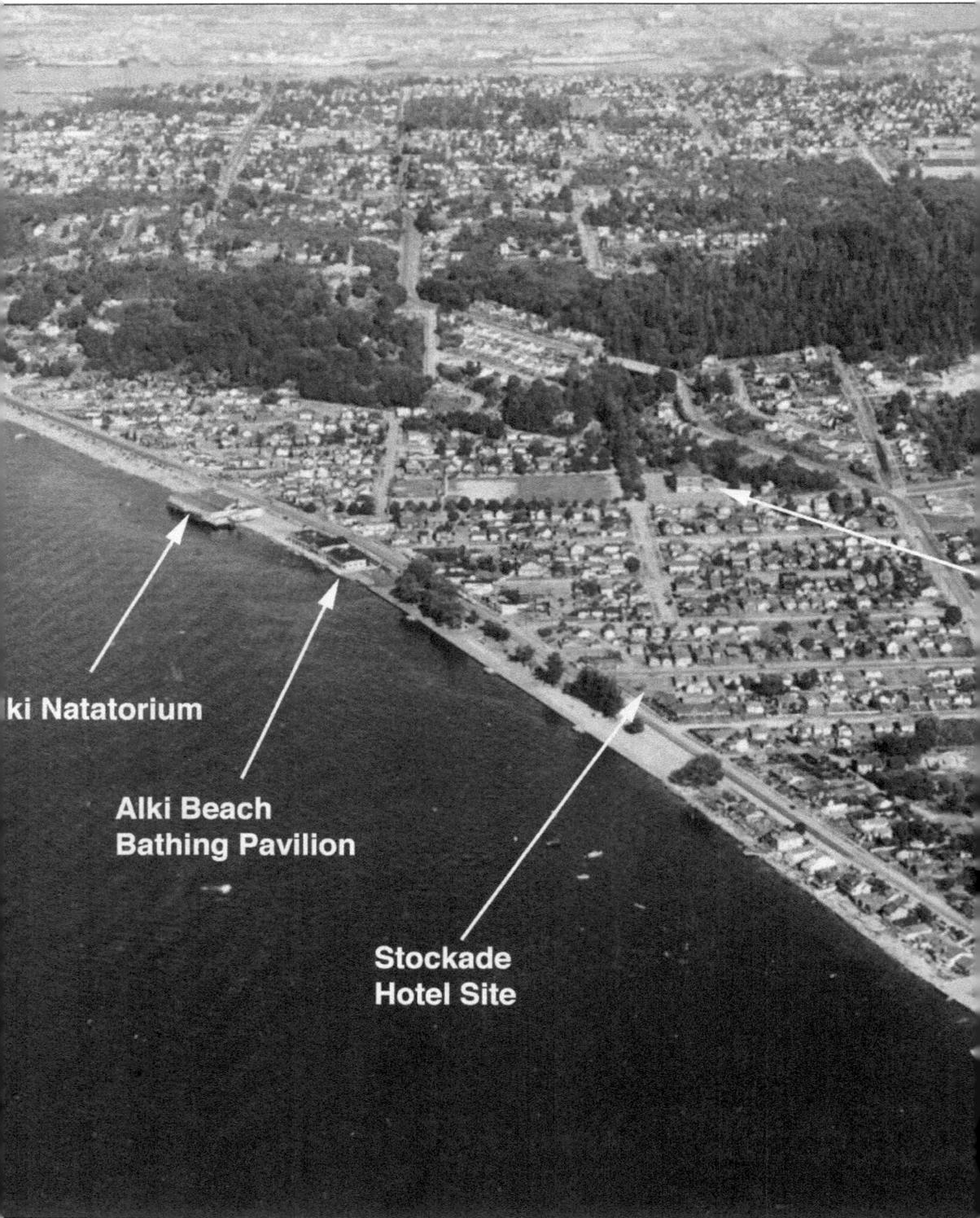

ki Natatorium

Alki Beach
Bathing Pavilion

Stockade
Hotel Site

44

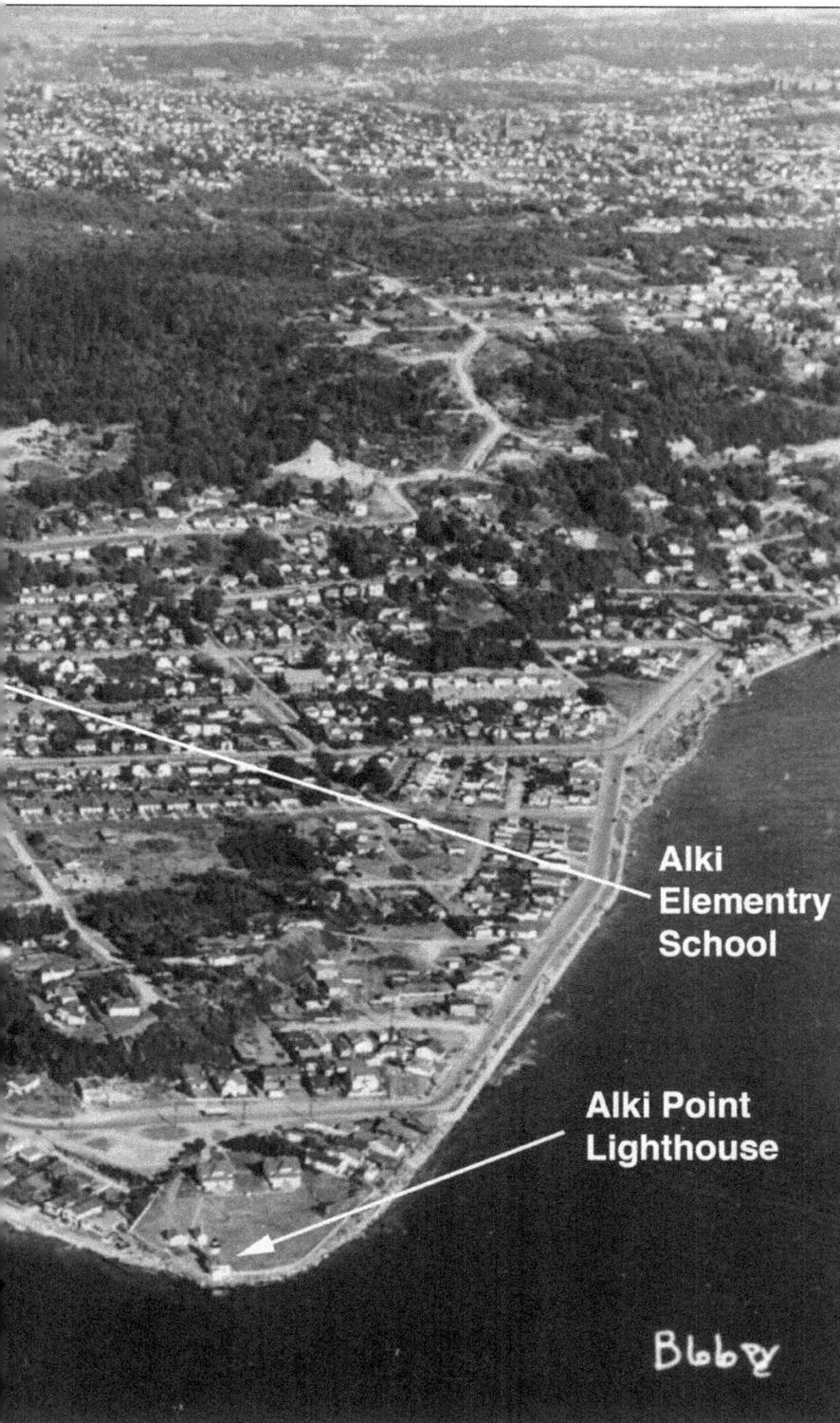

Alki Elementry School

Alki Point Lighthouse

Bbby

The Alki Natatorium and the Alki Beach Bathing Pavilion are on the left-side shoreline in this panoramic aerial view of Alki Point around 1940. To the right of those buildings is Alki Elementary School. Farther down the shoreline is the Stockade Hotel site. The hotel was demolished in 1936. The large stand of trees in the center is Schmitz Park and at the point is the Alki Point Lighthouse.

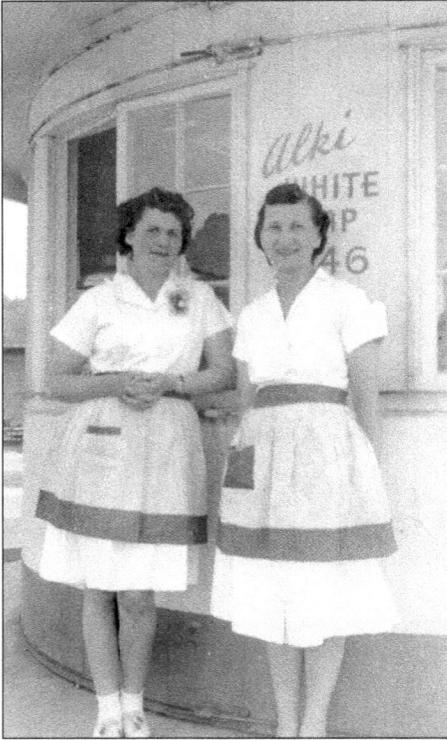

Mrs. Klint and Mrs. Peterson pose in front of their Alki White Cap Ice Cream and Hotdog stand at Alki Avenue SW and Fifty-ninth Avenue SW. The Klints and Petersons went into business together during World War II in this structure made out of a wooden water tank. The Klints sold their interest in 1948. Hit by a city bus in 1949, the stand collapsed from the impact.

Automobiles are parked in front of Spud Fish and Chips restaurant at 2666 Alki Avenue SW around 1940. Brothers Jack and Frank Alger opened Spud Fish and Chips around 1935 in a converted garage off Alki Avenue SW. They initially served fish and chips for 10¢. When cooking grease was rationed during World War II, customers donated their ration coupons so Spud could stay in business.

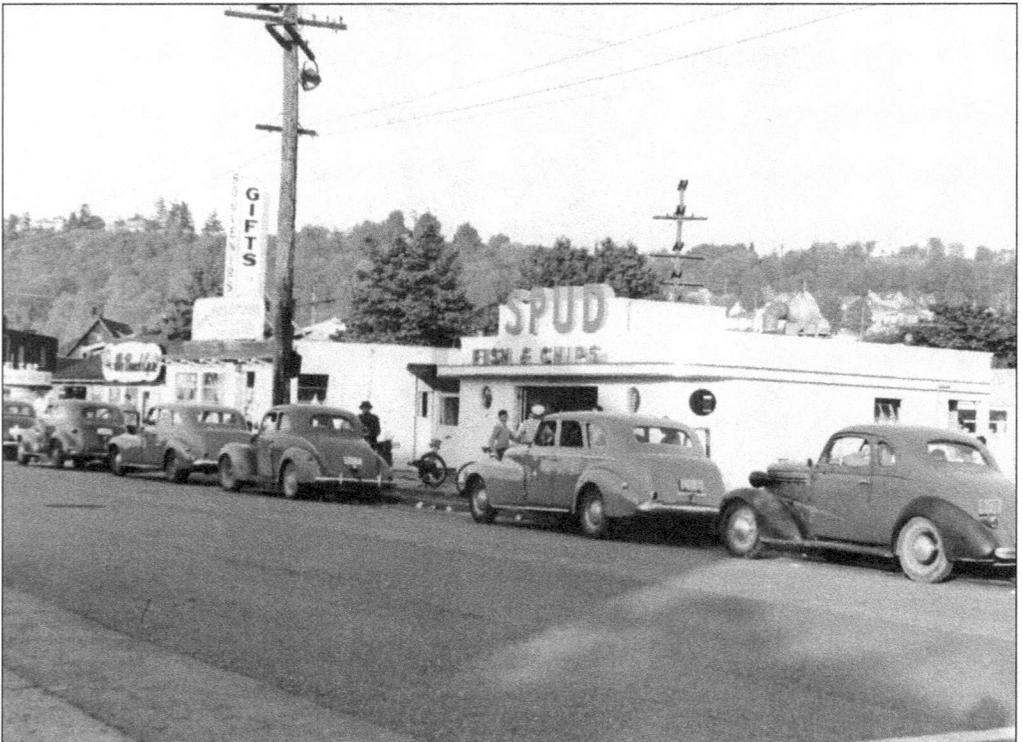

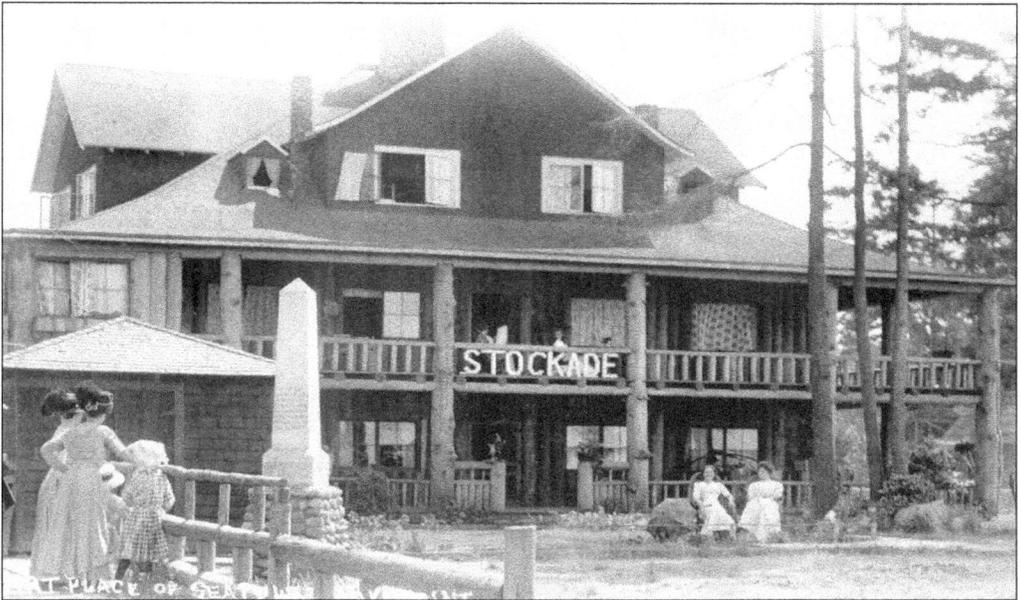

This is the Birthplace of Seattle monument in front of the Stockade Hotel on Alki Avenue SW around 1910. It commemorates the settlers landing on Alki Beach in 1851. It was dedicated on November 13, 1905, by Arthur Denny's daughter Lenora and was moved to the beach side of Alki Avenue SW in 1926. Plaques recognizing the Duwamish Tribe and the women of the Alki landing party were added to the monument in 2001.

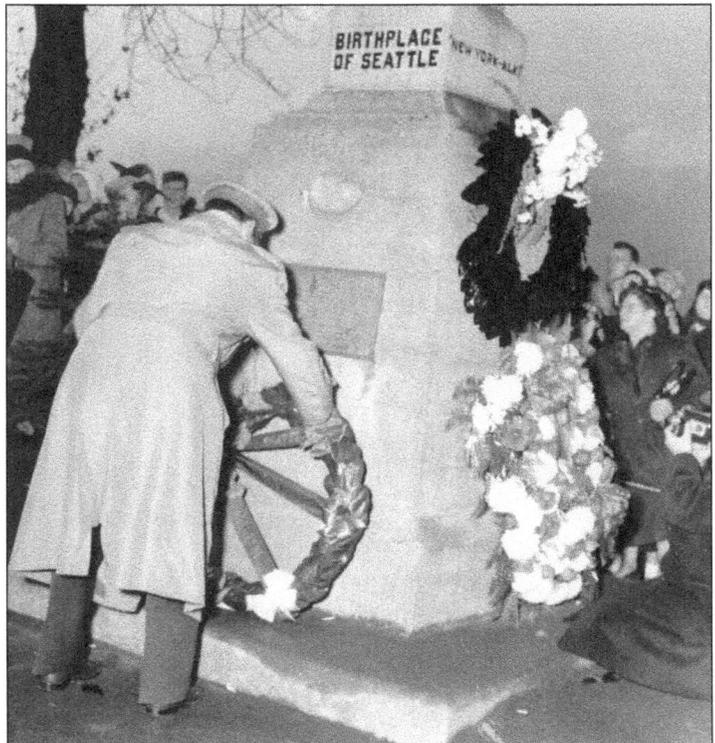

Gen. Douglas MacArthur lays a wreath at the Birthplace of Seattle monument on Alki Avenue SW on November 13, 1951. General MacArthur took part in the founding ceremony during Seattle's centennial celebration. He was in Seattle for a political speech at the University of Washington. Ninety-one-year-old Seattle pioneer John Adams presented the wreath to the general.

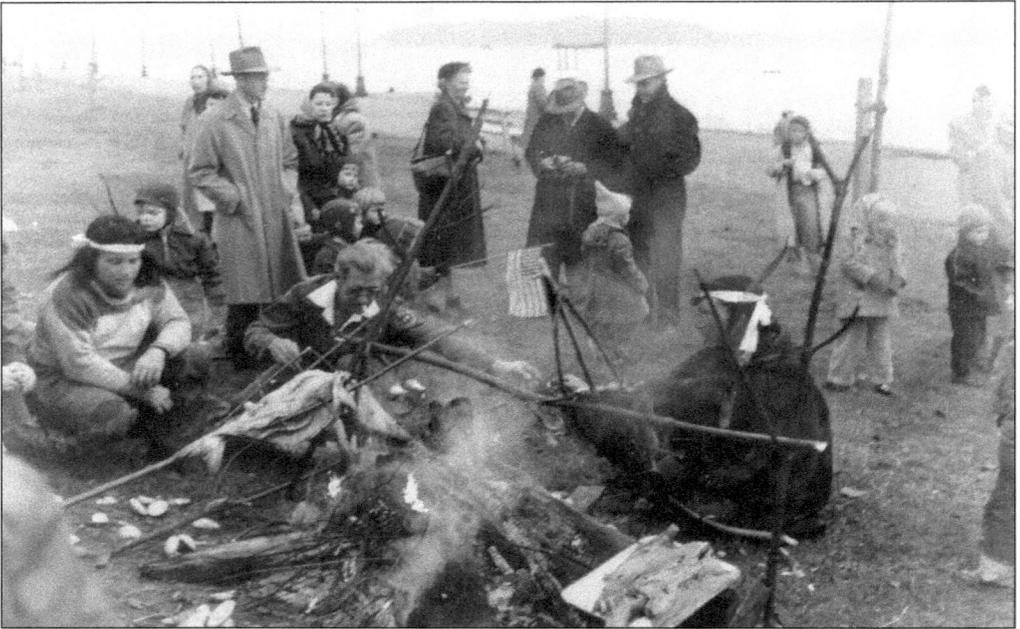

On November 13, 1951, a reenactment of the landing of the first settlers at Alki celebrated the centennial of their arrival (shown above). In 1851, a group of 10 adults and 12 children, comprised of the Denny, Bell, Boren, and Low families, and Charles Terry, arrived on a rainy day after a nine-day trip from Portland on the schooner *Exact*. They were met by Duwamish tribal members. The sesquicentennial celebration (2001) organized by the Southwest Seattle Historical Society is shown below. Descendents of the settlers and Duwamish tribal members were present at both reenactments.

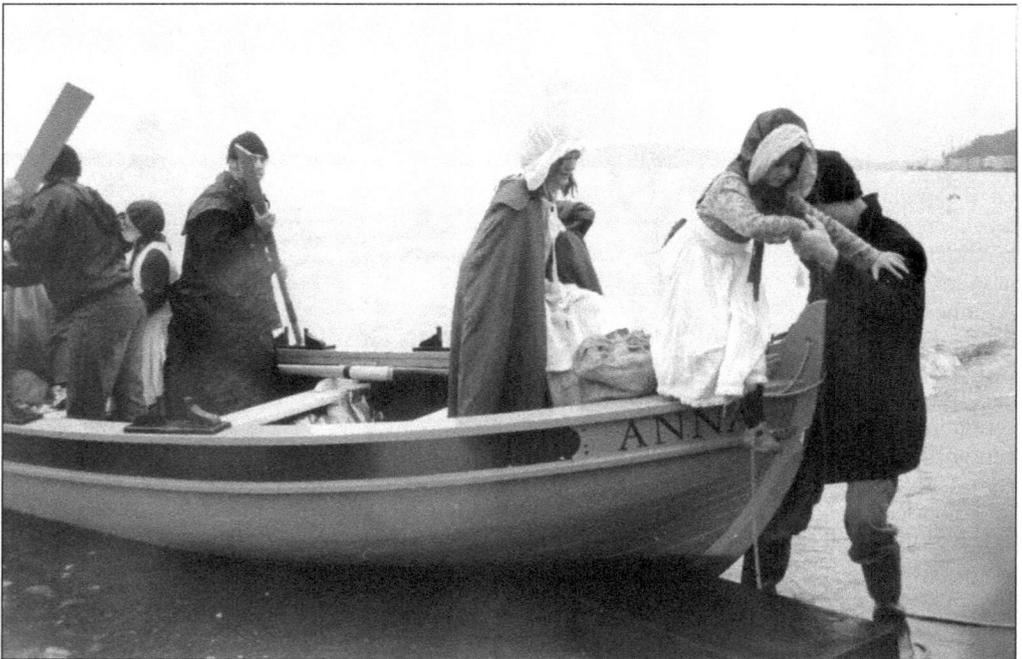

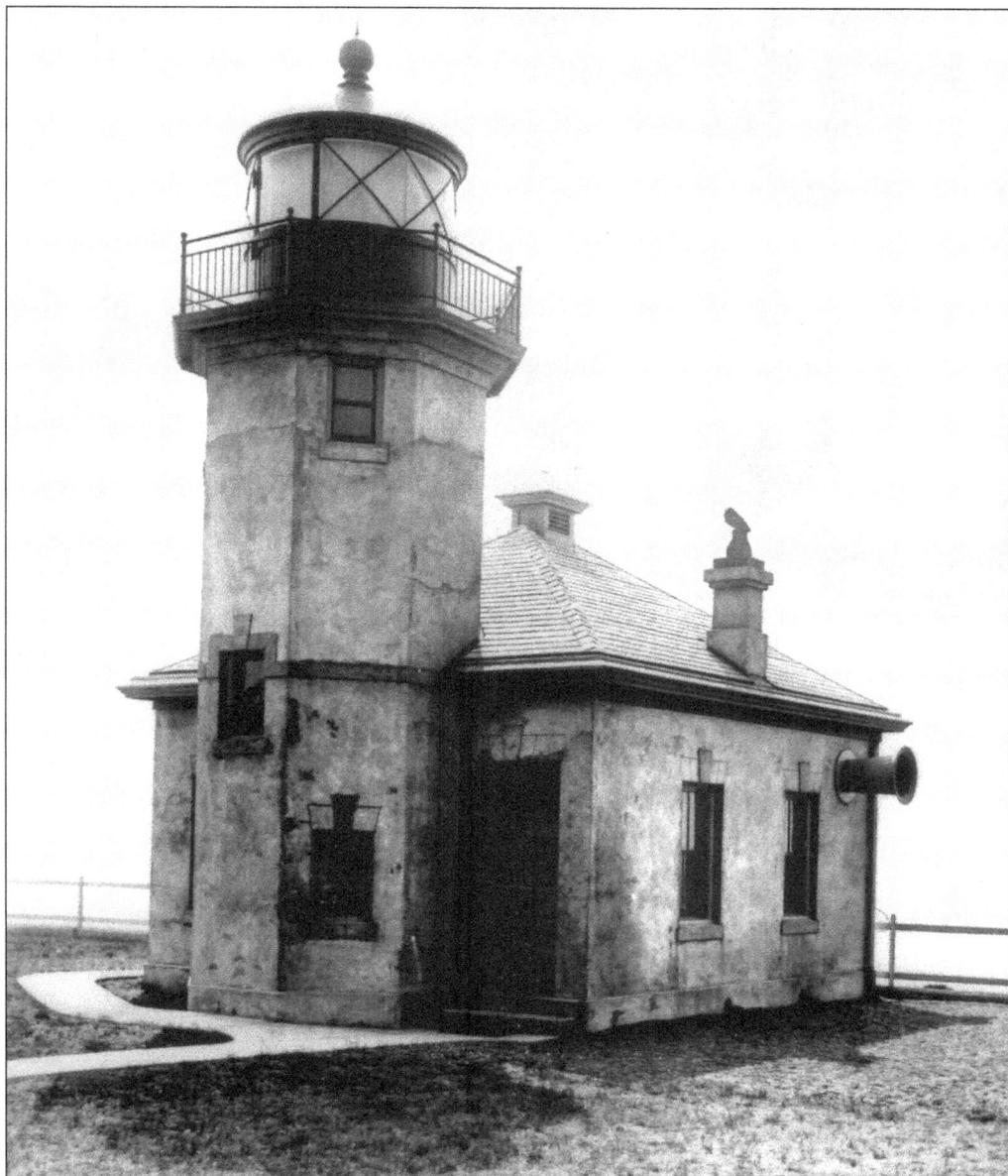

The Alki Point Lighthouse is pictured shortly after its completion in 1913 (just before it was painted). Alki Point marks the southern entrance to Elliott Bay. In 1868, Hans Martin Hanson, who owned 320 acres on the point, placed a private light there to aid local navigation. The Lighthouse Service officially established an oil post lantern at the point in 1887 and paid Hanson $15 a month to keep it. In 1910, the U.S government bought a 1.5-acre parcel from the Hanson family for a permanent light. The lighthouse was equipped with a Fresnel lens and a three-directional foghorn. It became fully automated in 1984. (Courtesy Coast Guard Museum Northwest.)

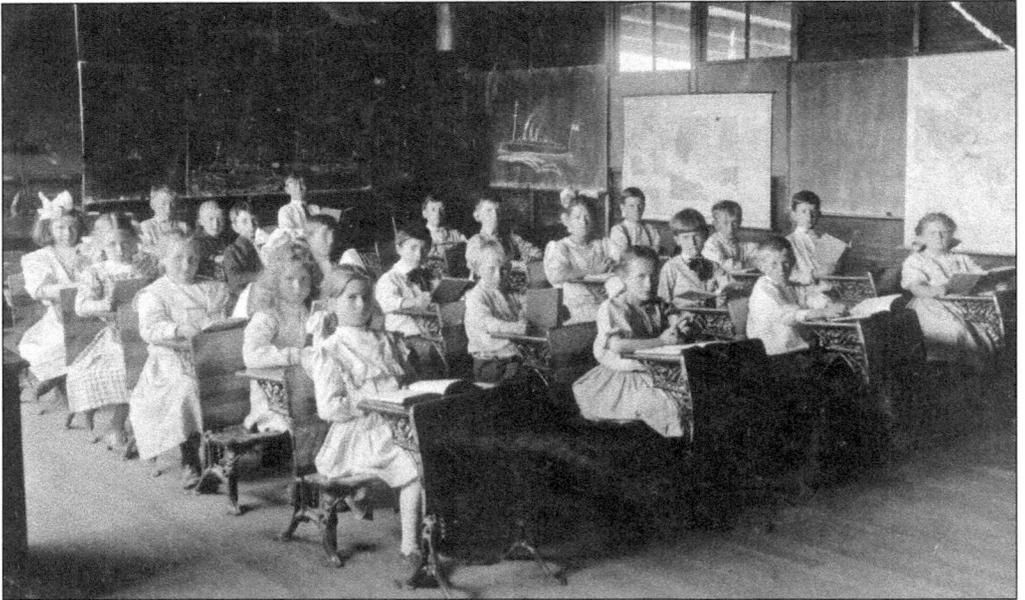

Mary Rice's third and fourth grade class is shown around 1909 at the South Alki School, also known as the "Carroll Street School." Attentive students sit with their books open in their classroom at this school established for younger children near Alki Point.

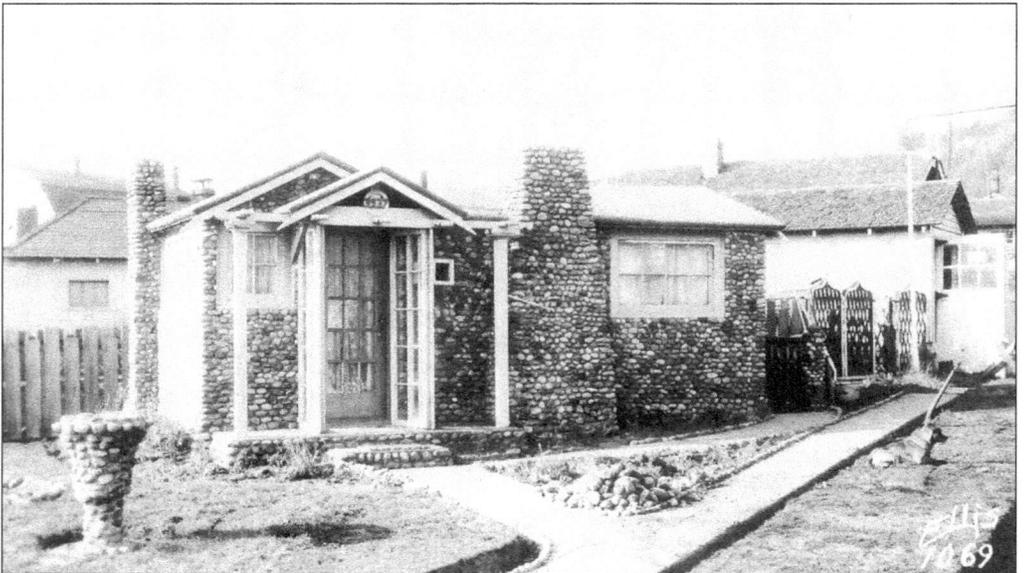

The Cobblestone House was located at the north end of Beach Drive SW. This unique beach home was written up in *Ripley's Believe It or Not!* in the 1930s as "the smallest, complete modern house in the United States." The house boasted an elevator that led to a large basement.

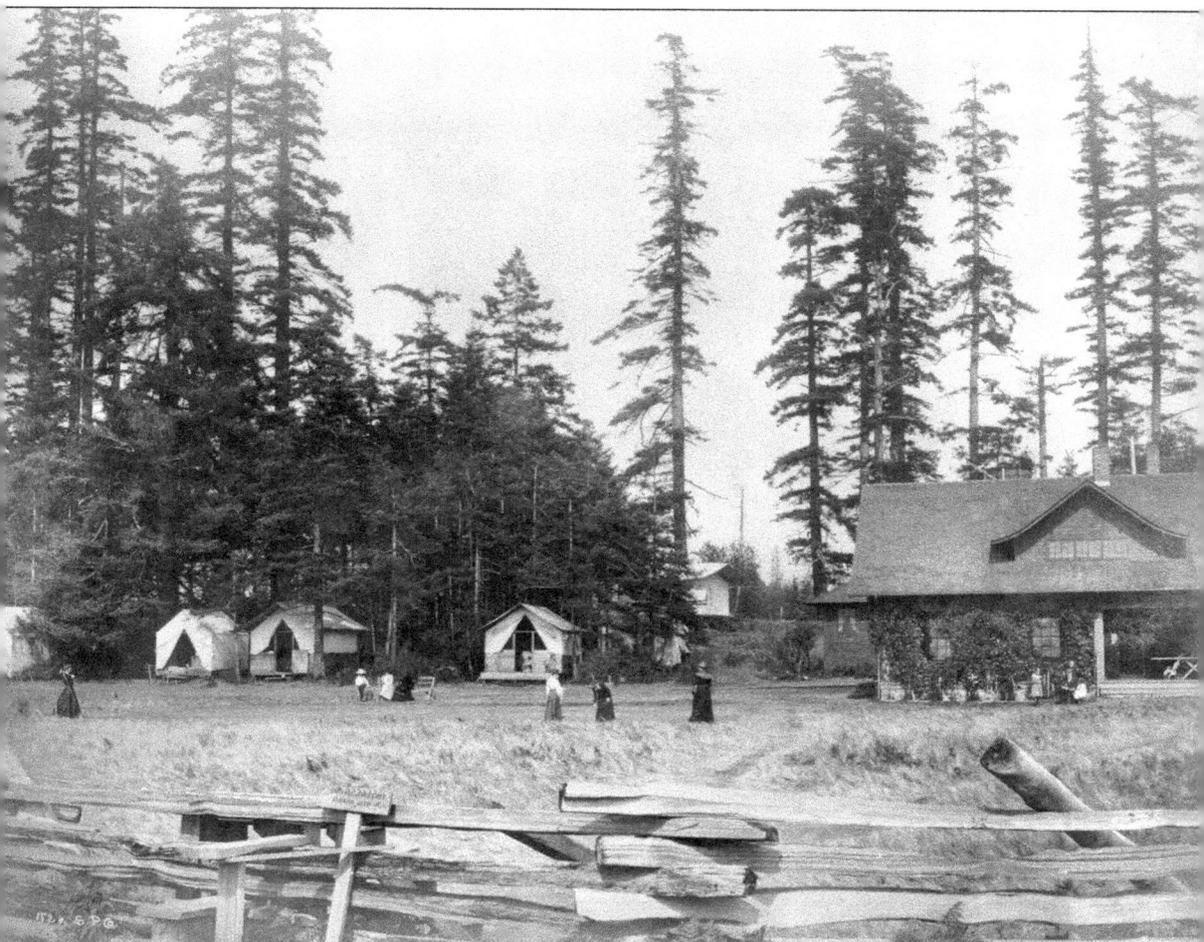

Around 1905, Rose Lodge at Alki Point, off Beach Drive SW, was a resort with excellent beach access that catered to summer visitors. It had about 50 tent cabins and a dining hall in addition to the main lodge. The tents were replaced with actual cabins in the 1920s. The lodge building still exists.

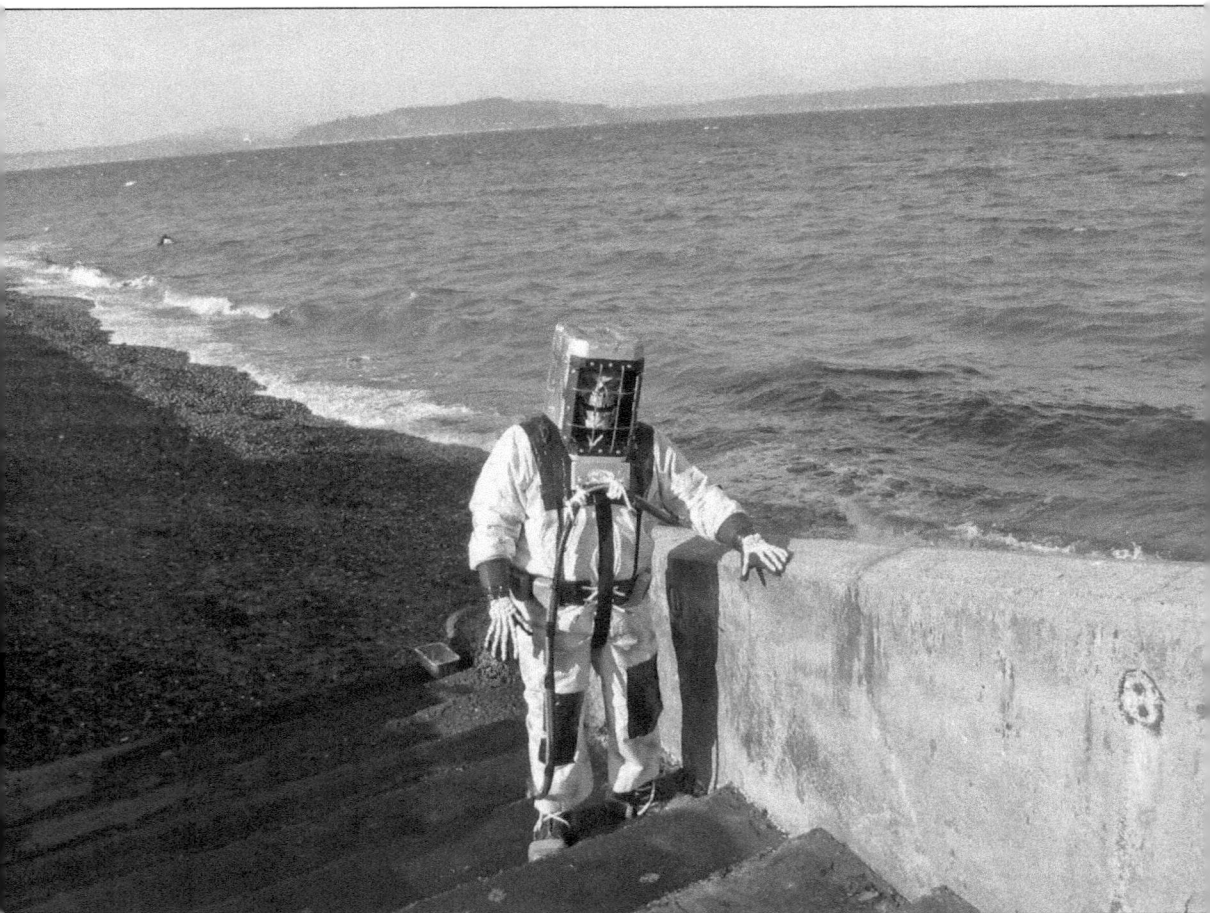

Capturing the Alki Beach experience is always an adventure. There is no telling what can come up from the depths of Puget Sound. (Courtesy Don Kelstrom.)

Three

ADMIRAL DISTRICT

The Uriah R. Niesz family poses with West Seattle Central School's first graduating class at the family home in 1910. One of the peninsula's earliest land developers, Niesz platted eighty-two 5-acre plots for sale on the upper west side plateau in 1885 and called it the West Seattle 5-Acre Tracts. This preceded the West Seattle Land Improvement Company's 1888 development. A dedicated civic booster, he also donated land for the West Seattle Library.

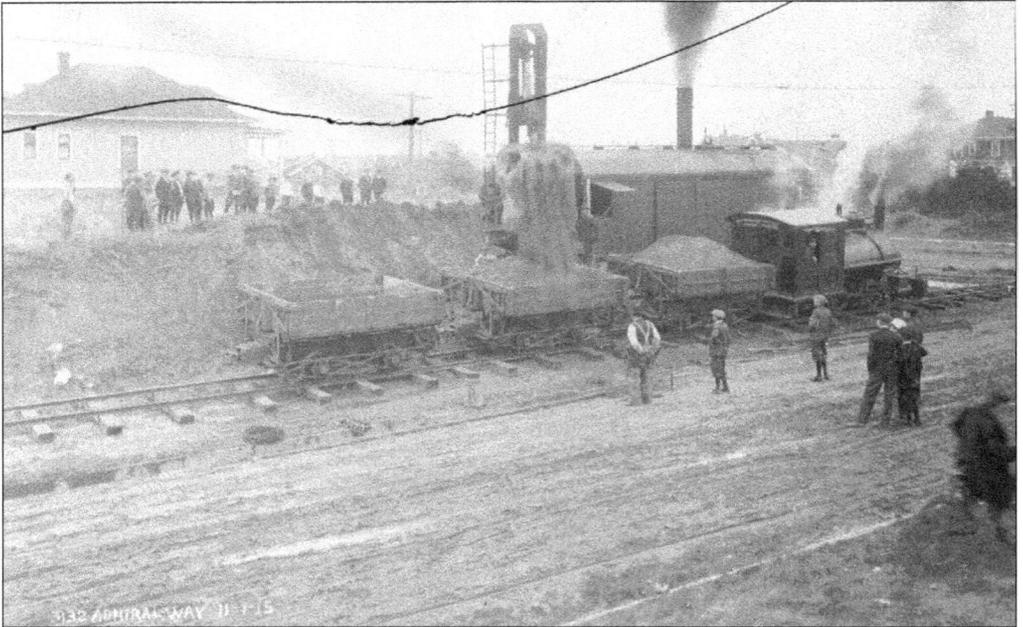

Admiral Way SW is shown under construction in November 1915. In 1911, the city proposed to make West Seattle more accessible to accommodate growth by extending a continuous street across the peninsula from SW Spokane Street to the Alki Point neighborhood. Admiral Way SW was completed in 1917. (Courtesy Seattle Municipal Archives, No. 859.)

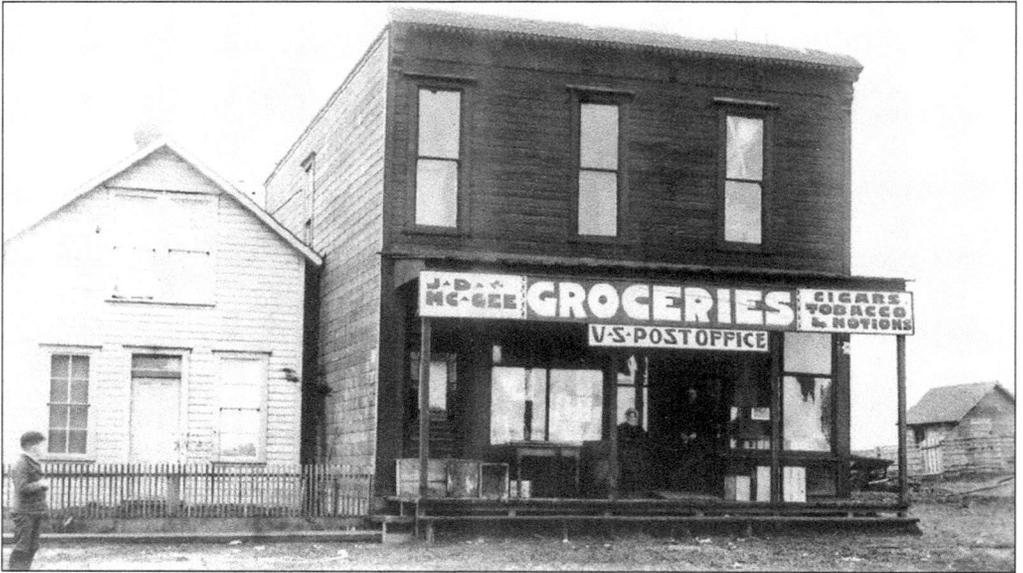

J. D. McGee Groceries was located on Olympic Avenue. The 1899 Seattle Directory lists McGee as a grocer and postmaster. In lieu of an official U.S. post office in West Seattle at the time, some private businesses were licensed to provide mail service to local residents as McGee did. He offered both services from 1899 until he sold his business in 1907. That same year West Seattle was annexed to Seattle, and the street name changed to Forty-fourth Avenue SW. (Courtesy Seattle Municipal Archives, No. 66238.)

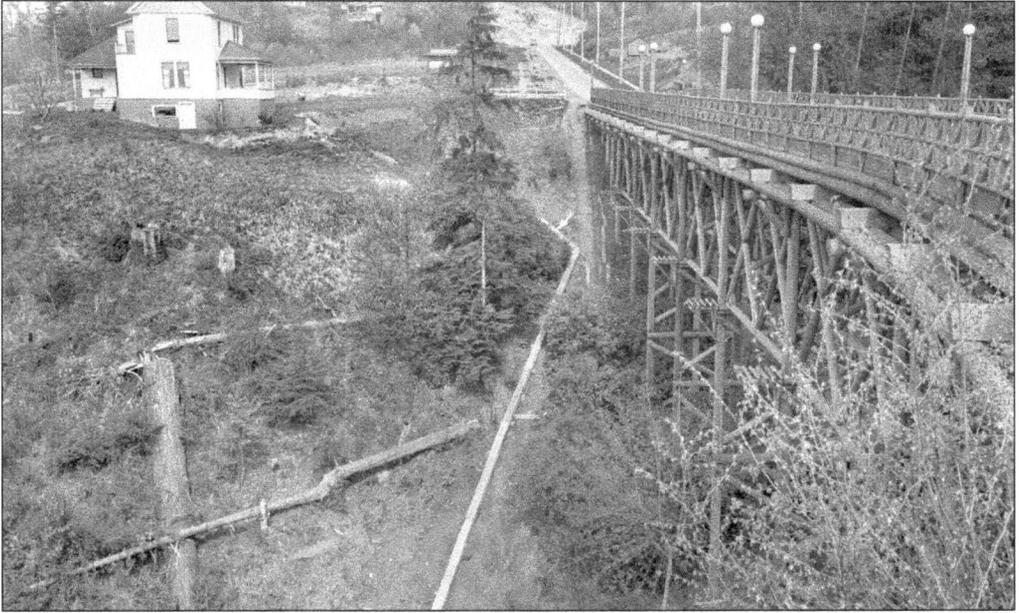

This view of Schmitz Park Bridge looks northeast in 1919 (above photograph). The wooden piling bridge spanning the Schmitz Park ravine was built around 1916 to replace a footbridge. The untreated pilings lasted only 12 years. The 1937 photograph below shows the new concrete Schmitz Park Bridge looking northeast along Admiral Way SW. (Above courtesy Seattle Municipal Archives, No. 12640; below courtesy Seattle Municipal Archives, No. 11412.)

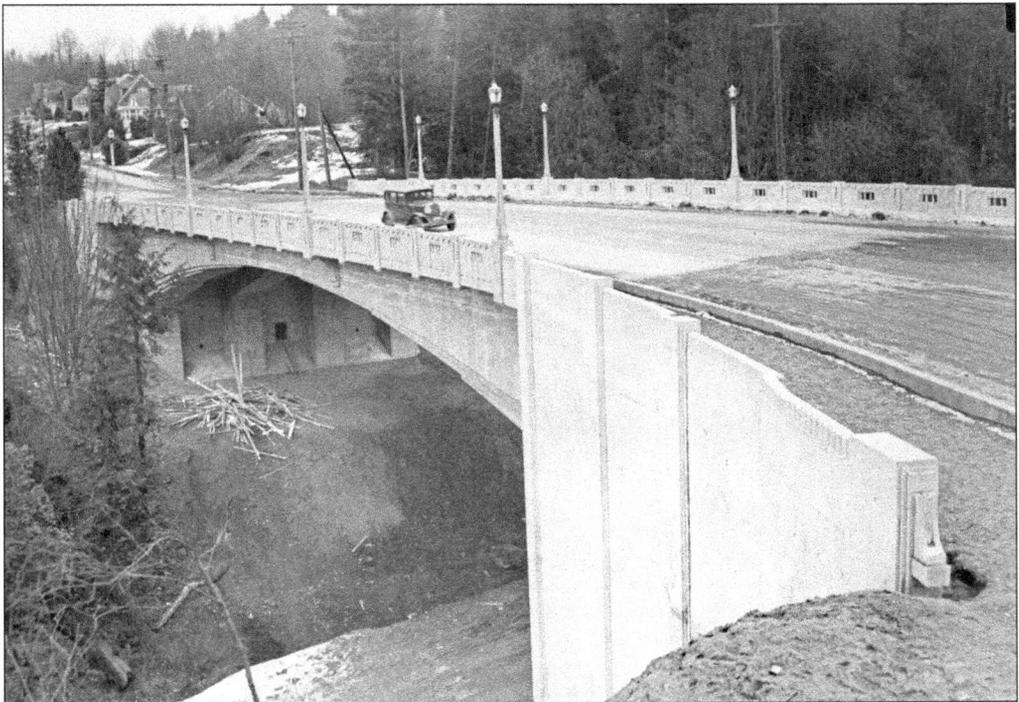

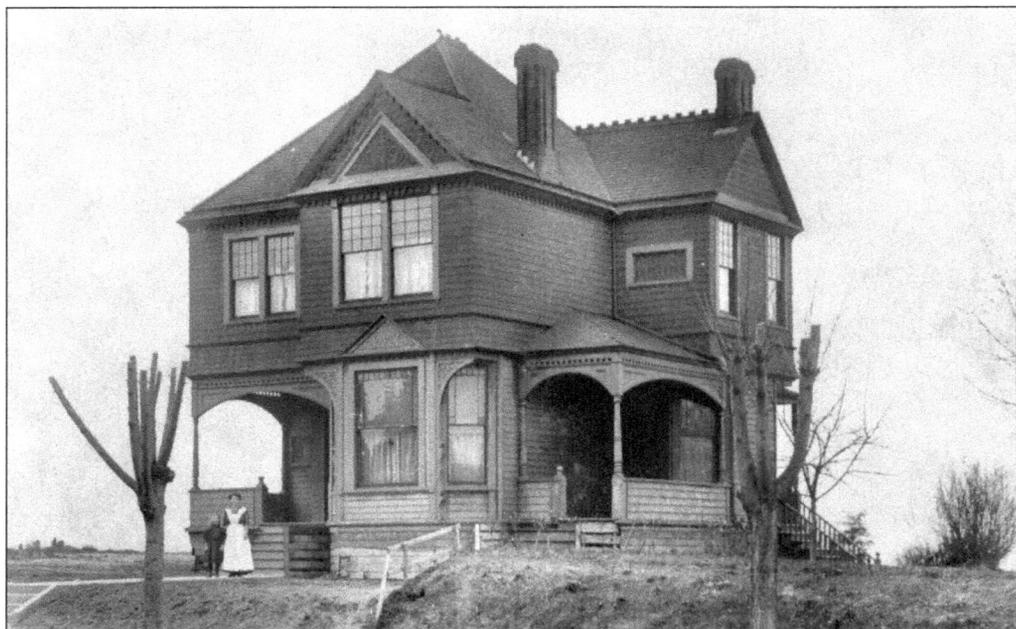

Around 1899, the Victorian Walter Hainsworth House at Columbia Street, now Forty-sixth Avenue SW, was one of the first residences in the Admiral District of West Seattle. William Henry Hainsworth II, Walter's father, founded the country's first commercial steel foundry in Pittsburgh, Pennsylvania, before moving to the Northwest.

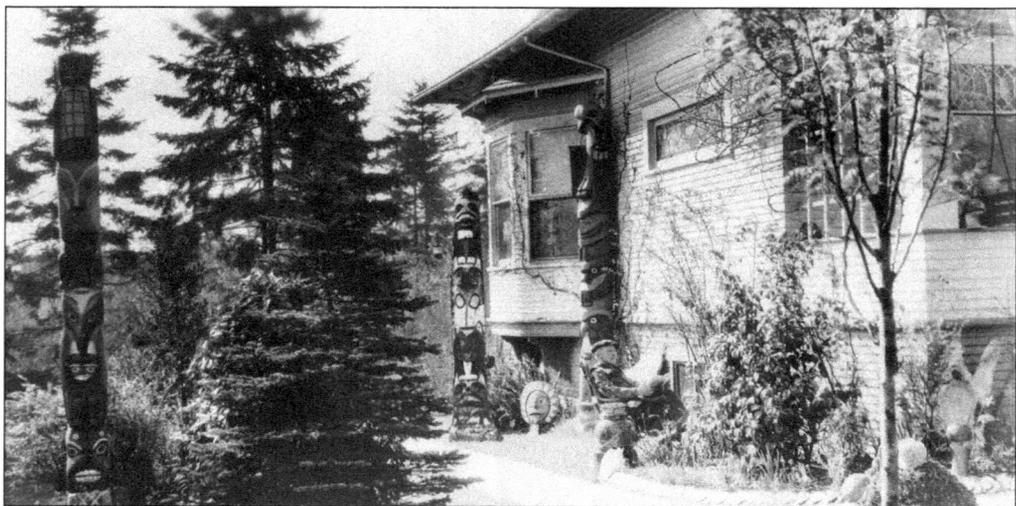

Joseph E. Standley, founder and owner of Seattle's Ye Olde Curiosity Shoppe, is shown at his home located at 1750 Palm Avenue SW around 1910. The home was also known as the "Totem Place" for "Doc" Standley's collection of totem poles that stood on the property. Today the totem poles and shell yard art are gone, but the house remains.

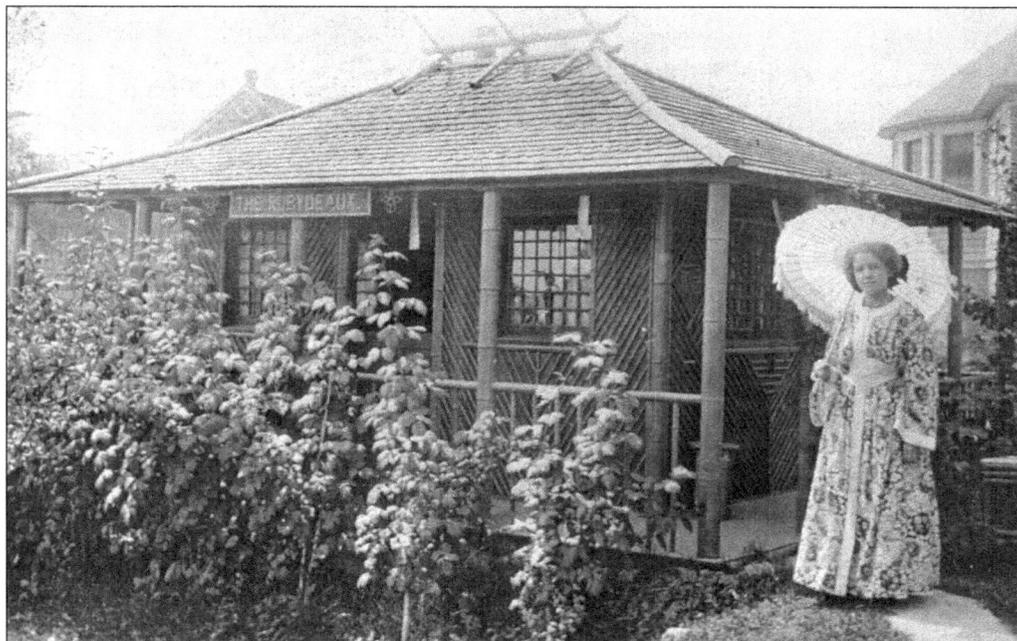

Ruby Standley, Joseph E. Standley's daughter, stands by her "Rubydeaux" around 1910. Standley built the Rubydeaux in the backyard of his residence at 1750 Palm Avenue SW for his daughter, who desired her own Japanese teahouse.

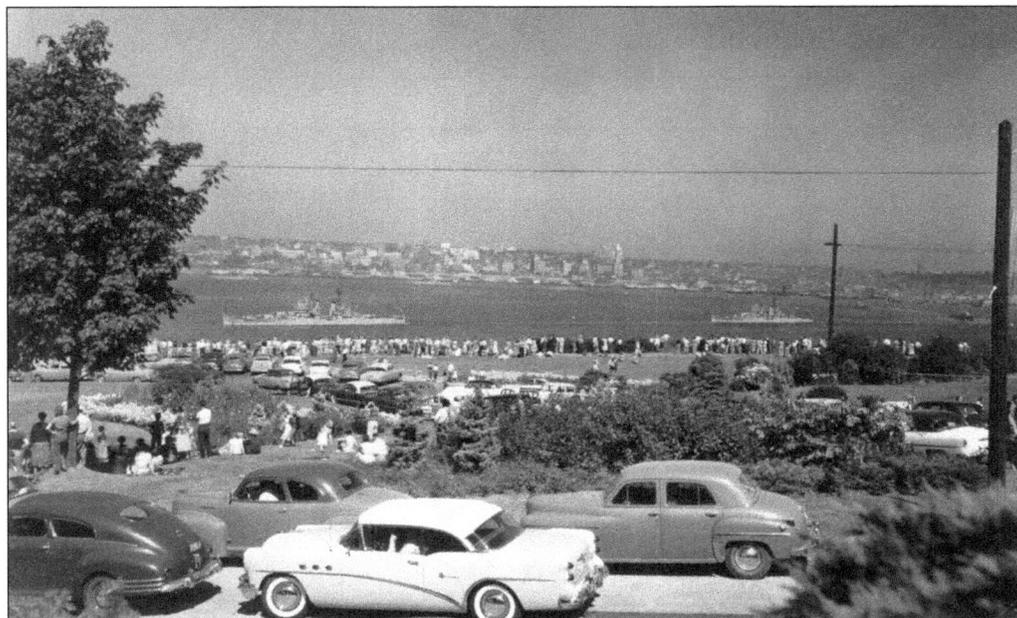

A crowd watches a Seafair event in 1955 from Hamilton View Park, initially named Duwamish Head Park. The land was purchased in 1914, but it would not become a public park until 1954. In the 1930s, Civil Works Administration (CWA) and Works Progress Administration (WPA) crews graded the area and removed stumps creating the accessible view. In 1957, the park was named for Rupert Hamilton, the *West Seattle Herald* publisher/editor from 1923 to 1939.

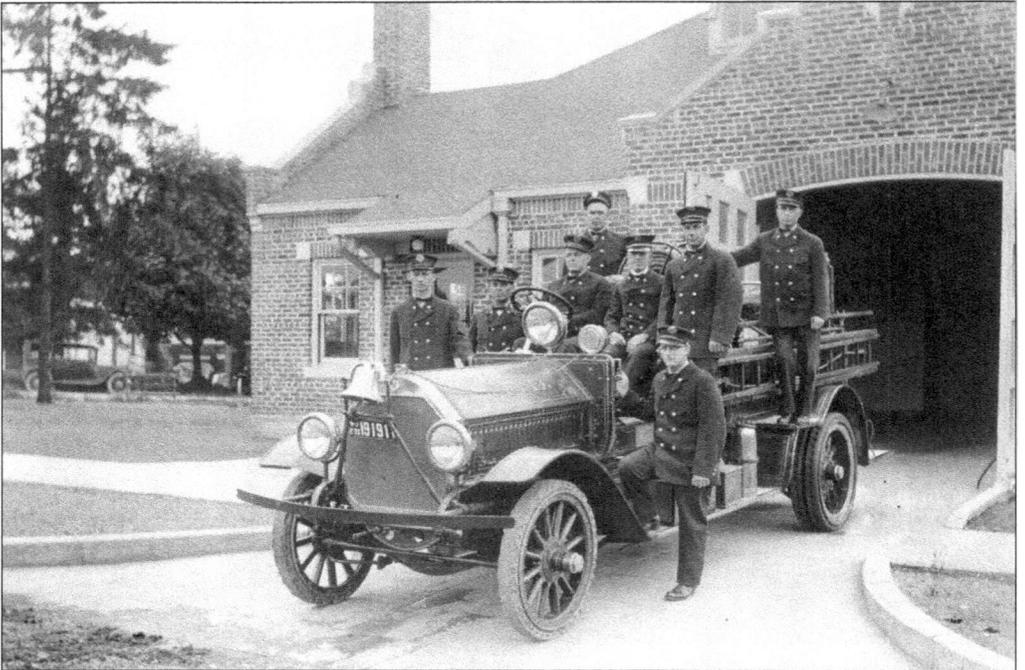

Firemen pose in front of Seattle Fire Department Station No. 29 in 1922. The fire station, built in 1921, was located at 2139 Ferry Avenue SW. It remained in service until 1969, when it was replaced by the current firehouse. The fire engine is a solid-tired Seagraves, complete with a manual bell and a hand-cranked siren.

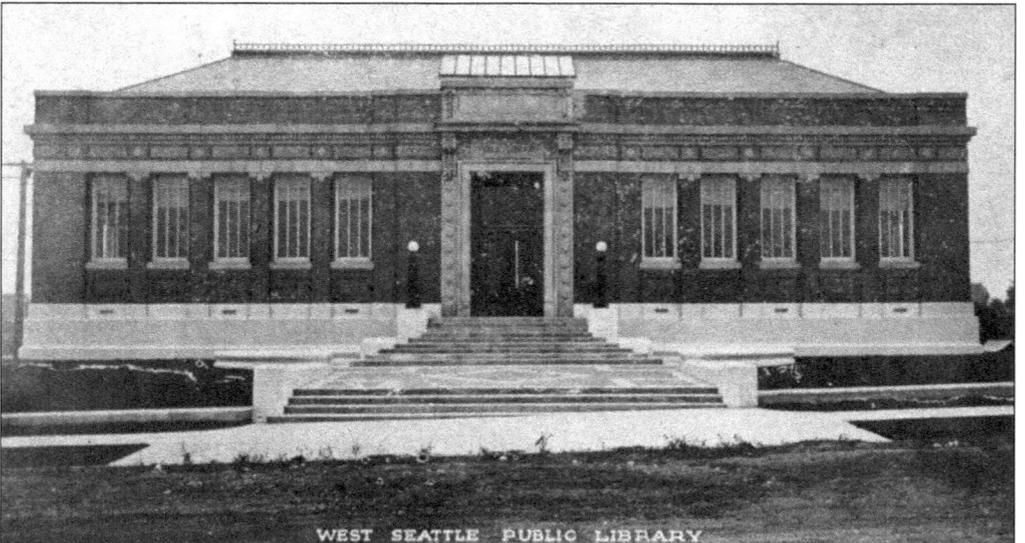

The West Seattle Library Admiral Branch, located at Forty-second Avenue SW and SW College Street, opened in June 1910 after two years of planning and construction. It was built on land donated by local residents and with a $35,000 grant from philanthropist Andrew Carnegie in addition to city funding. It was Seattle's first Carnegie branch library and initially had a collection of over 5,500 volumes.

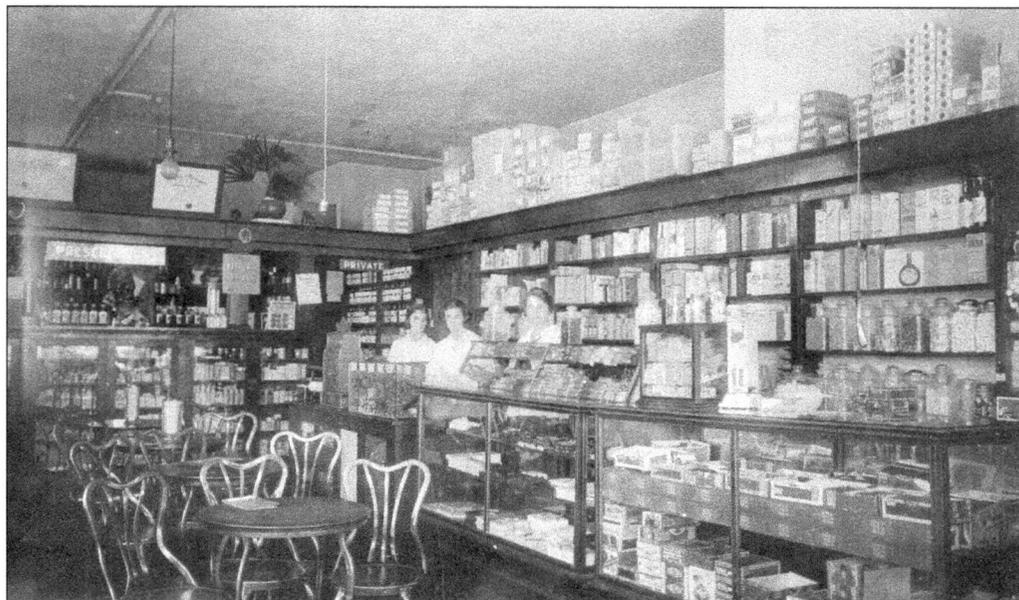

The interior view of Rothschild Drugstore, located at 2600 California Avenue SW, is shown around 1925. Appearing from left to right are Elena Carlson Nelson, Mildred Matson, and Bess Rothschild. Nelson was one of the first female pharmacists; she graduated from the University of Washington. She worked at Rothschild's for 40 years. The drugstore offered a complete pharmacy, soda fountain, and was stocked with candy, cigars, and other assorted items.

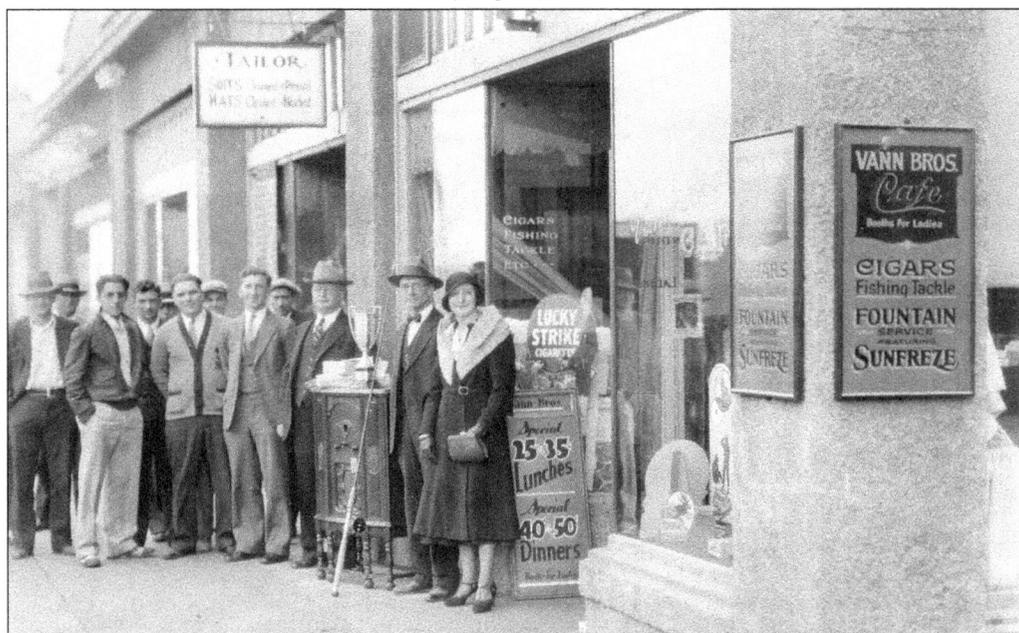

Lucky fishing derby winners pose with the prizes outside the Vann Brothers Café, located at 2656 California Avenue SW, around 1920. Besides offering 25¢ to 35¢ lunches, 40¢ to 50¢ dinners, and fountain service, the café patrons could purchase cigars and fishing tackle. They also provided "booths for the ladies." Vann Brothers relocated to 4209 SW Alaska Street in 1934.

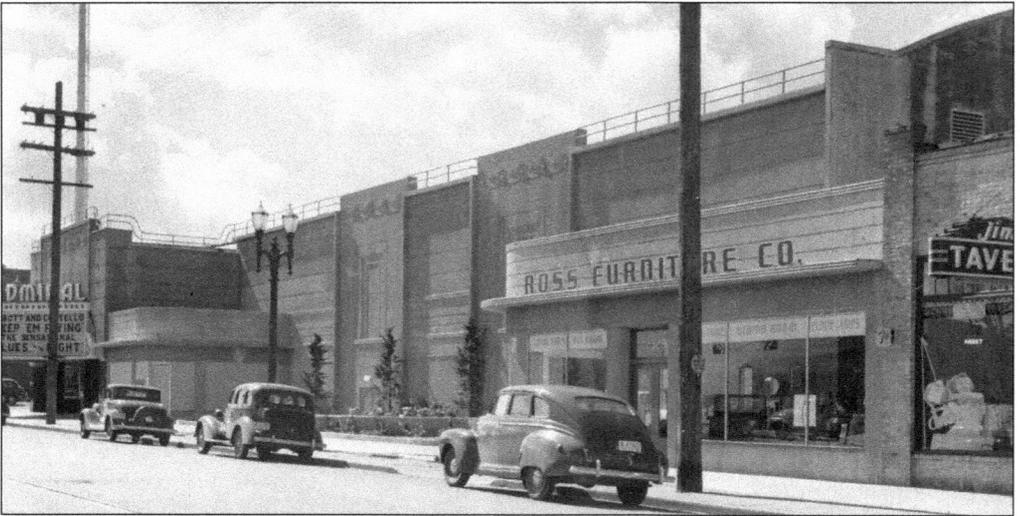

This is a view of businesses north of Admiral Way SW on California Avenue SW around 1942. The visible businesses are, from left to right, the Admiral Theater, the Ross Furniture Company, and Jim's Tavern. Other businesses later occupying Ross's 2329 California Avenue SW address have included the Band Wagon Music Center, Blackbird Bistro, and the Porterhouse restaurant.

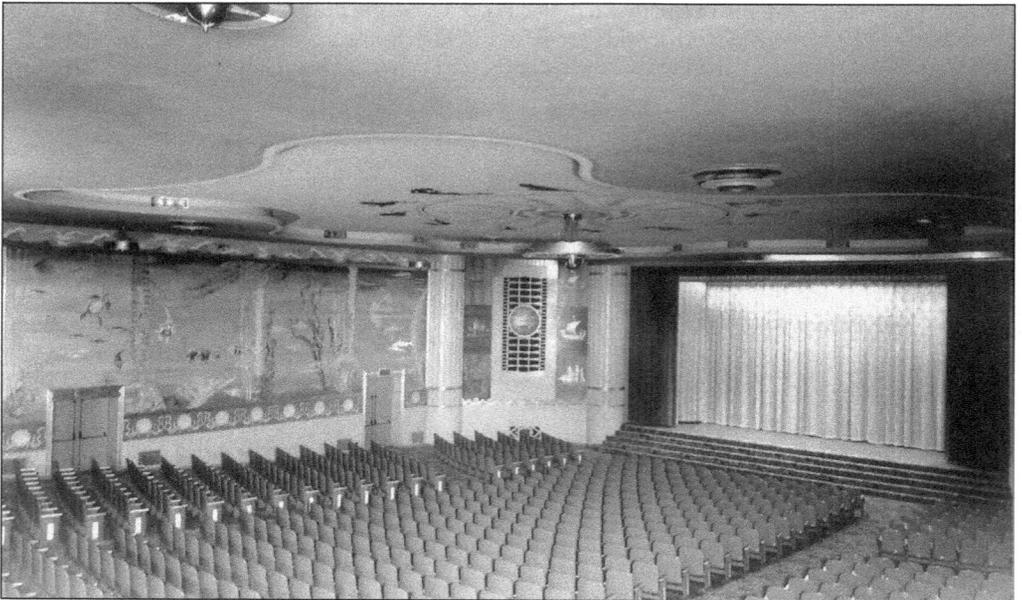

The Admiral Theater, located at 2343 California Avenue SW, opened on January 22, 1942. The 1,000-seat theater employed a nautical theme, featuring a ship's mast and porthole windows on the outside. The nautical theme continued inside, shown here around 1942. Note the undersea mural on the wall with glow-in-the-dark detailing, the compass-style zodiac ceiling light fixtures, and the ship silhouettes flanking the stage. In 1973, the theater was converted to "twin" 430-seat theaters, and in the 1980s it was threatened with conversion to a shoebox cinema. With a community outcry to "Save the Admiral," the Southwest Seattle Historical Society successfully guided the theater to landmark status, thereby preserving it for future generations.

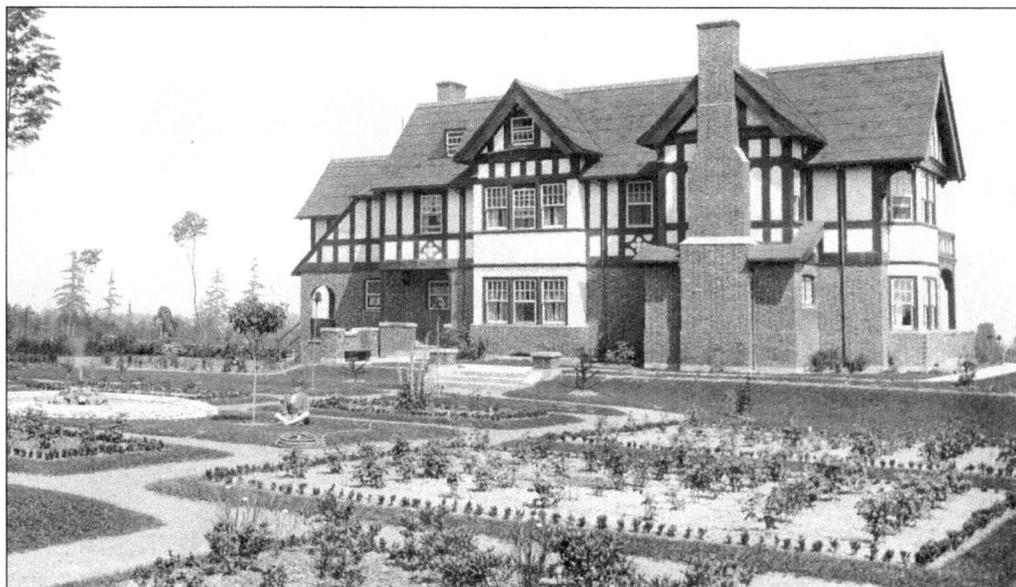

The William H. Hainsworth family home was a grand affair, located at 3661 Olga Street. The Tudor revival-style home was built in 1907 and still stands in the Admiral neighborhood. Its first-floor level was constructed with clinker brick, and the upper floors were built of timbers and stucco. The original estate included formal English gardens, tennis courts, pools, and a summerhouse.

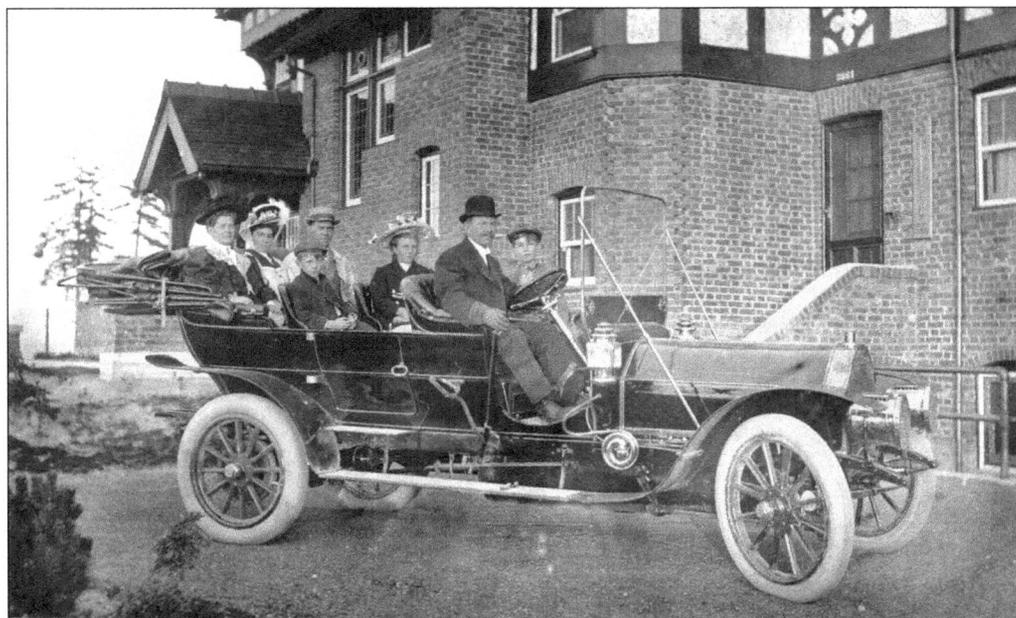

The Hainsworth family poses in front of their residence in 1910. The driver of their elegant Pierce Arrow touring car is William H. Hainsworth III. Pictured from left to right are (in the center seats) his children, William, Jeanette, and Arthur; (in the back seats) Mary Hainsworth II, Florence Hainsworth III, and brother John Walter Hainsworth. William H. Hainsworth III built the Spring Apartment Hotel in 1922 (now the Hotel Vintage Park) in downtown Seattle. When the Depression hit, he lost both the hotel and extensive family property.

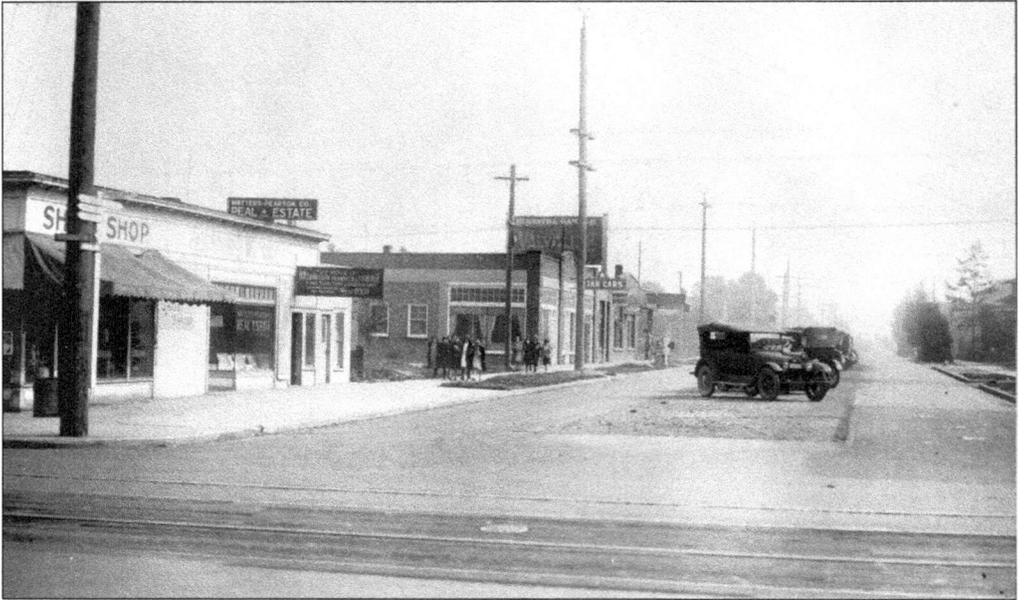

This view is looking east at the intersection of California Avenue SW and SW Admiral Way around 1920. Visible businesses are, from left to right, an unidentified shoe store, Fairmount Fuel Company, Watters and Pearson Real Estate Company, Westside Motors (which sold Star automobiles manufactured by Durant Motors Incorporated), and the Hiawatha Garage. Note the central parking strip on Admiral Way SW.

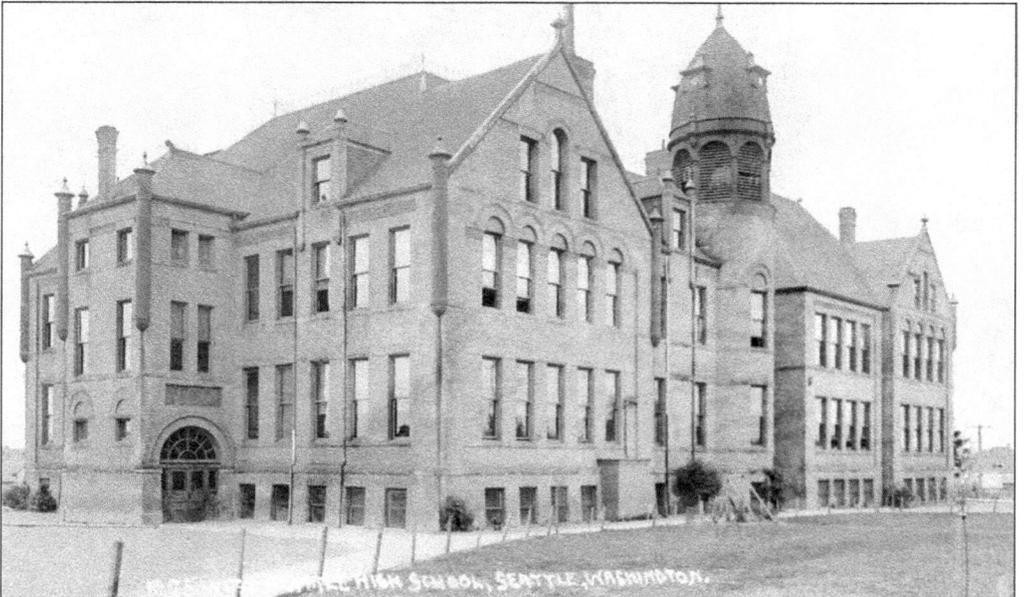

The West Seattle Central School, located at California Avenue SW and South Street (now SW Lander Street), is shown around 1910. The eight-room schoolhouse was built initially in 1893. In 1908, an additional eight rooms were added to the structure. The school was known by many names including West Seattle Grammar and High School, West Seattle School, and the Brick School. It was later named Lafayette Elementary School.

Lafayette Elementary School shows the damage incurred after the 7.1-magnitude earthquake in 1949. Because it occurred during spring break, no students were killed or suffered injuries at the school. Damaged beyond repair, the school was demolished, and the newly built school opened in 1950.

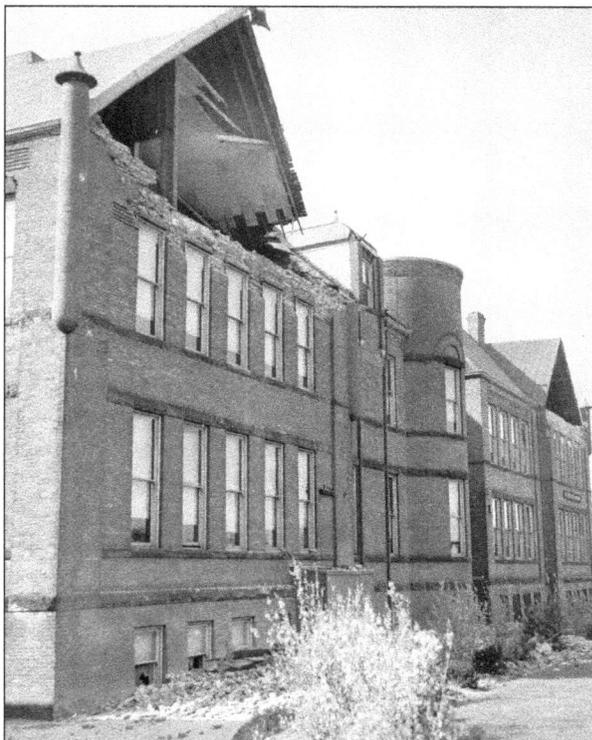

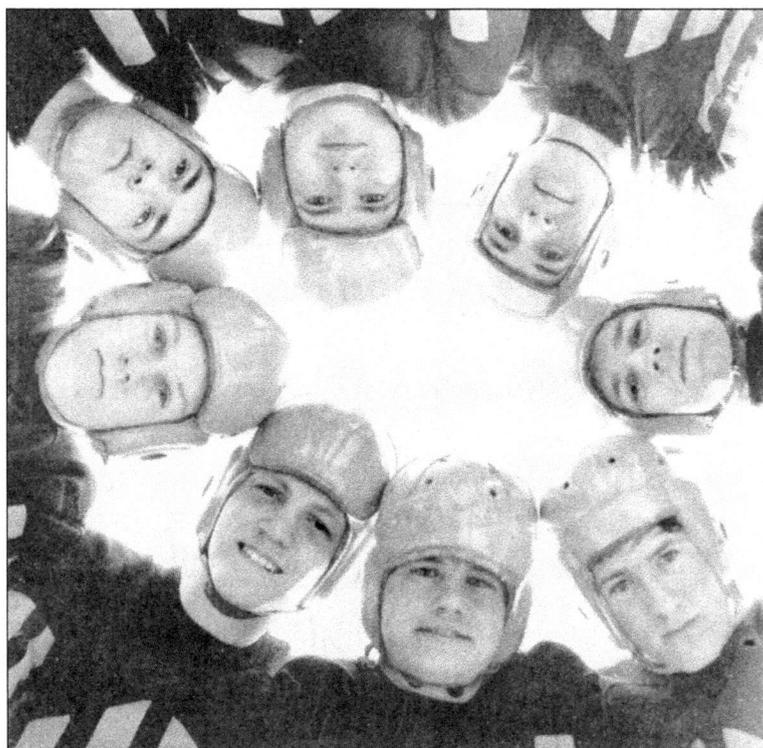

Eight members of the 1936 West Seattle High School varsity football team huddle up. It was a rough gridiron season for the West Seattle Indians, as they finished with a 2-2-2 record. In 2002, the school changed their team name from the Indians to the Wildcats.

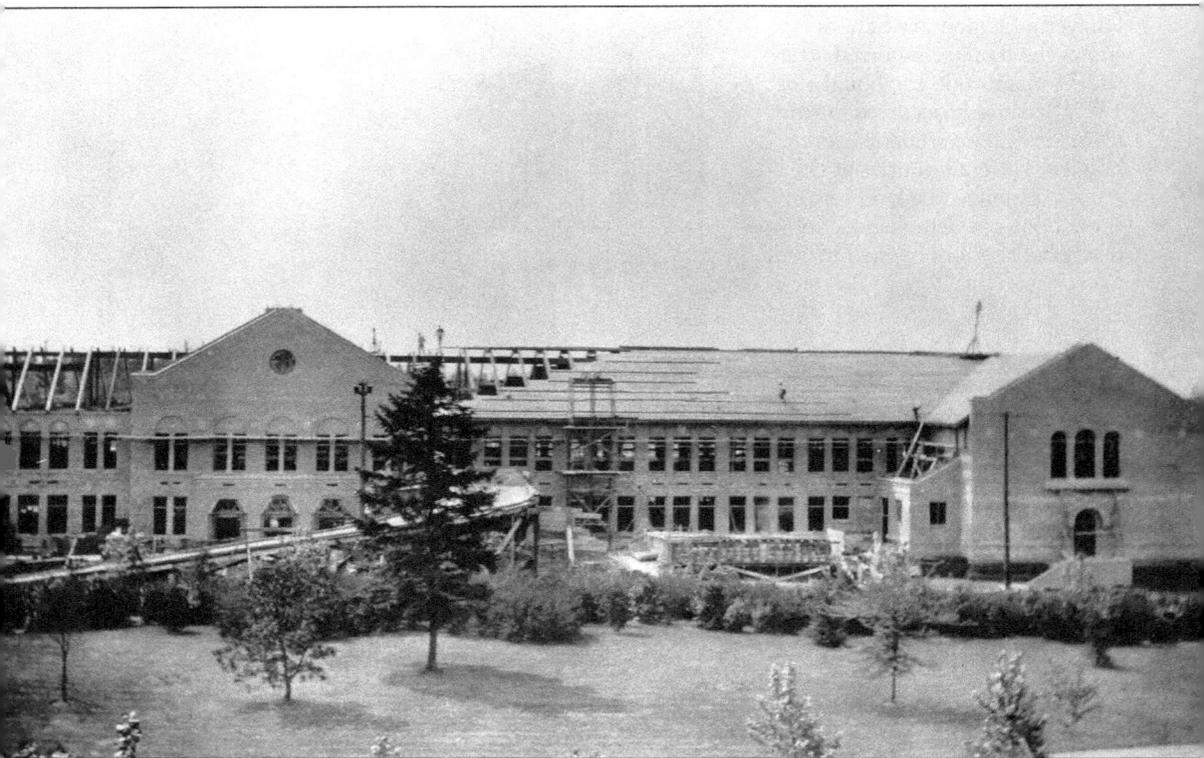

Workers were still finishing interior details at West Seattle High School when it opened in the fall of 1917. Enrollment went from 472 in 1917 to 1,402 in 1925. Students came from as far away as Burien during the first seven years. The student magazine *Chinook* declared in 1917, "Now it seems to us we have one of the finest buildings that could be desired."

Four

ALL RAILS MEET AT THE JUNCTION

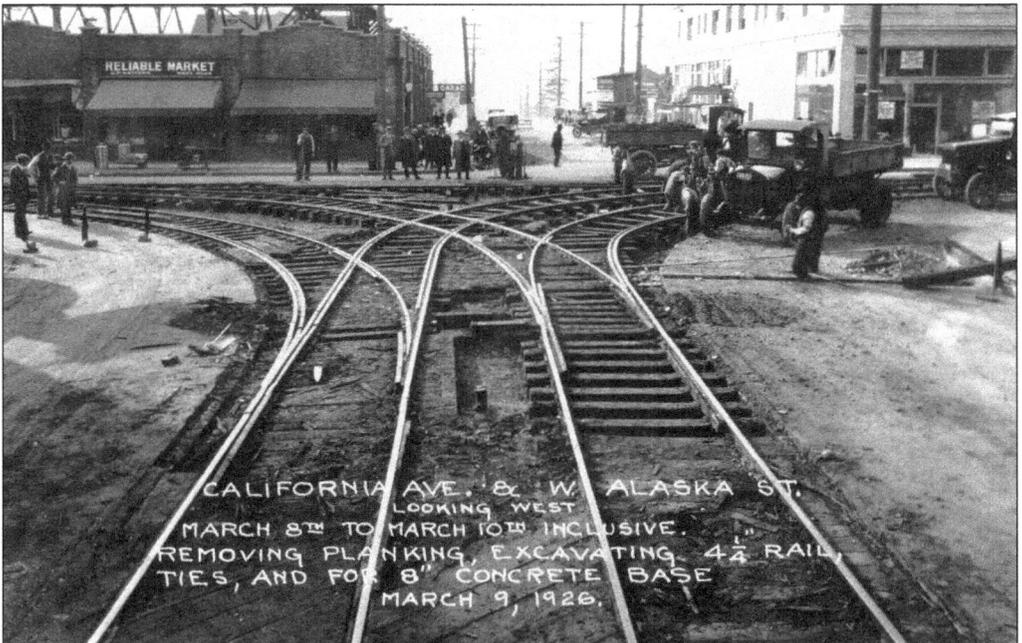

The meeting of streetcar lines, not streets, gave rise to the "Junction" label. The tracks merged at California Avenue SW and SW Alaska Street, thereby defining this area as the Alaska Junction. This view looking west shows the No. 3 line tracks heading right to the Admiral District and the No. 2 line heading left to Fauntleroy. Modern times have added the Admiral and Morgan Street Junctions, defining business centers and losing the streetcar origination of the term. All streetcars stopped running to the Duwamish Peninsula by the end of 1940.

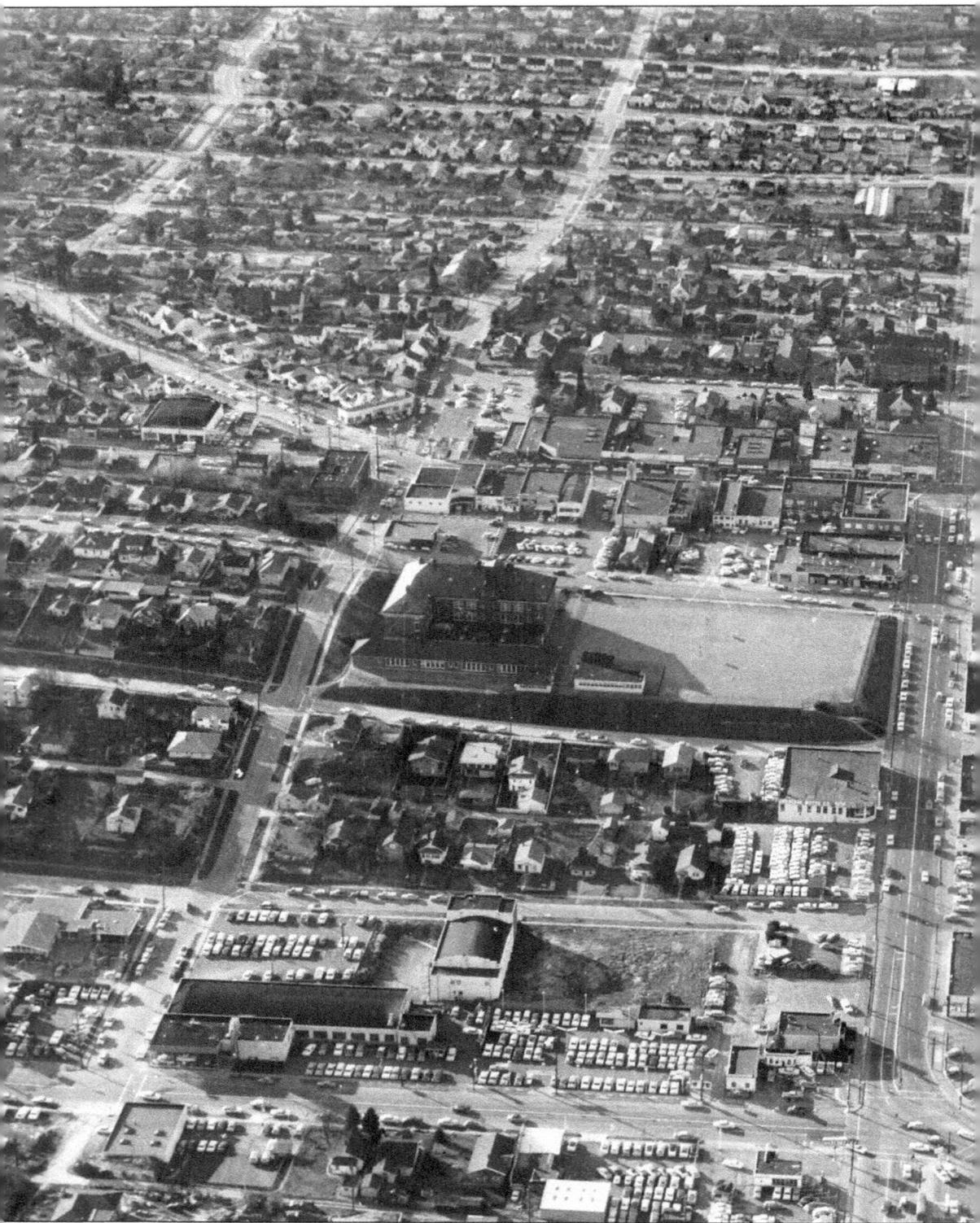

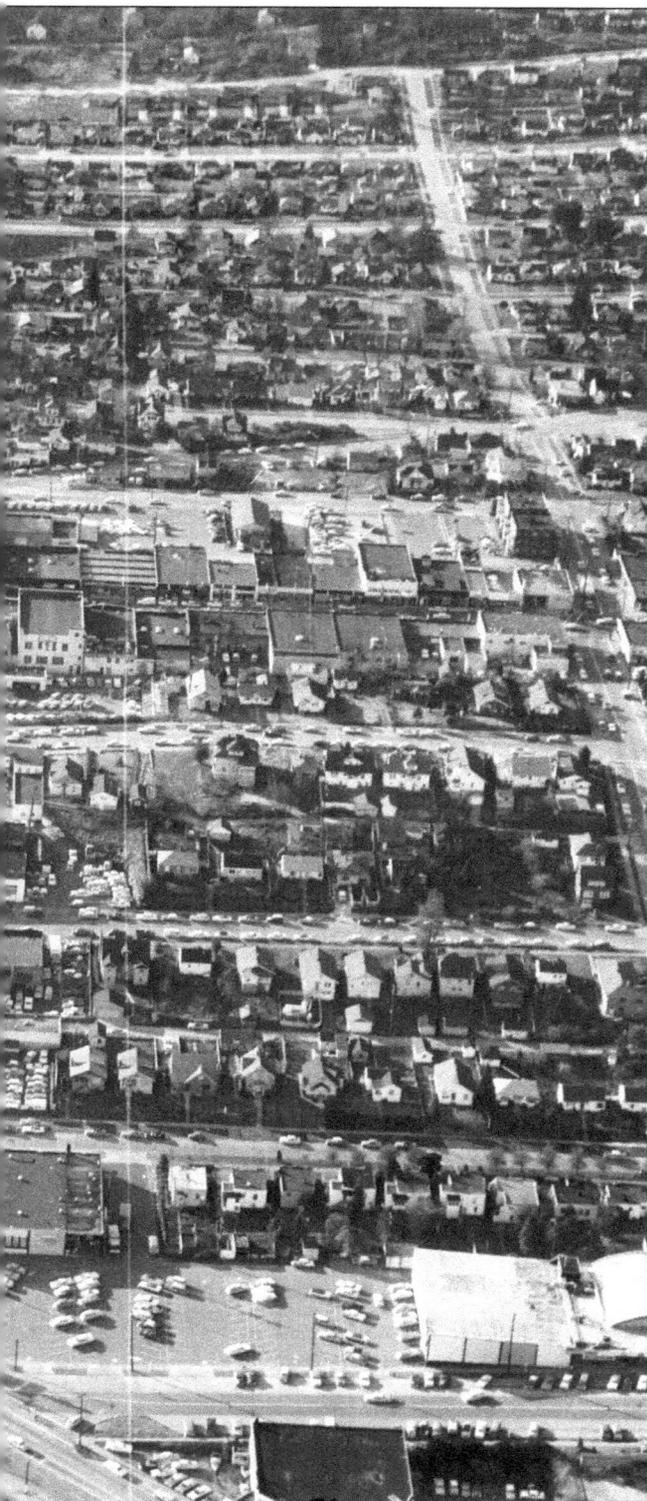

A 1960s aerial photograph of the Alaska Junction shows California Avenue SW (running north to south) and SW Alaska Street (running east to west) approximately in the center. The open field is the Jefferson Grade School playfield. Gene Fiedler Chevrolet is to the north of the playfield and Andresen Chrysler-Plymouth is to the east.

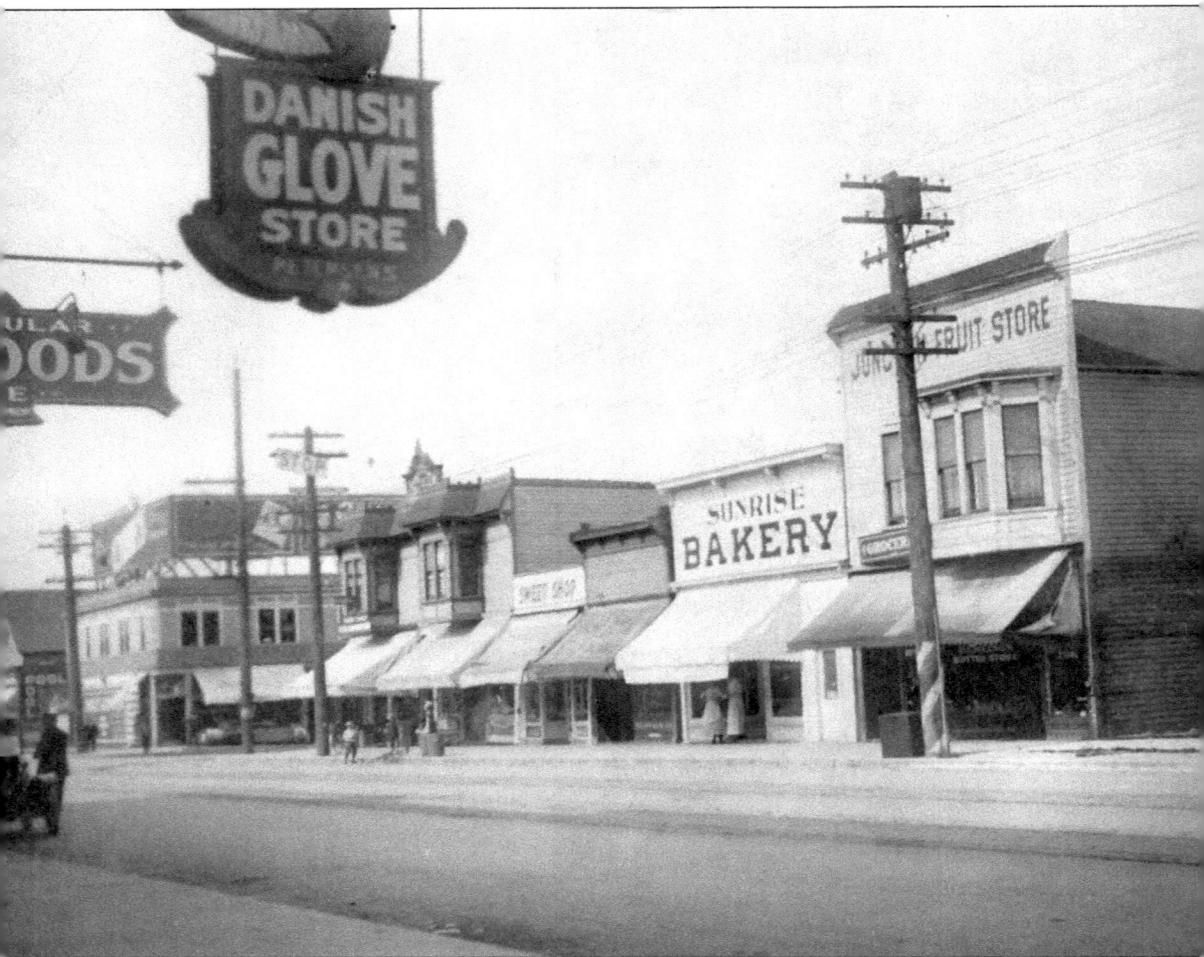

This view is looking southwest toward the California Avenue SW and SW Alaska Street intersection around 1915. The wooden building in the center with the dormers was replaced by the Hamm Building, which is currently occupied by Easy Street Records.

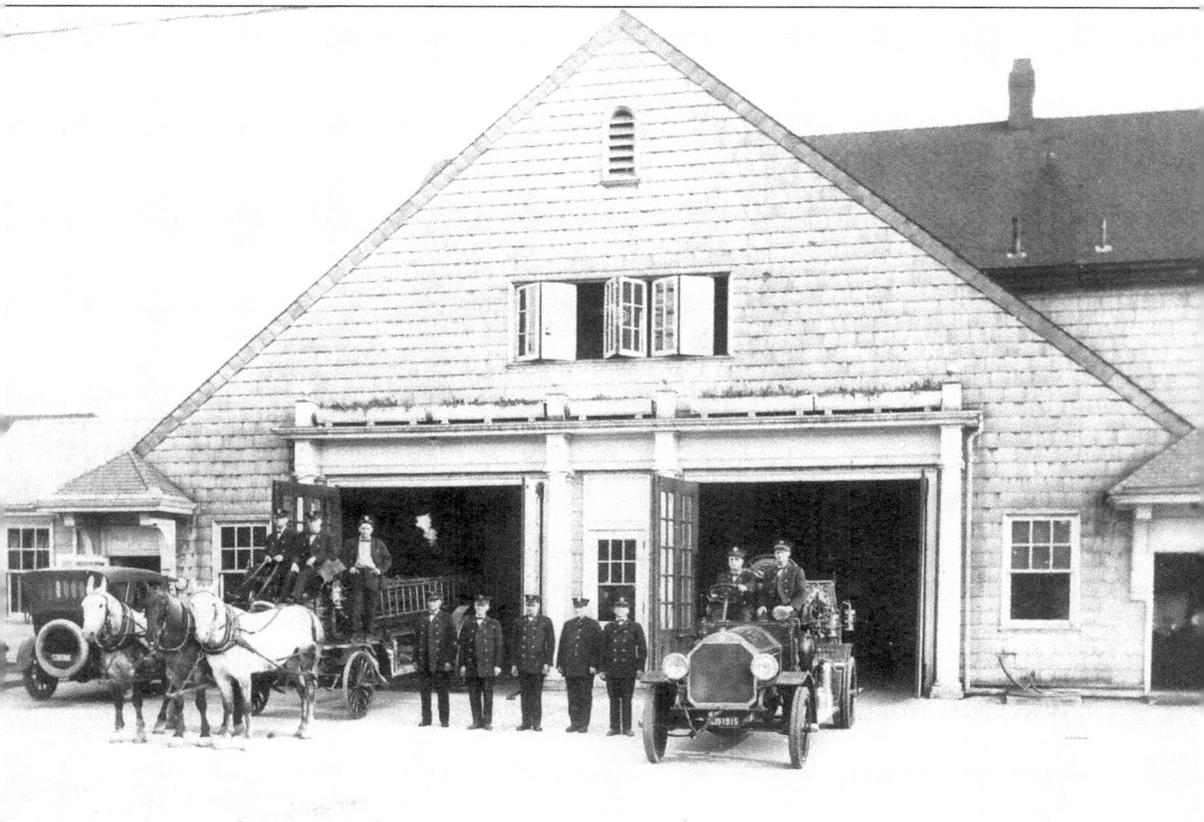

Built in 1914, Fire Station No. 32 (at the southeast corner of SW Alaska Street and Forty-fourth Avenue SW) had the last horse-drawn ladder company in Seattle. It used real "horse power" from 1921 to 1924, before being replaced with a motorized truck. The building was razed in 1966; the site now hosts the popular Sunday West Seattle Farmers Market.

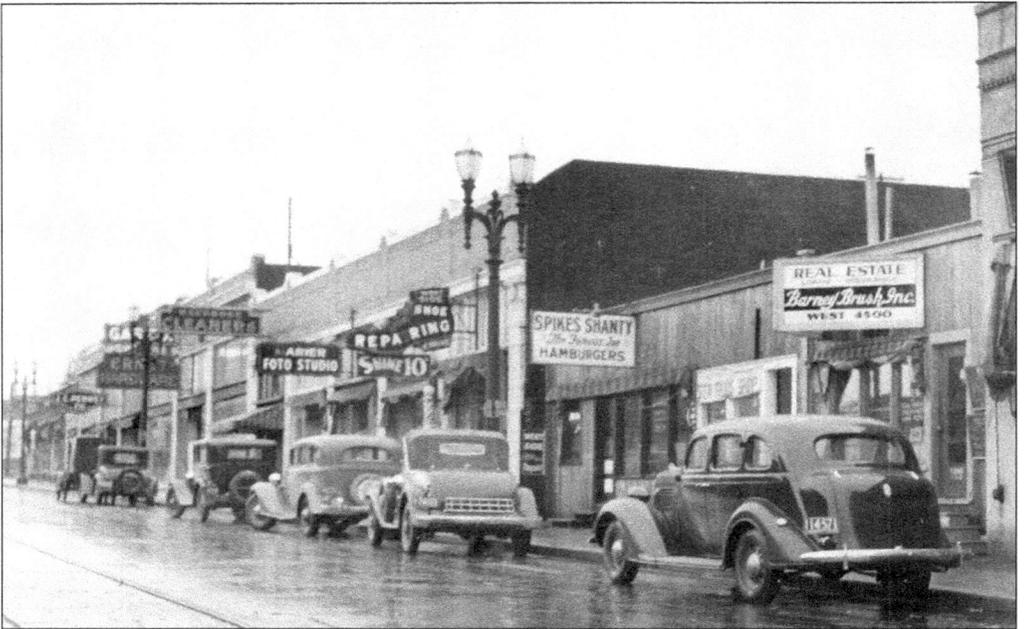

A rainy view of the Junction in the late 1930s looks northeast on California Avenue SW toward SW Oregon Street. JCPenney, to the north, was in business in the Junction from 1928 to 1987. In 1940, Spikes Shanty and Barney Brush Incorporated were replaced with a new building.

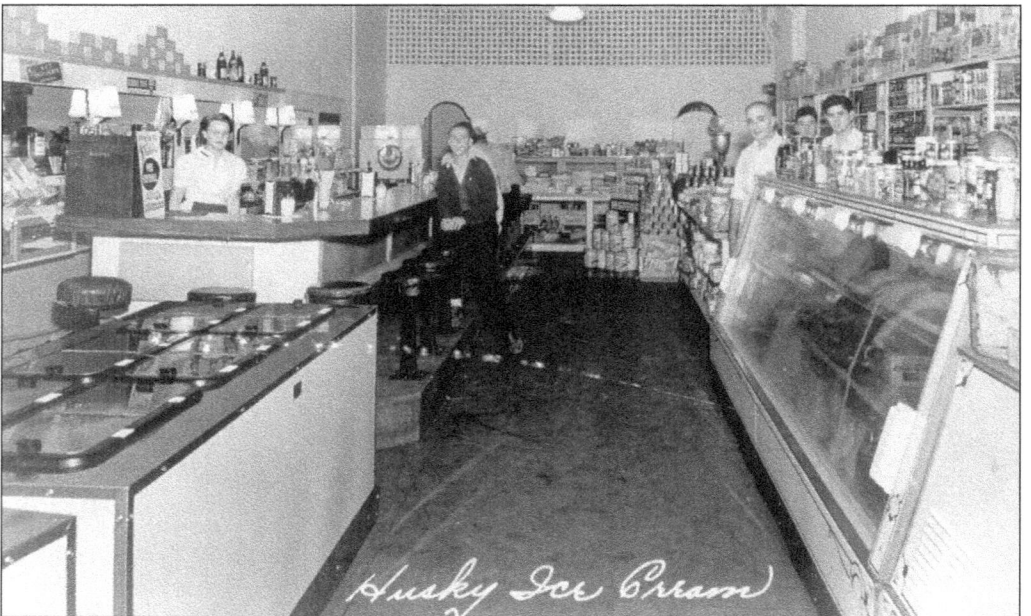

Husky Deli, originally known as Edgewood Farm Store, was opened in 1933 by Herman Miller and family. This image of the business, which features a soda fountain and "Husky Homemade Ice Cream" as well as hamburgers and milkshakes, was captured in 1937, two years after becoming Husky Deli. It is now operated by the third generation of Millers.

A nighttime scene shows the front entrance to Vann Brothers Restaurant at 4542 California Avenue SW around 1938. Signs advertise fishing tackle and booths for ladies. In addition to their restaurant, the Vann brothers were sport activity enthusiasts, promoting the West Seattle Athletic Club and local fishing derbies; they also rented skis and sold outboard motors. Note the tackle box displayed in the left-hand window.

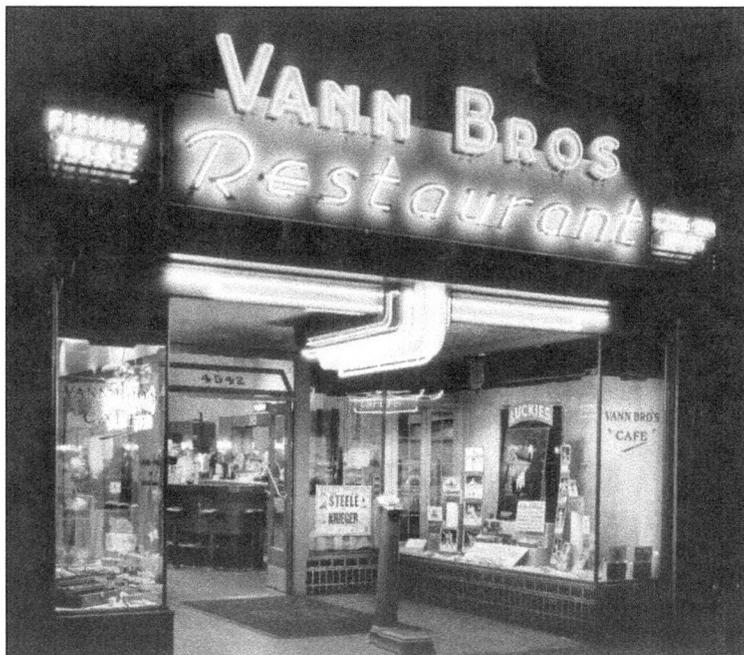

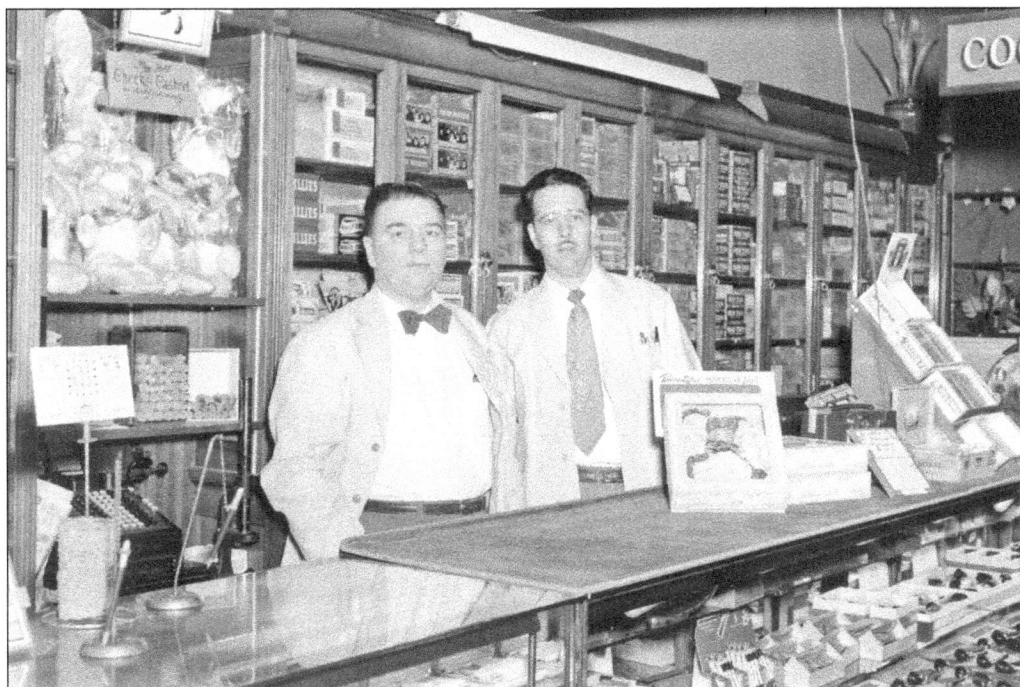

Cashier Ervin Vann (left) and his cousin Roger Vann are at Vann Brothers Restaurant in the 1930s. The restaurant was part of their "modern, up-to-date-store" that included this counter section well stocked with quality cigars, pipes, tobacco, and smoking supplies. Originally in the Admiral District, Vann Brothers relocated to the Junction, first on SW Alaska Street, then on California Avenue SW.

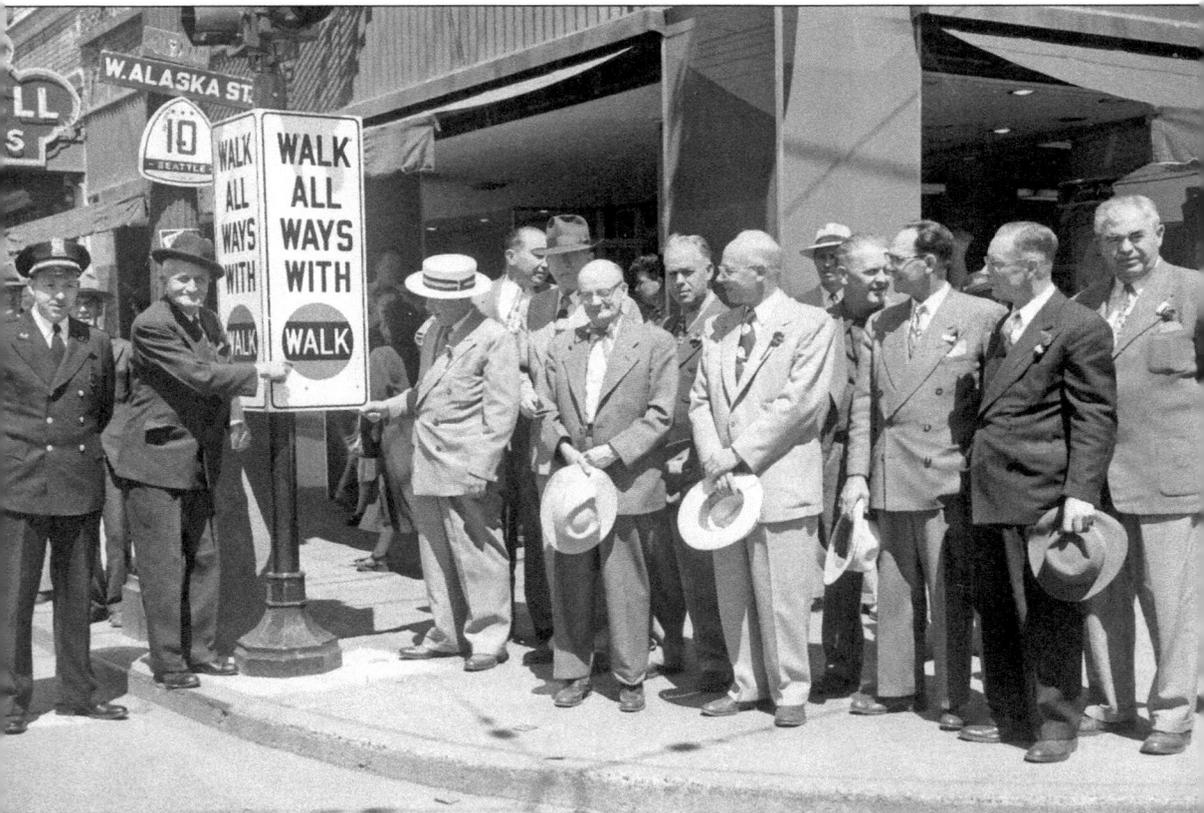

In 1952, the newly installed "Walk All Ways with Walk" signal, in the Junction, stops traffic in all directions while pedestrians are able to cross in any direction. Pedestrians endorsed the system but many motorists did not like the delays in getting through the intersection. The all-way signal was removed in 1974, but was reinstated by popular demand in 1988 and has remained ever since.

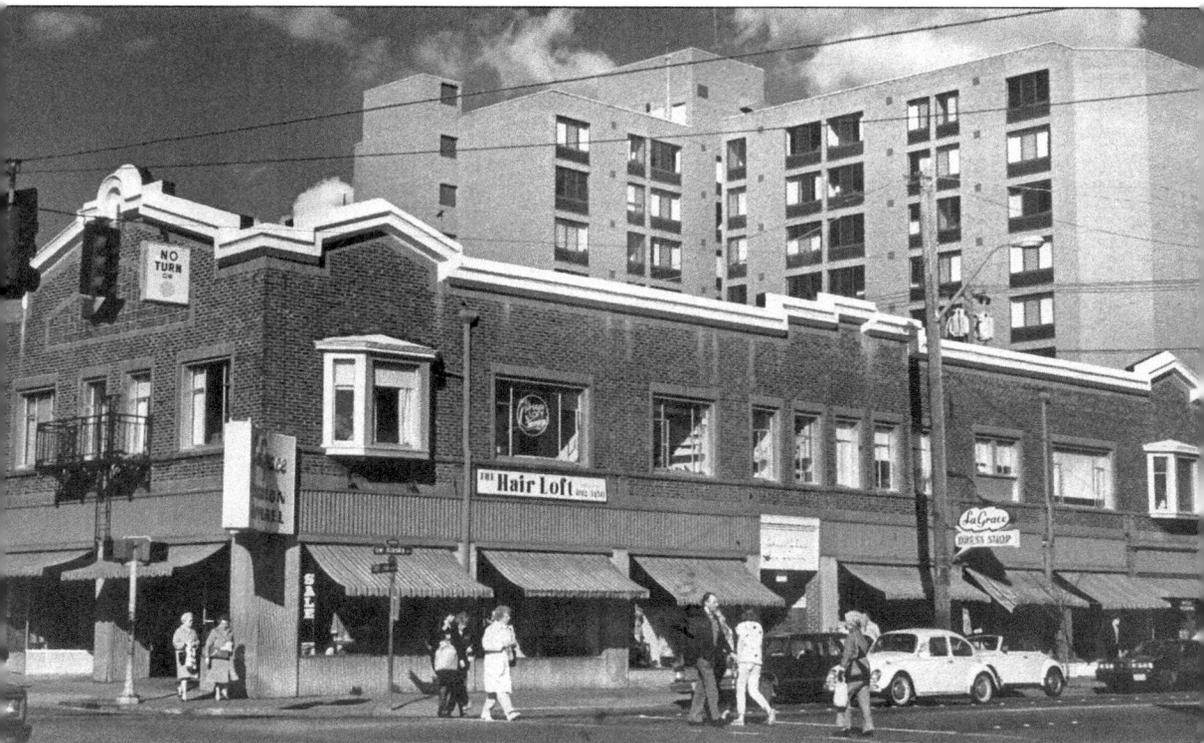

The Campbell Building, at the northeast corner of California Avenue SW and SW Alaska Street, was named after W. T. Campbell, a realtor and developer who sold property early in West Seattle's history. The tall structure in the background is the Alaska House, a subsidized apartment building for the elderly and disabled built in 1979. West Seattle leader Helen Sutton's LaGrace Dress Shop is visible behind the Volkswagen beetle.

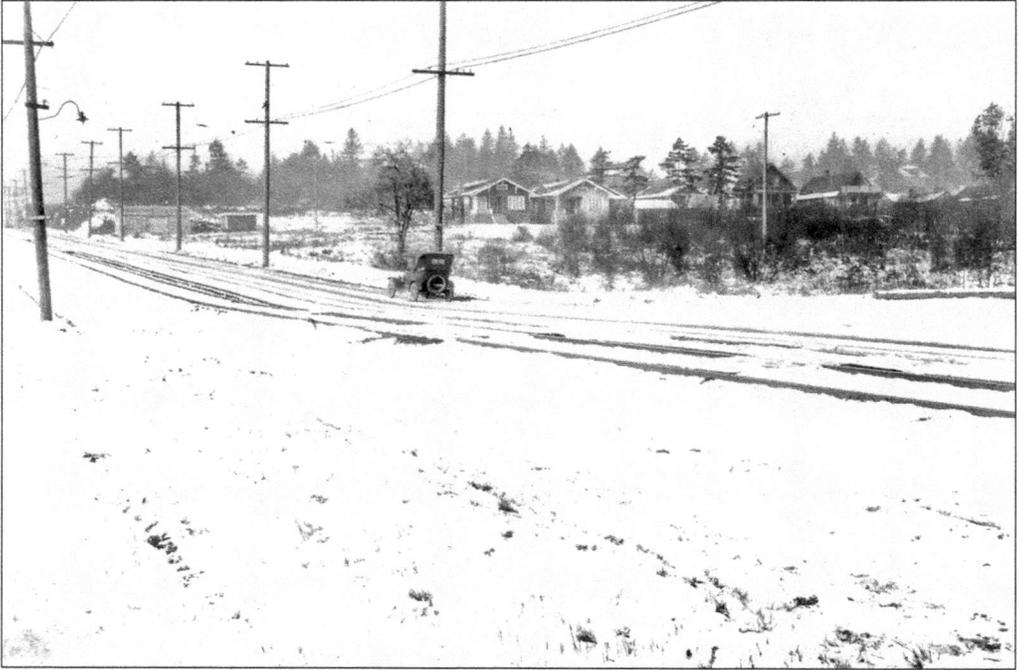

A Model T Ford braves the snow as it trundles west on SW Alaska Street on December 13, 1922. The sign on the pole to the left says Fauntleroy Avenue; the streetcar tracks in the foreground on Alaska Street lead to the Junction. Both houses in the center of the picture still exist on Fortieth Avenue SW.

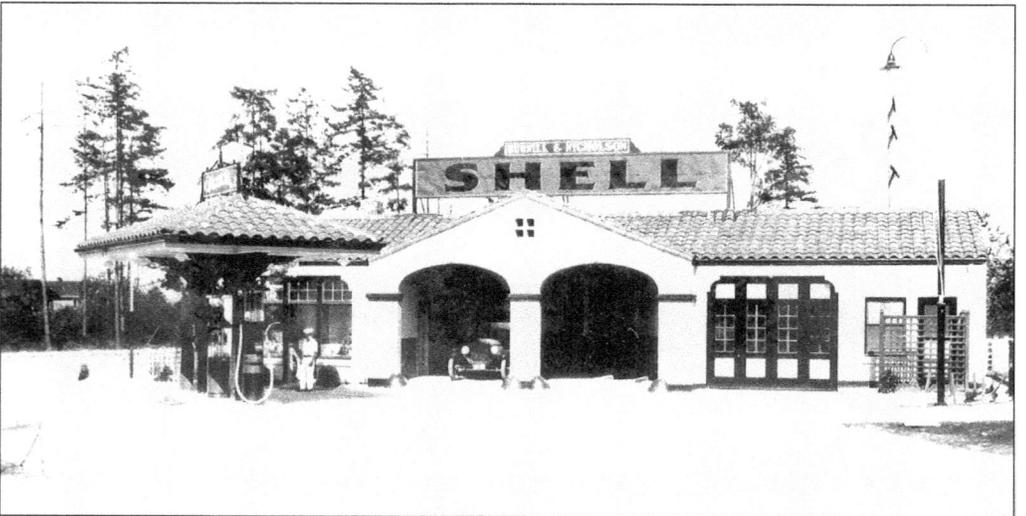

Gasoline prices in the 1920s averaged 20¢ to 22¢ per gallon at Tom Burnill and Bert Nicholson's Shell Service Station at 4528 Fauntleroy Way SW. Hand-pumped gasoline was visible in a clear glass cylinder atop the pump, so customers could see what they were purchasing, and was then gravity fed into the automobile. The building still exists and has been converted to a dry cleaning establishment.

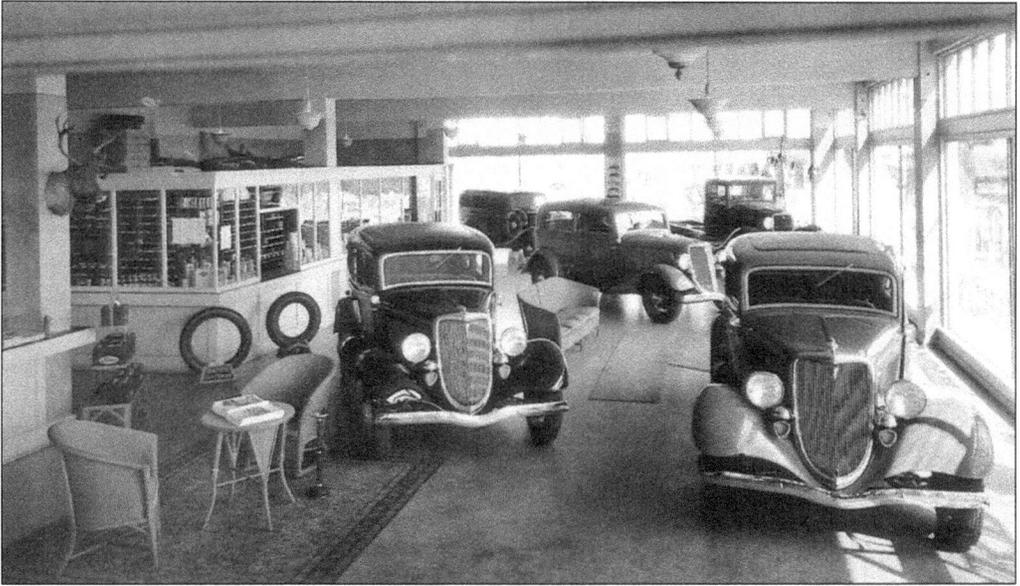

The new 1934 Ford cars and one truck are on display in the showroom at Marriott Motors at 3922 SW Alaska Street. West Seattle's "Auto Row" existed from the 1920s to the 2000s and was patronized by residents citywide. During the first Hi-Yu celebration in 1934, Marriott Motors advertised in the *West Seattle Herald*, touting demonstrations of the powerful new V-8 engine.

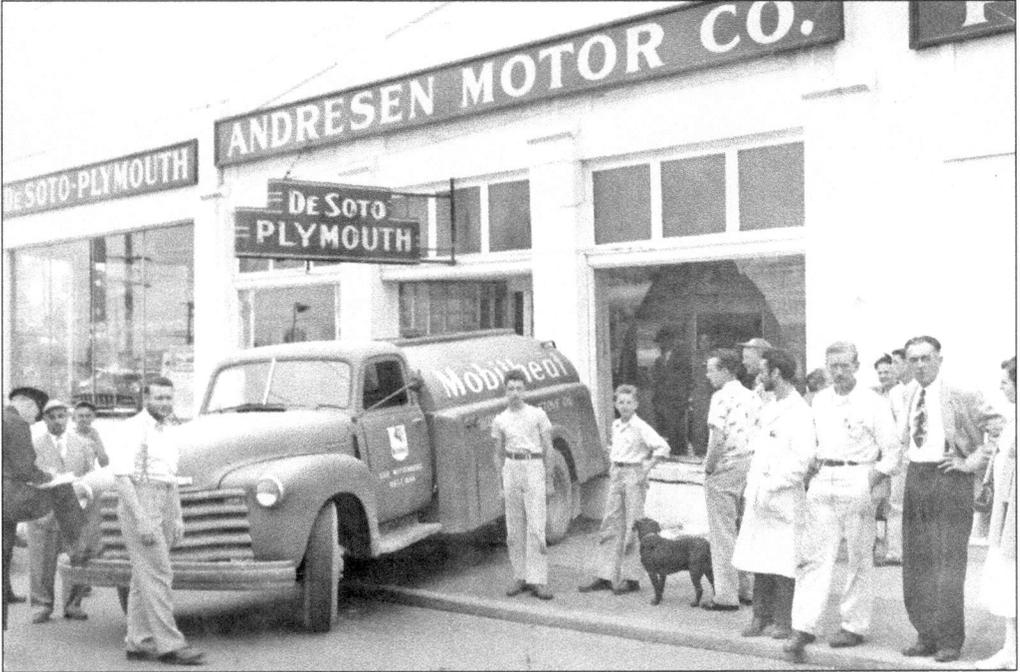

A crowd looks at a slight mishap involving Leo Wittenburg's fuel delivery truck outside the Andresen DeSoto-Plymouth car dealership in 1951. Located at 4019 SW Alaska Street, Andresen Motor Company was a member of the eight West Seattle Automobile Association dealers in 1952. Currently there are no new car dealerships in West Seattle.

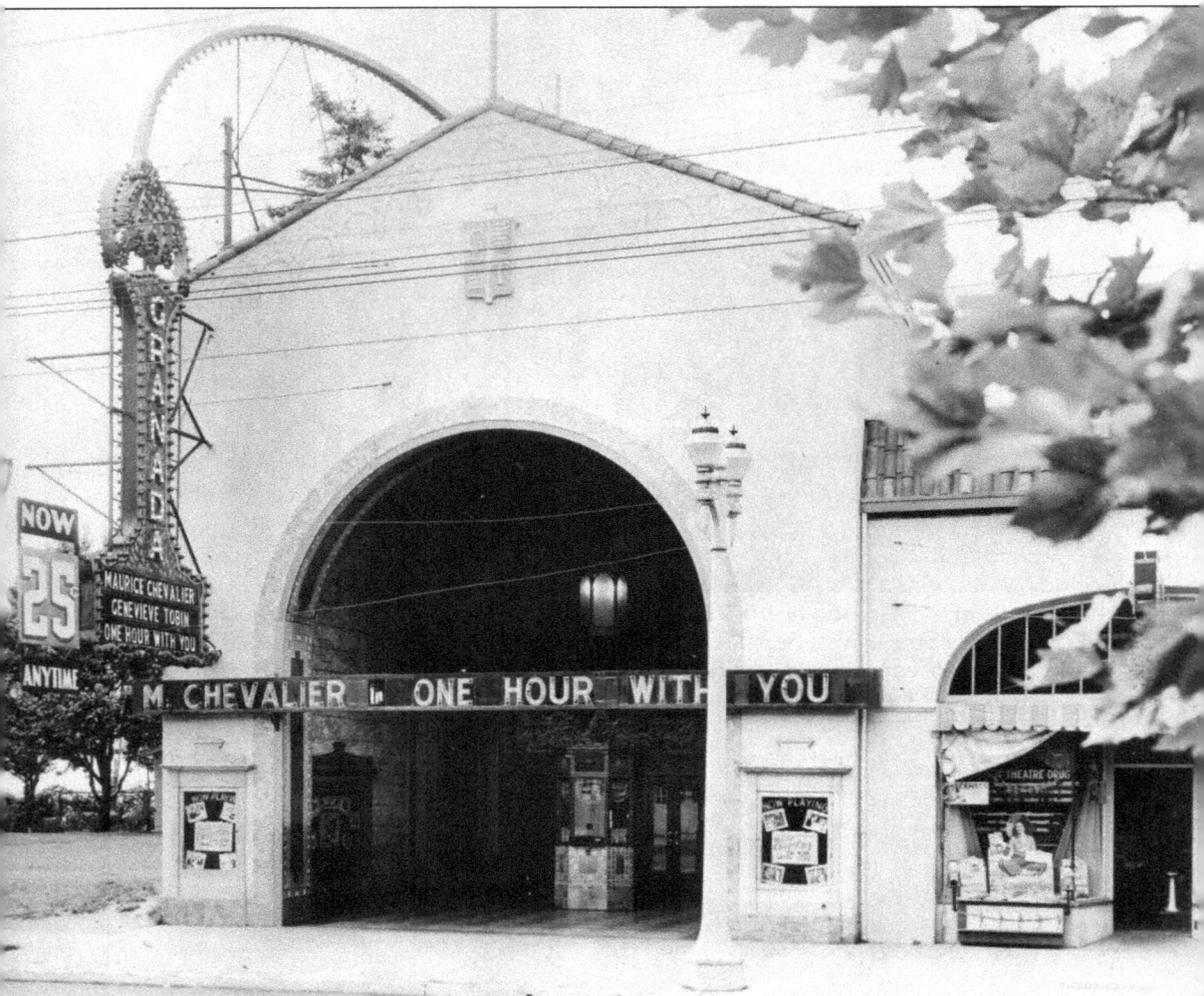

The luxurious Granada Theater, located at 5011 California Avenue SW (shown around 1932), featured a distinctive "skyrocket" marquee and a 2/7 Wurlitzer opus 1194 theater organ. The theater opened July 23, 1926. It seated 1,000 with ticket prices at 25¢ for adults and 10¢ for children. After attendance dwindled in later decades, various owners were unable to keep it from meeting the wrecking ball in 1977. Condos now occupy that location. (Courtesy University of Washington, Special Collections, No. 14663.)

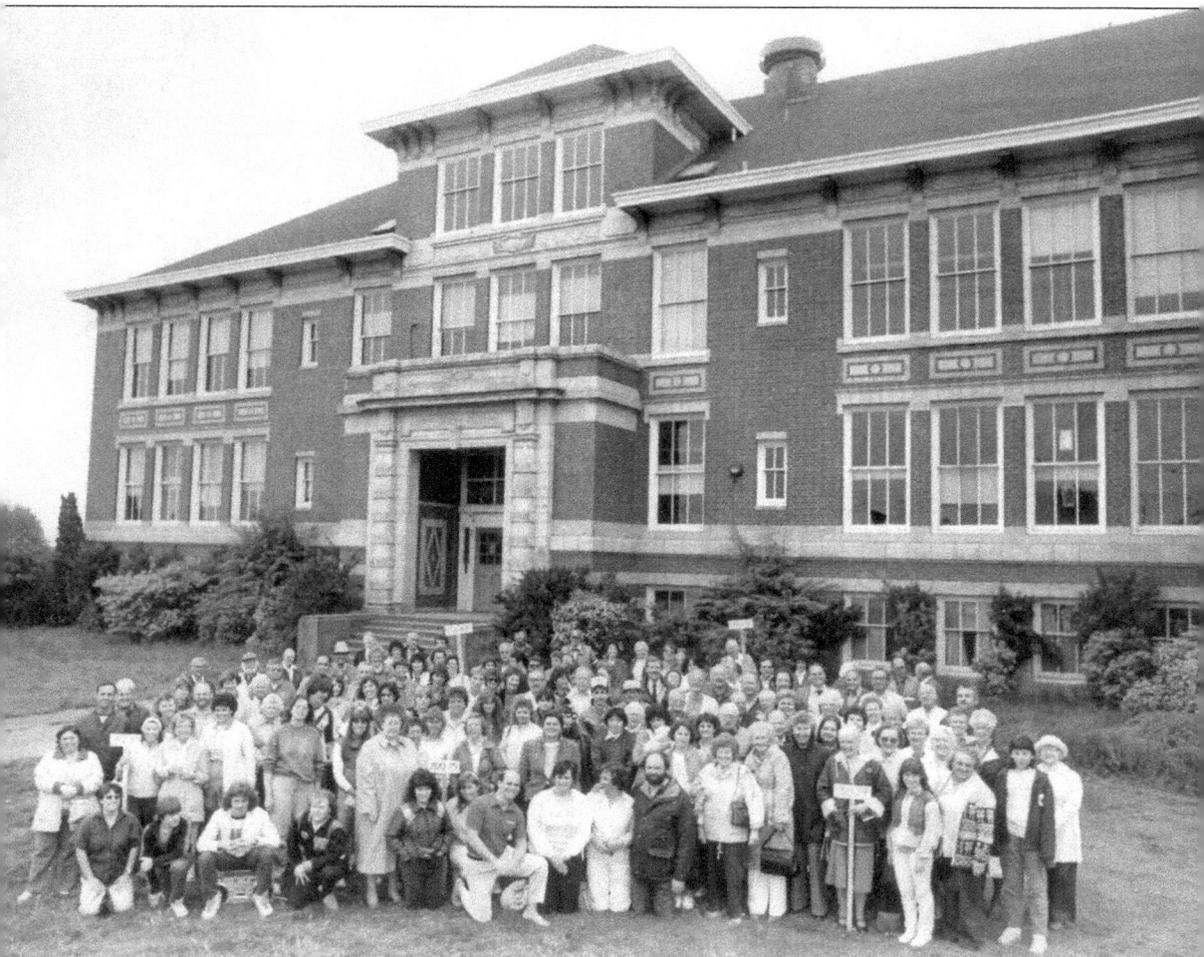

Former Jefferson Grade School students are pictured just before the school's demolition in June 1985. Originally named the West Seattle Junction School, it was built in 1911 for the booming Junction population and later named in honor of Thomas Jefferson. An eight-room addition in 1928 accommodated a growing enrollment, which increased again during World War II. The school taught first through eighth grades, kindergarten, and special education classes. Due to declining enrollment beginning in the 1950s, the school closed in 1979.

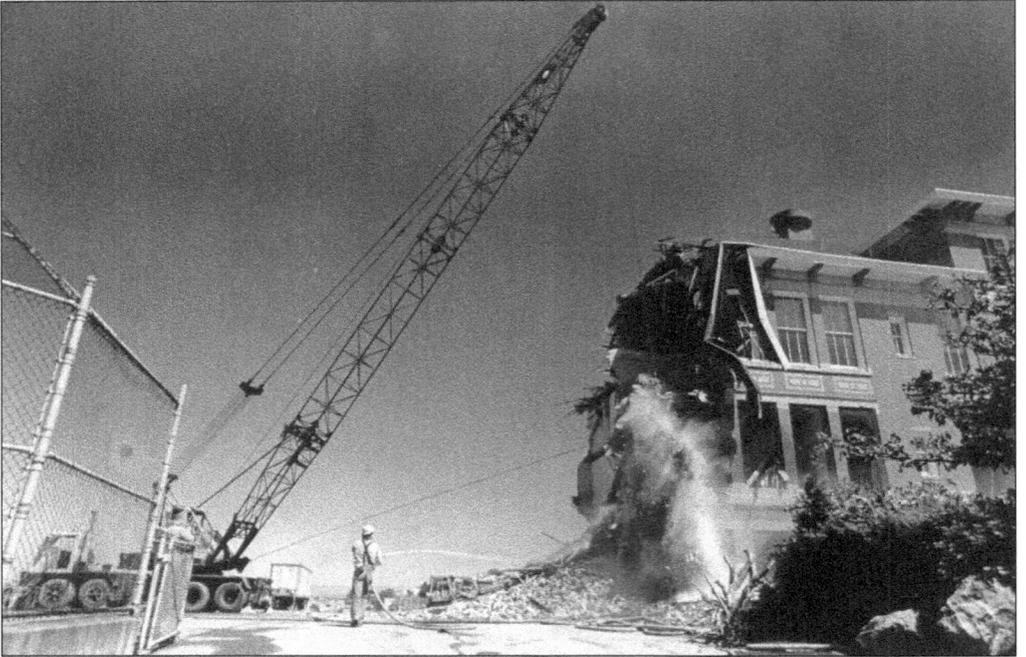

On June 18, 1985, a wrecking ball strikes the side of the Jefferson Grade School while a worker sprays the falling debris with water. Construction of the Jefferson Square retail/residential complex began on the former school site in 1986.

A time-lapse night photograph shows the Jefferson Square shopping center parking lot when it opened in December 1987. A shopping center, with offices and an apartment complex on the second and third levels, was built on the site of the razed Jefferson Grade School.

Five

FAUNTLEROY

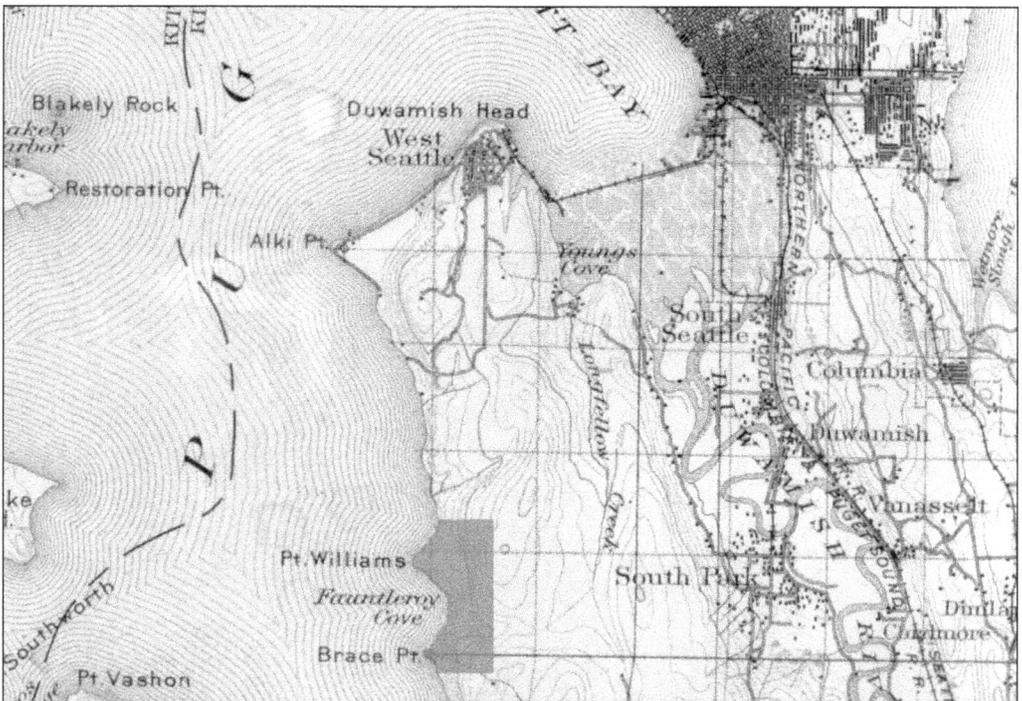

The Fauntleroy neighborhood rests along Puget Sound's Fauntleroy Cove in Seattle's southwest corner. Nowadays a strong community of residents and a key transportation link by ferry to both Kitsap County and Vashon Island, in earlier times it was only easily accessed by steamship or canoe. The present name was acquired in 1857 when the United States Coast and Geodetic Survey ship *R. H. Fauntleroy* and crew explored Puget Sound. The captain had named his ship after the father of his fiance, and Fauntleroy Cove after the woman herself: Ellinor Fauntleroy. By the 1880s, farming began at Brace Point and land clearing and logging occurred throughout the Westside. By the time the West Seattle streetcar extended a line southward to Endolyne in 1907, Fauntleroy real estate boomed. Soon permanent homes began replacing shoreline summer cabins and tents and with them, the permanent community began. Within 10 years, key elements of Fauntleroy were in place: Fauntleroy Community Church, the Kenney, Fauntleroy Elementary School, the ferry dock, and Lincoln Park.

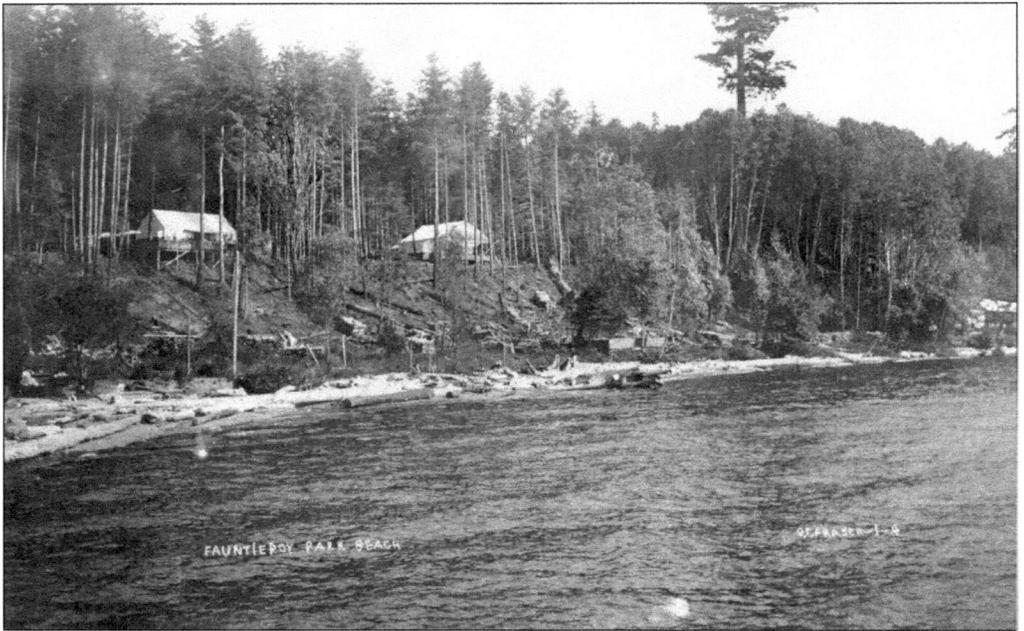

This is the 1901 platform tent housing, located on the north side of Fauntleroy Cove where Lincoln Park is today. As with Alki Beach and Beach Drive SW, early Fauntleroy was a beach vacation spot for visitors from the city. The area also supported farms and logging.

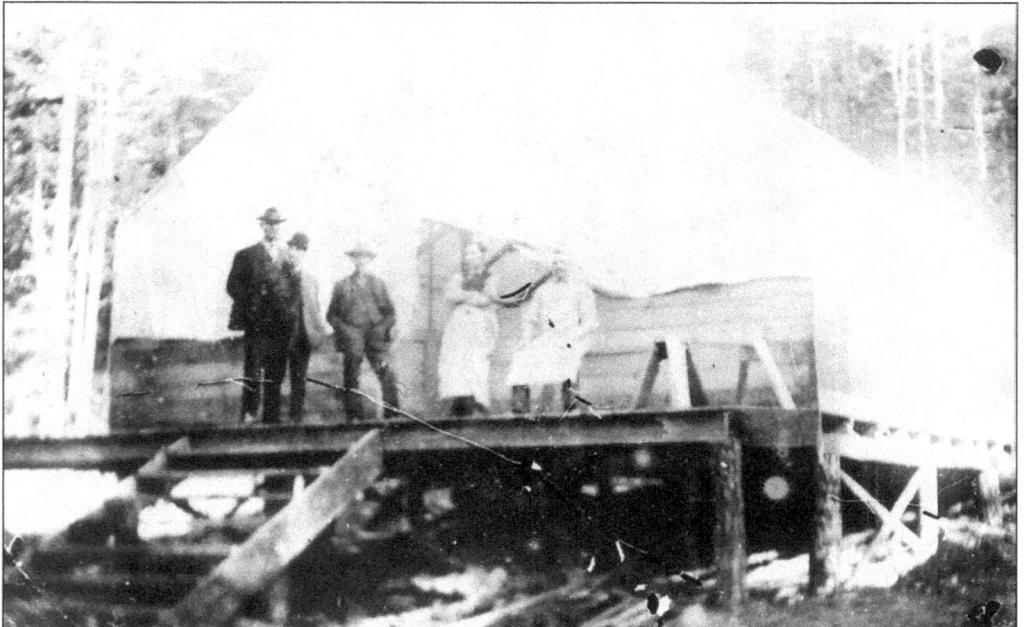

John Adams also set up the first tent store and restaurant on SW Rose Street around 1906. He then began to promote the idea of adding a streetcar line to the isolated Fauntleroy area. On February 15, 1907, the Seattle Electric Company started streetcar service between downtown Seattle and Fauntleroy. Later that same year, the California Avenue SW line was connected to the Fauntleroy line. (Courtesy University of Washington, Special Collections 4627.)

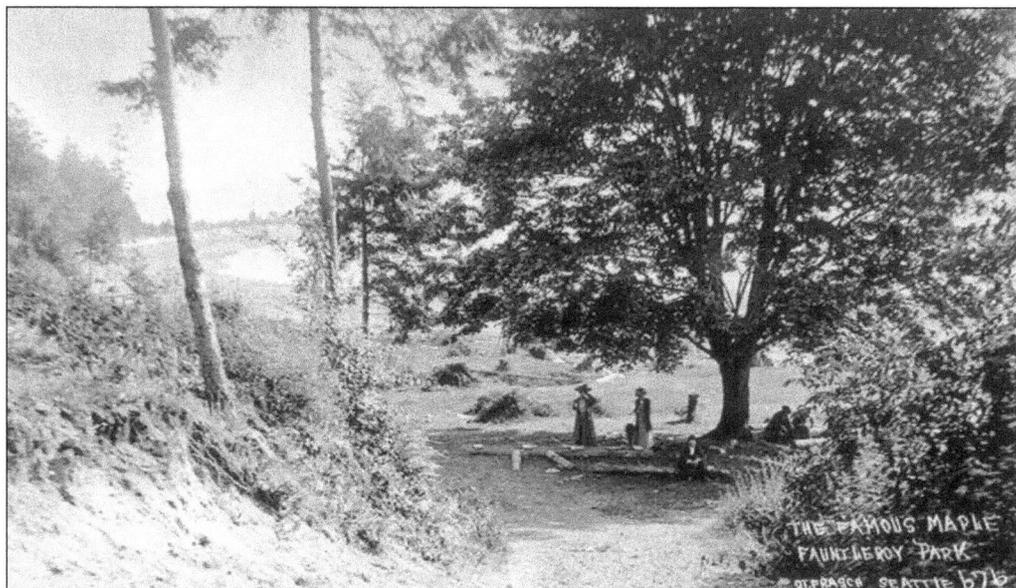

People at Fauntleroy Cove sit under a maple tree enjoying views of the Puget Sound by a dock at SW Roxbury Street around 1905. During the early part of the 20th century, there were at least three docks at Fauntleroy Cove. Only the Fauntleroy Ferry Dock remains today. (Courtesy University of Washington, Special Collections 4631.)

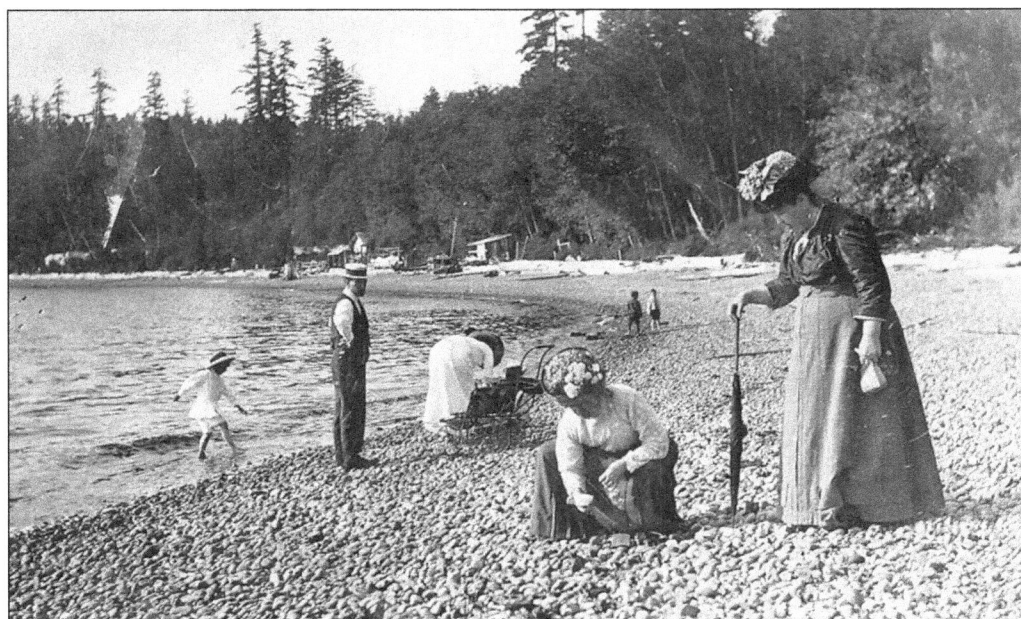

People are dressed in formal attire, enjoying the Fauntleroy Cove beach around 1910. They are wading in the water and looking for seashells on the beach. Cabins can be seen in the background.

Workers are clearing trees in the area of SW Rose Street and Fauntleroy Way SW around 1906. For landowners, the first step was often clearing trees and selling the timber. The cleared land was then sold to home builders. In 1907, West Seattle began to grow thanks in part to the convenience of a streetcar line and new roads. (Courtesy University of Washington Libraries, Special Collections 4625.)

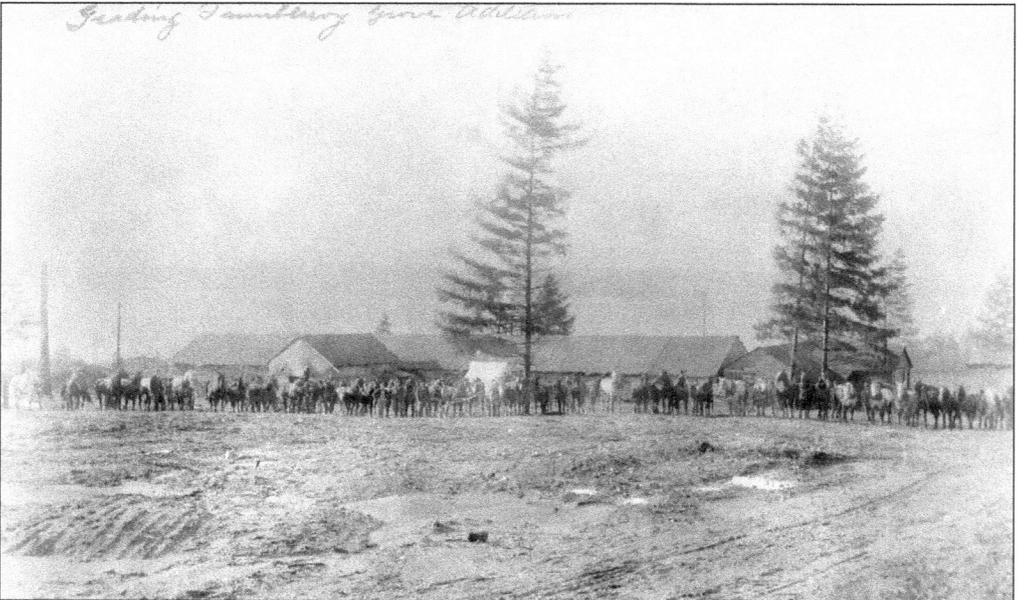

The SW Rose Street grading project, seen here around 1910, shows contractor N. McKinnon using 50 horses to grade the land between California Avenue SW and Fauntleroy Way SW. The street regrading allowed for the development of new home sites in the area.

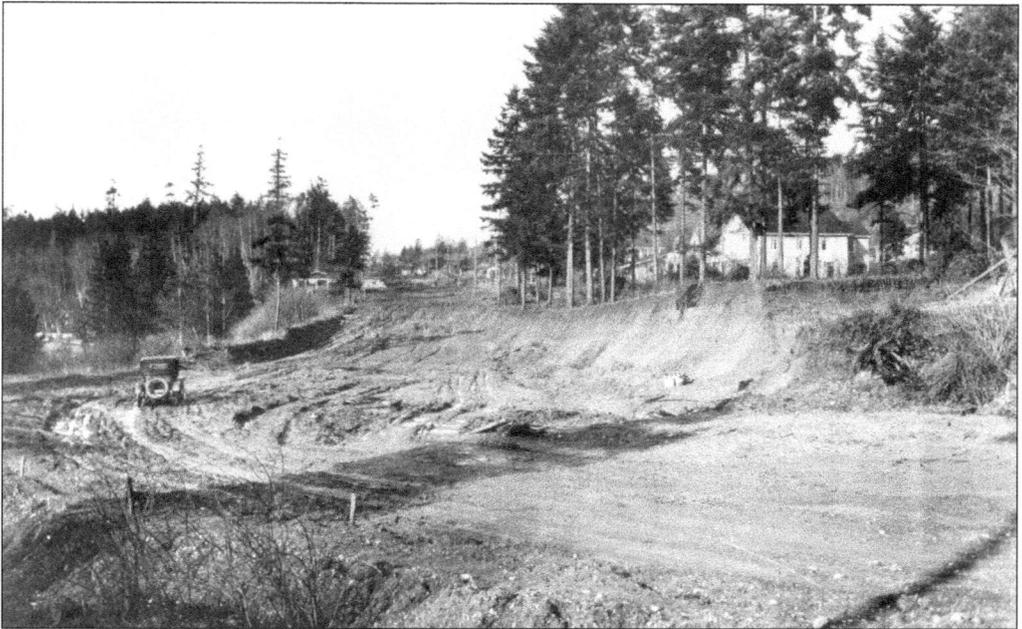

In 1907, Fauntleroy Avenue, now Fauntleroy Way SW, was graded for the first streetcar. This photograph shows construction near the Fauntleroy Ferry Dock. The high ground on the right, overlooking the construction, is known today as Captain's Park, and the houses in the picture are still there. (Courtesy University of Washington Libraries, Special Collections 4629.)

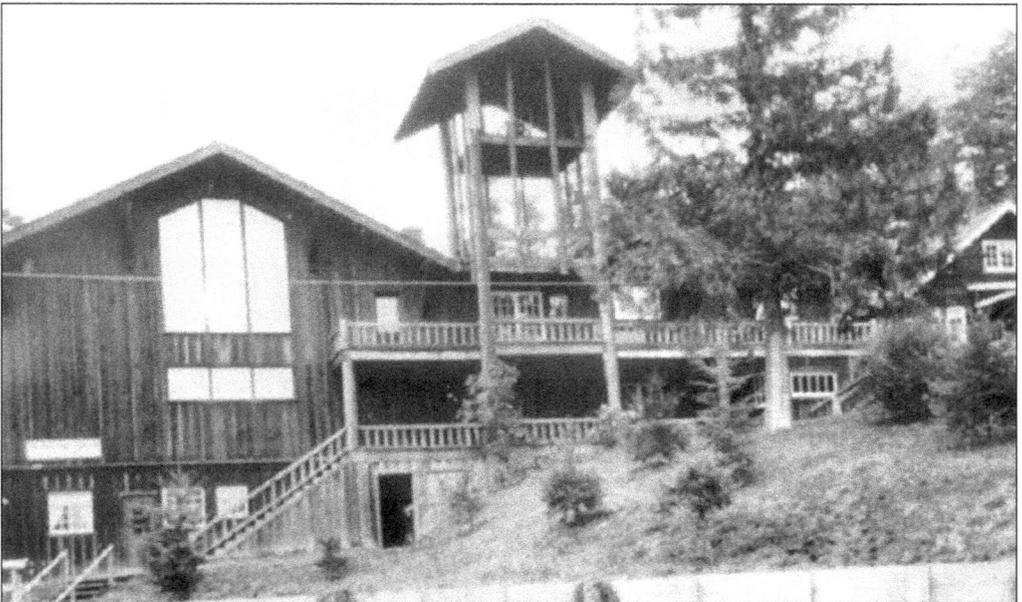

The Fauntleroy Community Church is a part of the early Fauntleroy neighborhood center along with the school and business block. In 1908, volunteers built the original church on land donated by John Adams. It was known as "the church built in a day." In 1914, a gymnasium was added, and a bell tower followed three years later. By 1924, the attached community center became a Seattle YMCA branch. (Courtesy Fauntleroy Community Church UCC and Francis Adams Burke.)

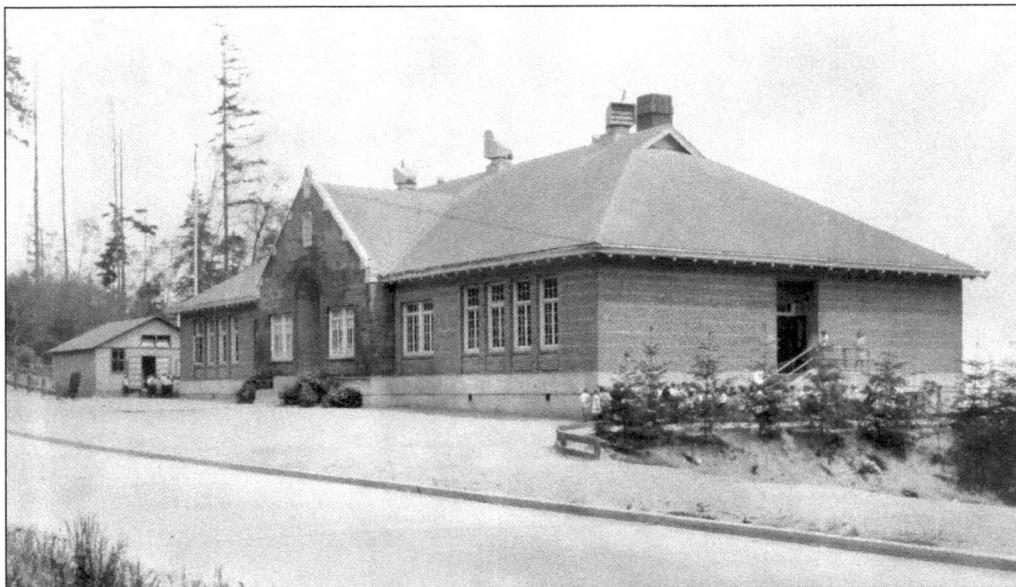

Fauntleroy Grade School, at 9131 California Avenue SW, is shown in 1945. It was constructed in 1917–1918 for first through fourth grades. Because of rising attendance, it was expanded in 1949 and again in 1952. The school closed in 1981, and the Seattle School District leased the building to the Fauntleroy Community Service Agency. With help from the city and state, the agency purchased the building in 2010. (Courtesy Seattle Public Schools, 224-1.)

In 1950, sixty acres of the wooded Fauntleroy hillside was transitioned to housing. Over the next five years, the Arthur C. Webb Company built more than 250 homes, many utilizing the skills of Latvian brick masons. The Fauntlee Hills neighborhood is comprised of more than 250 homes near SW Barton Street and Fauntleroy Way SW.

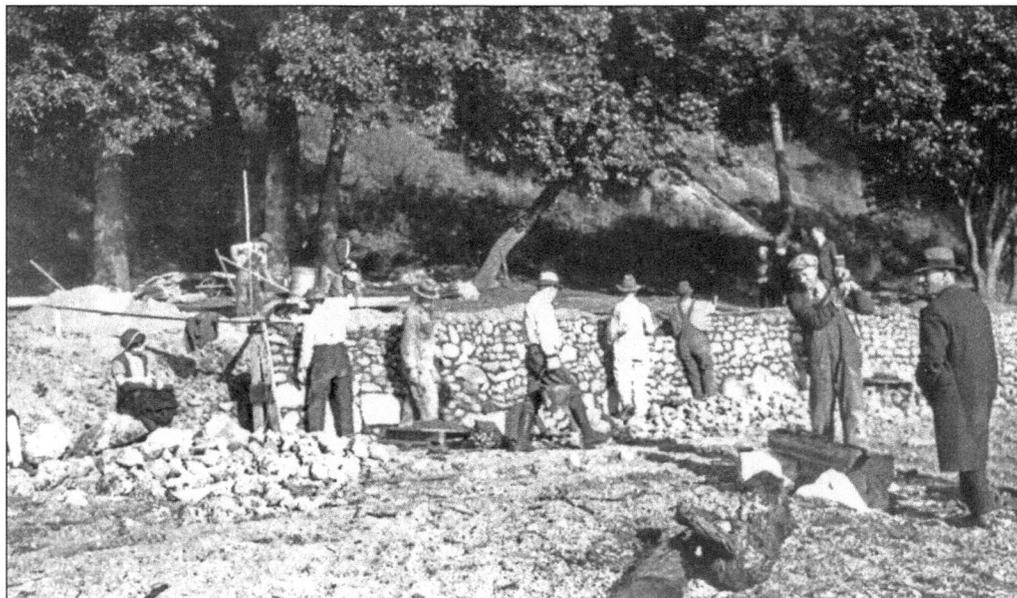

Workers from the Civil Works Administration (CWA) are building the seawall at Lincoln Park in 1933. Lincoln Park was acquired by the city in 1922. In 1931, workers from Seattle's Unemployed Fund built a seawall using boulders retrieved from the beach. In 1933, through the state's emergency employment program and CWA, 260 men worked on the park to build shelters, trails, and tennis courts, in addition to the seawall. (Courtesy Seattle Municipal Archives, No. 29709.)

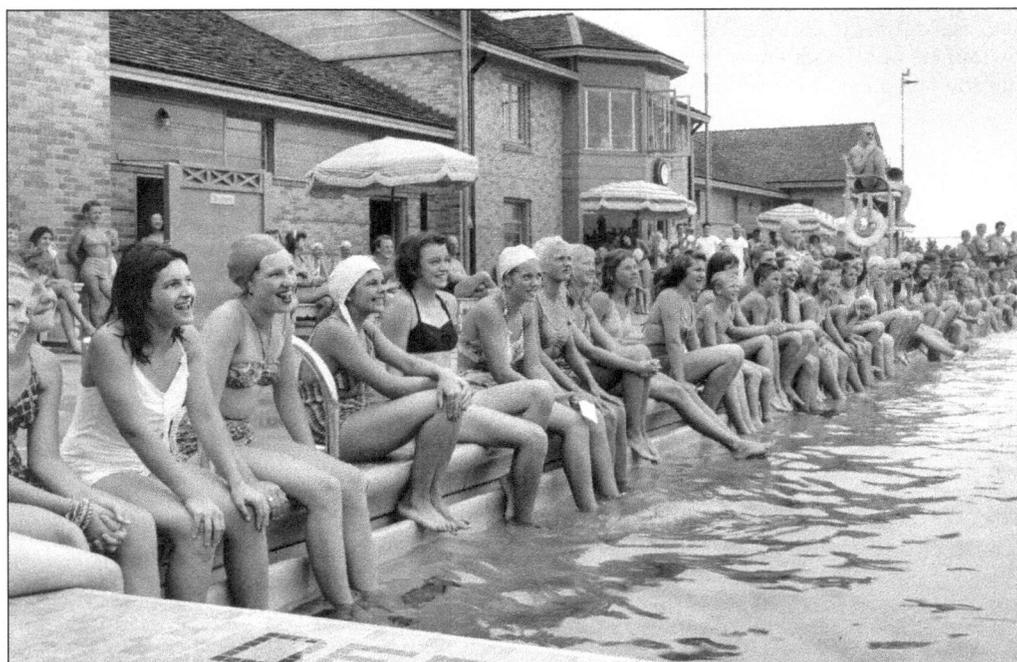

The West Seattle Commercial Club, now known as the West Seattle Chamber of Commerce, holds a picnic at Colman Pool in 1947. The Lincoln Park saltwater pool became a popular meeting place for community organizations. (Courtesy MOHAI, PI 21620.)

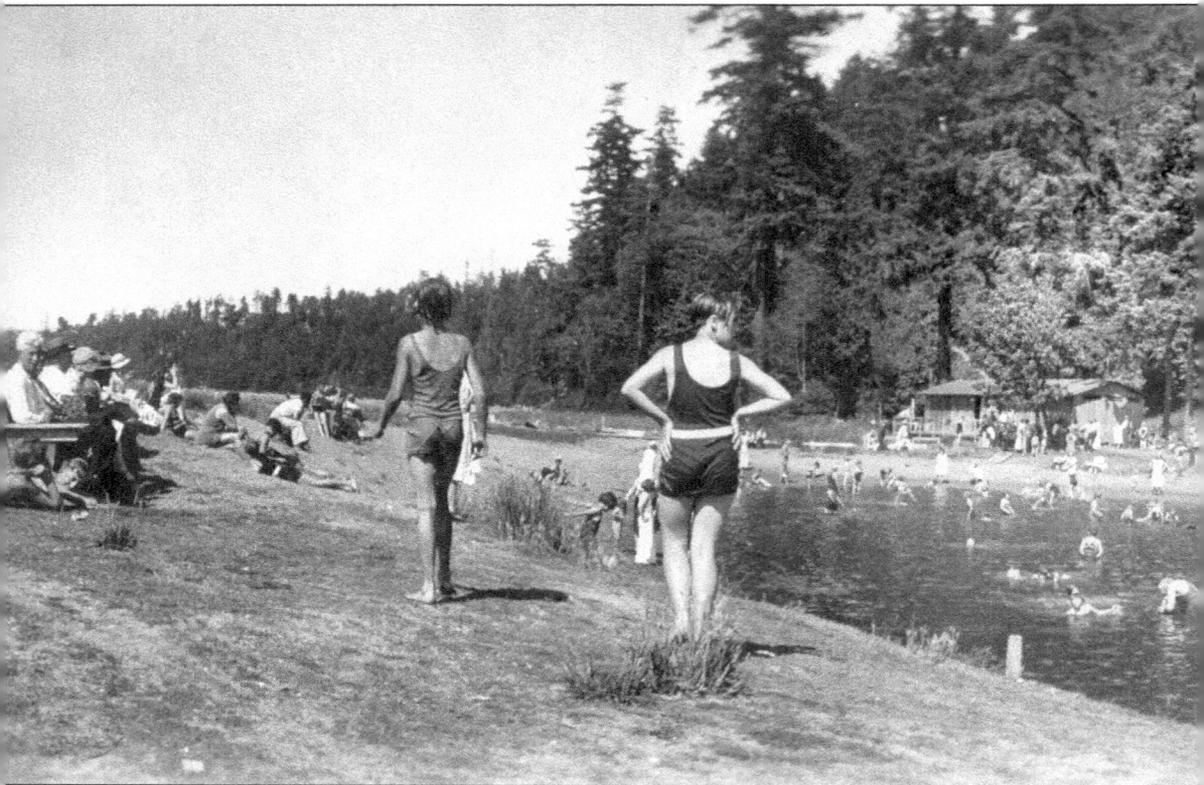

Swimmers of all ages enjoy the Lincoln Park Pool in 1933. It was dredged out on the site of a natural lagoon at Point Williams in 1925. It was 80 by 100 feet, with a springboard for diving at

Opposite: In 1941, the Colman family funded a new saltwater pool to replace the Lincoln Park Pool. It is still in operation today. (Courtesy Seattle Municipal Archives, No. 29735.)

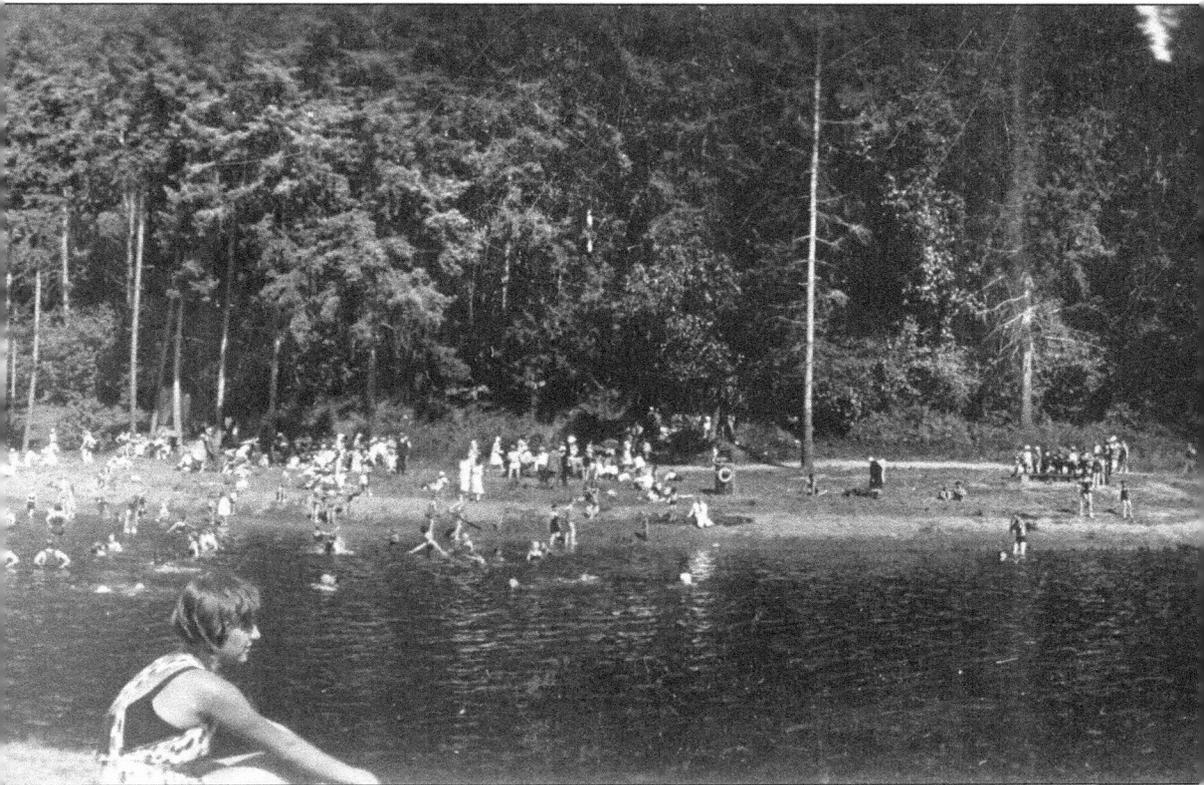

the deep end. A pipe with a gated valve allowed old water to flow out at low tide and new water to flow in at high tide. (Courtesy Seattle Municipal Archives, No. 29770.)

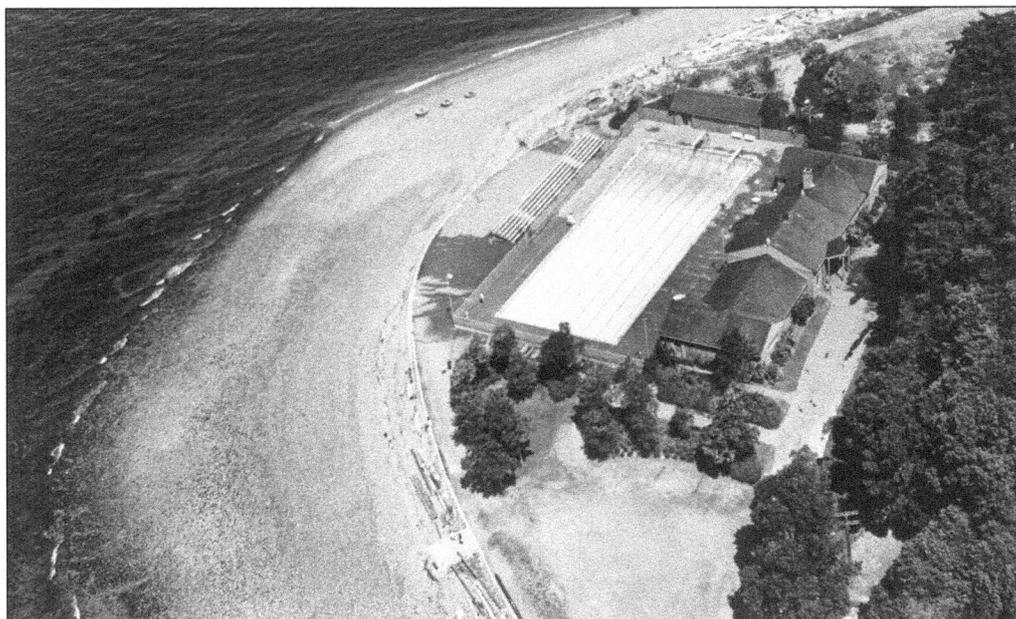

The streetcar line and wooden plank sidewalk are shown looking east at SW Myrtle Street and Fauntleroy Way SW around 1922. The top left corner of the photograph shows the Gatewood School addition under construction.

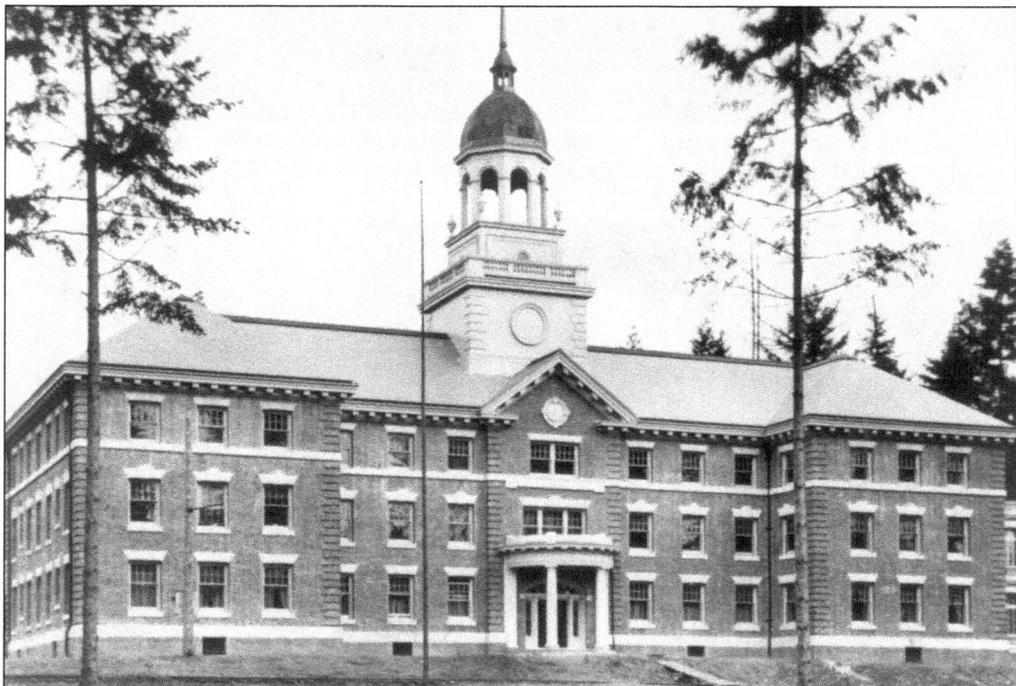

The Kenney Presbyterian Home for the Aged opened in rural West Seattle in 1909, designed as a replica of Philadelphia's Independence Hall. As the Kenney Home expanded to add other buildings, this structure was named the Seaview building. It gained City of Seattle Landmark status 100 years later in August 2009. (Courtesy University of Washington Libraries, Special Collections, CUR1701.)

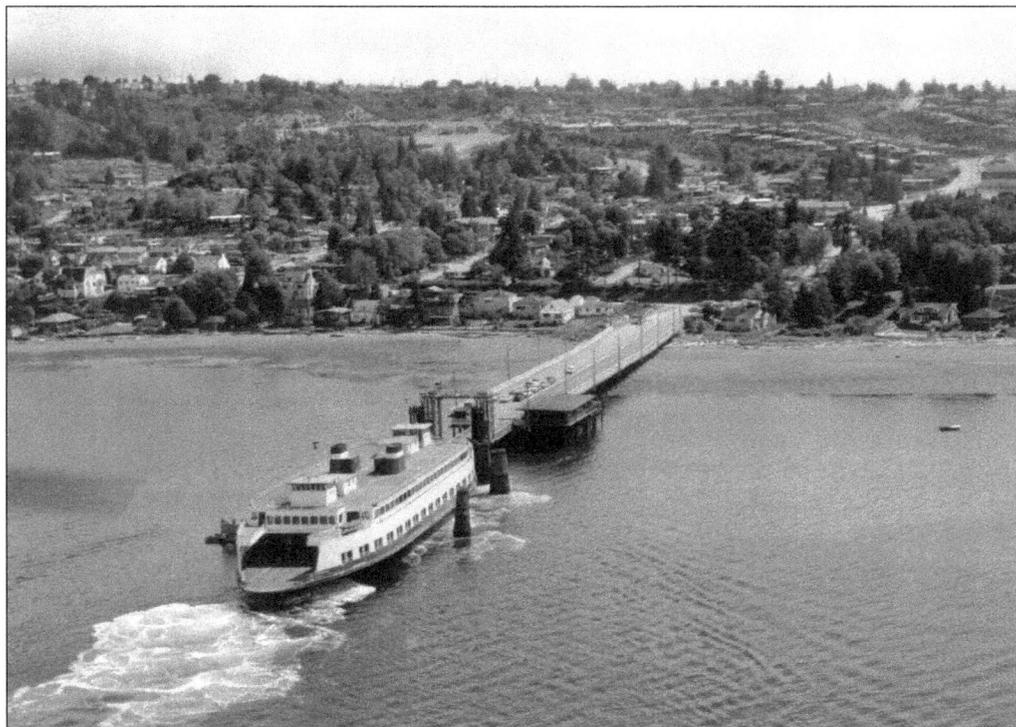

The Fauntleroy Ferry Dock is shown in the photograph above around 1965, and the Fauntleroy Ferry approach is shown below in 1957. In 1925, two ferry lines were established in West Seattle, one at Alki and one at Fauntleroy. The Fauntleroy Ferry Dock was built by the Kitsap County Transportation Company, a private company that ran the Fauntleroy-Vashon-Harper route. In 1951, the Washington State Ferry System took over most of the state's private ferry systems. Today the ferry sails from Fauntleroy to Southworth in Kitsap County, with a stop on Vashon Island. (Courtesy Puget Sound Maritime Historical Society and Seattle Municipal Archives, No. 54789.)

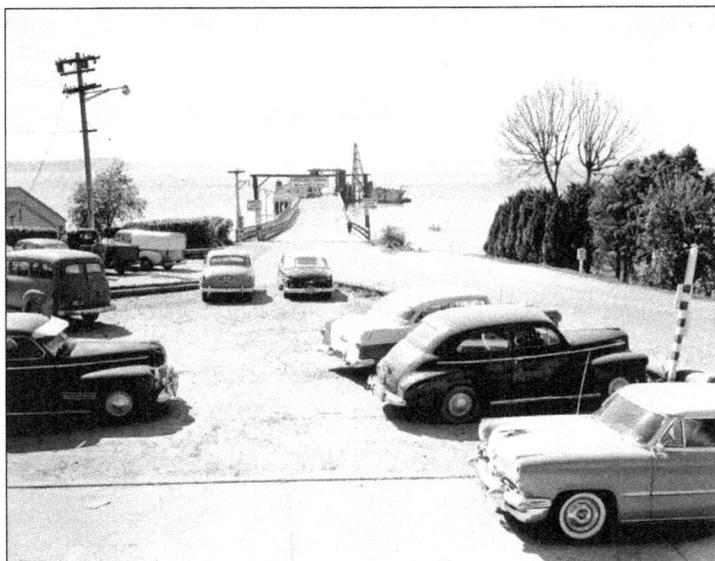

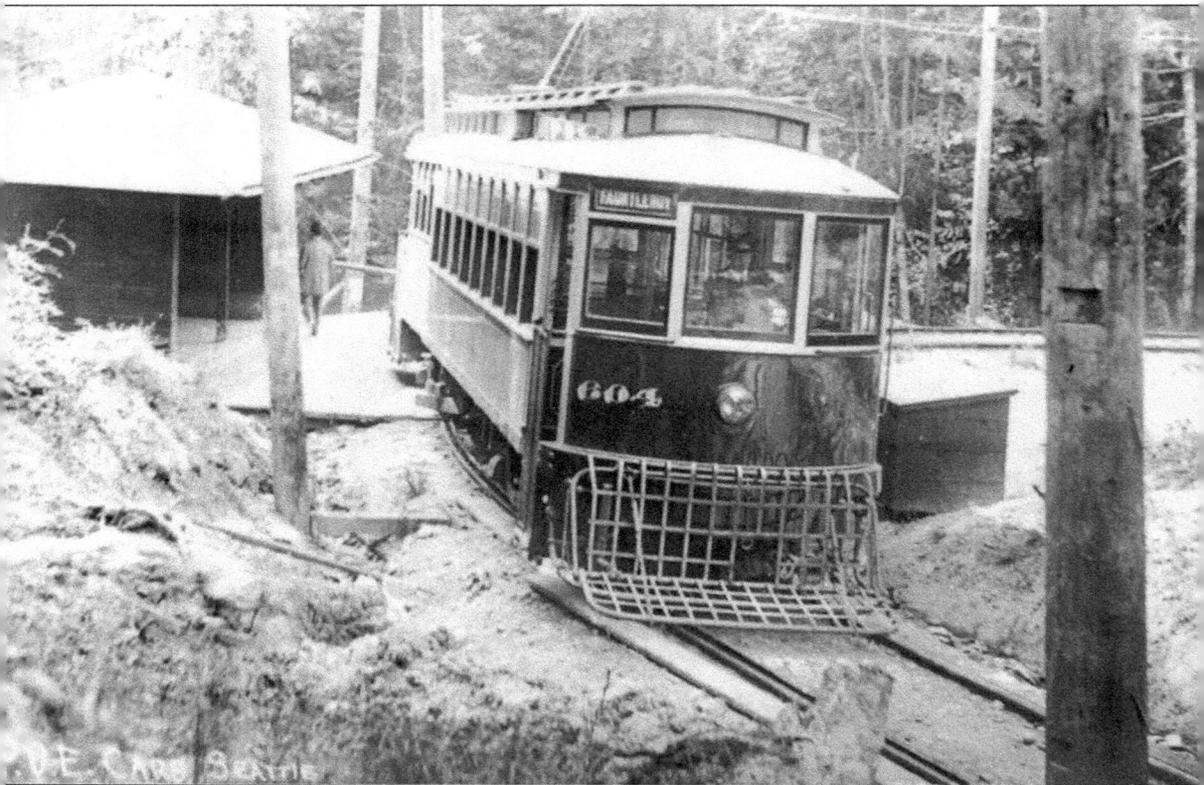

Endolyne's streetcar waiting shelter and turnaround loop was located northwest of Forty-fifth Avenue SW and SW Roxbury Street. The area became known as "Endolyne" from the Fauntleroy streetcar's first conductor, W. C. Fonda, announcing "end o' line," as the car reached the turnaround loop.

Six

WHITE CENTER

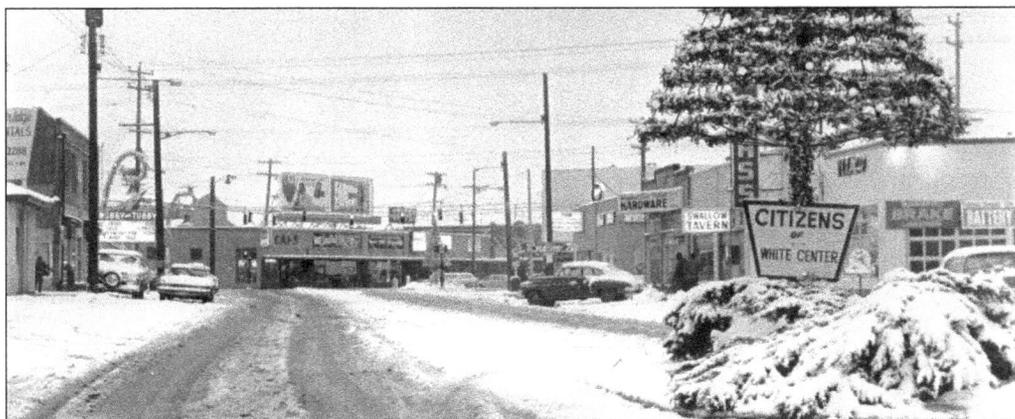

The White Center business district is shown covered in snow, looking south on Delridge Way SW from one block north of SW Roxbury Street, around 1960. The sign for Chubby and Tubby (now Walgreens) is on the left; the Swallow Tavern and Hughes Tru-Value Hardware are visible on the right. White Center was named with a flip of the coin between George White and Hiram Green.

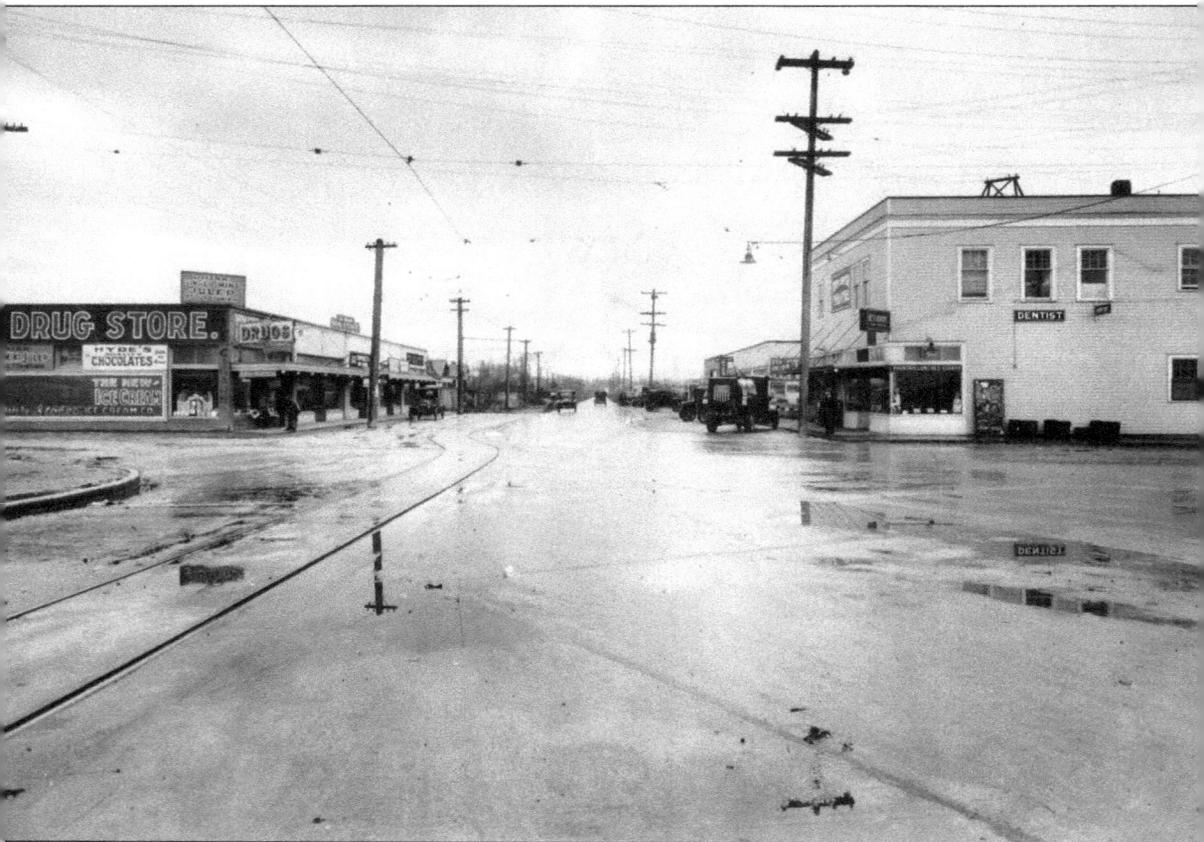

Streetcar tracks cross the three-way intersection (Sixteenth Avenue SW, Delridge Way SW, and SW Roxbury Street), looking south at the White Center main business district around 1920. In 1916, the White Center Theater and Apothecary House building on the right were constructed by Hiram Green, who also owned 5 acres from SW Ninety-eighth Street to SW Roxbury Street. Although businesses have changed over the years, the same buildings still anchor the corner. (Courtesy MOHAI, 83.10.3062.4.)

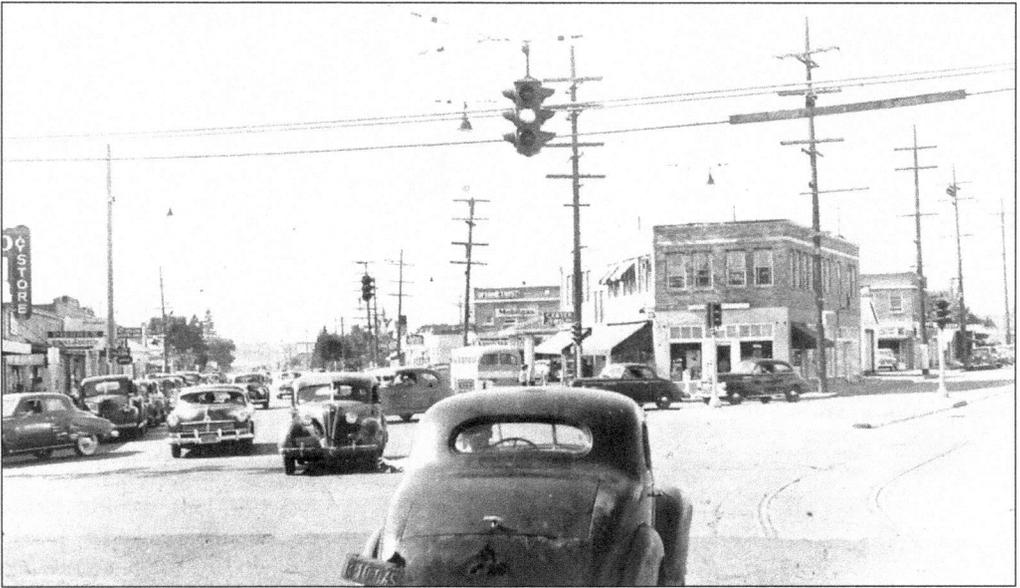

Above is a view looking north on SW Roxbury Street in 1948, Deldridge Way SW is to the left of the stoplight and Sixteenth Avenue SW to the right. The Trinagle building nestled between was originally a single-story building. The Rozella Building, named after Hiram Green's daughter, is behind. SW Roxbury Street is the border between the Seattle city limit and unincorporated King County.

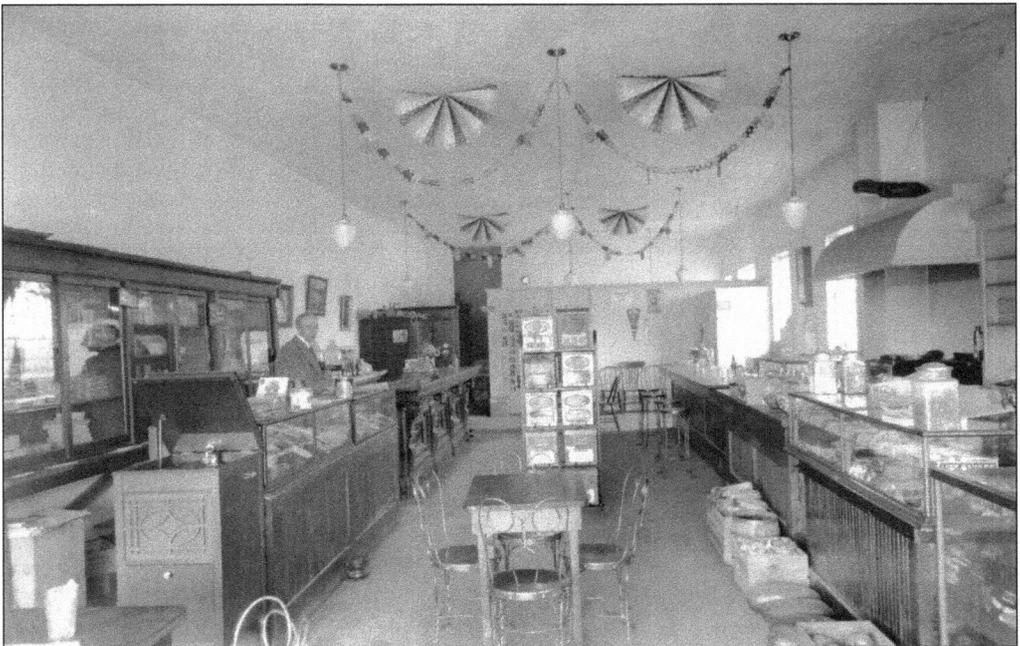

Nelson Van Zile stands behind the counter of the Van Zile Confectionary at Sixteenth Avenue SW and SW Roxbury Street around 1920. His well-appointed establishment included a lunch counter and soda fountain in addition to candy treats. The store was next door to the White Center Theater.

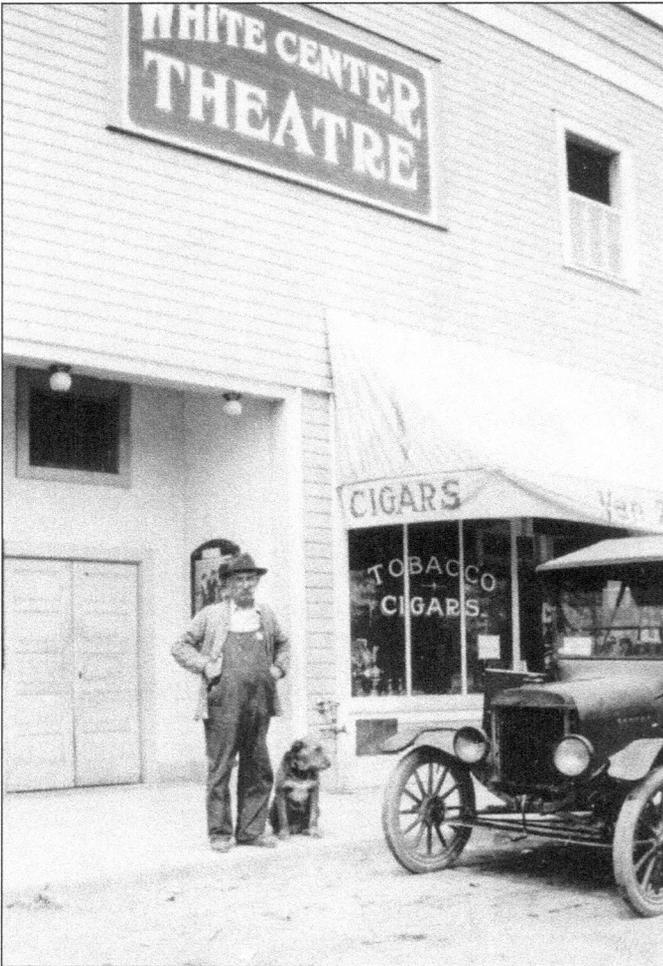

Originally built by Hiram Green in 1916, the theater was owned by George Srigley, founder of the *White Center News*. In 1937, dispirited after being attacked by local "toughs," he sold the theater to printer Walter Coy. Coy remodeled and modernized it, renaming it the White Center Grand (shown below in 1938). In 1942, Coy remodeled and upgraded the theater again, renaming it the Center Theater. The main entrance and lobby were relocated around the corner to 1617 SW Roxbury Street. The theater closed in 1955. (Below courtesy Puget Sound Regional Archives.)

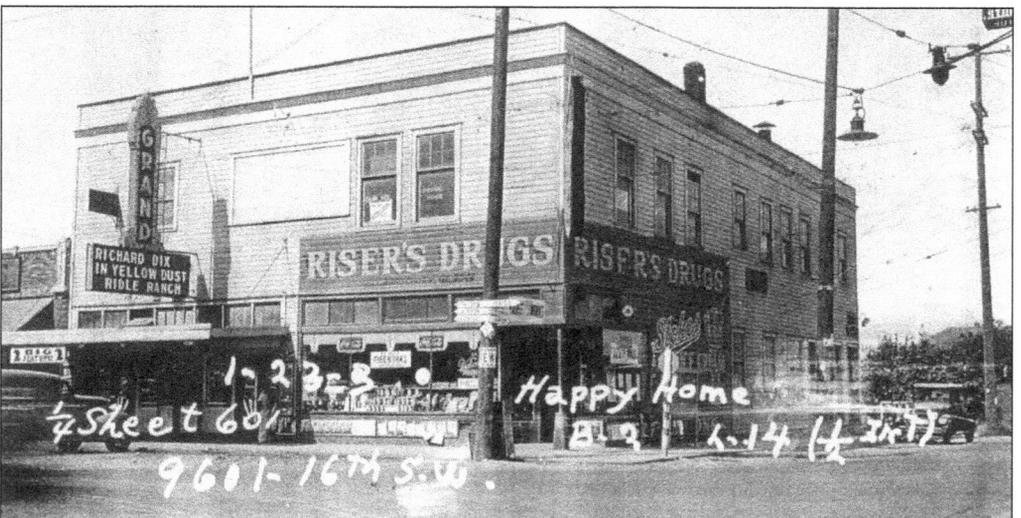

Beginning in the 1880s, the timber around White Center was felled and the subdivided acreage sold. Farming, logging, and shingle mill operations worked the land through the 1920s. This photograph was taken at Twenty-fourth Avenue SW and SW Cloverdale Street in the 1920s.

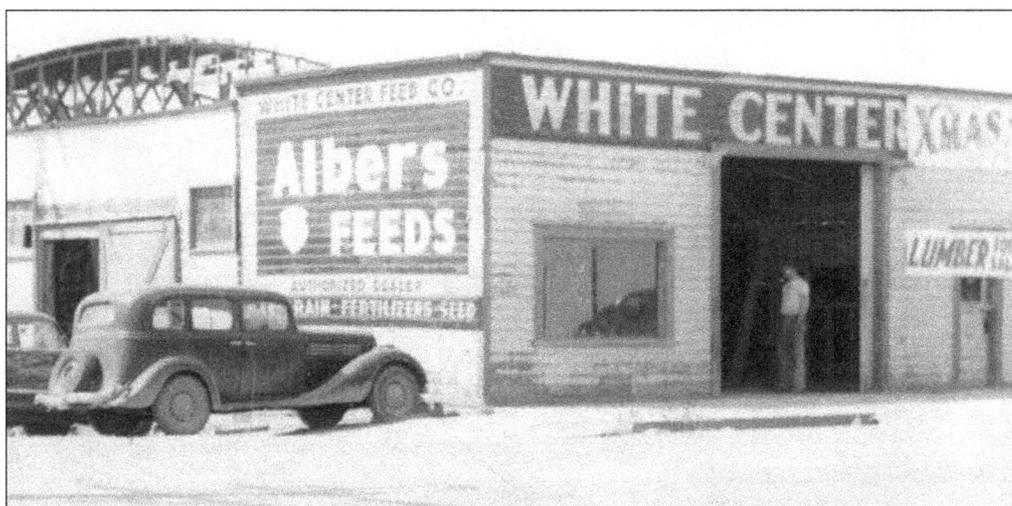

The White Center Feed Store on Sixteenth Avenue SW would supply local farmers with needed feed and seed. Roof framing for the Southgate Roller Rink can be seen in the background. It opened in 1937.

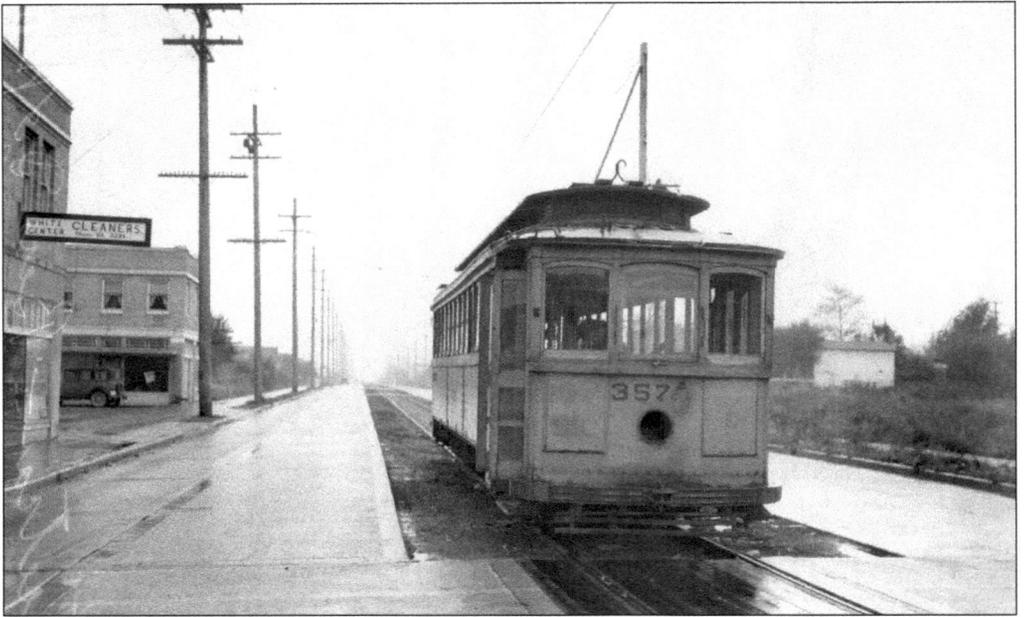

A retired streetcar is used for a bus shelter on Sixteenth Avenue SW, north of SW Roxbury Street, around 1934. Initially the line was the Highland Park and Lake Burien Railway that started service in 1912 to the area north of Lake Burien. The City of Seattle took over the service to White Center in October 1913 and operated it until service was discontinued in 1933. The Rozella Building is on the left, and the empty lot for the Chubby and Tubby store (now Walgreens) is on the right. (Courtesy MOHAI, PI 27181.)

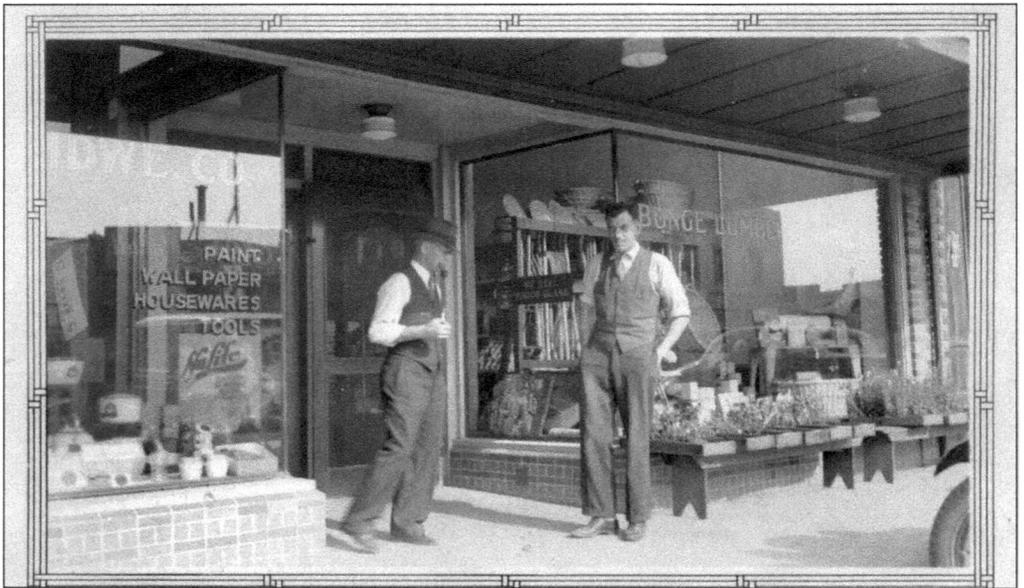

Two men in shirtsleeves and vests stand in the doorway of the Bunge Lumber and Hardware Company at 9616 Sixteenth Avenue SW. Small neighborhood stores carrying a wide array of merchandise from construction materials to household goods and bedding plants were typical of the time.

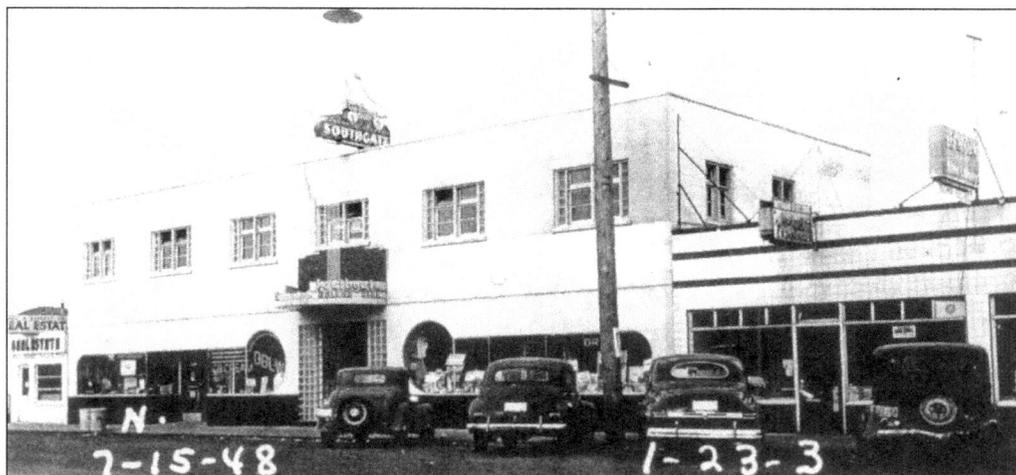

The original Southgate Roller Rink, at 9639 Sixteenth Avenue SW (shown above in 1948), was built by Hiram Green in 1920 as a boxing arena. In 1934, Hiram's daughter Ethel Green and William "Pop" Brown bought the building, converting it three years later from a live music and dancing venue to a roller rink. "Seattle's Friendly Rink" became one of the most popular entertainment spots in Seattle. (Above courtesy Puget Sound Regional Archives.)

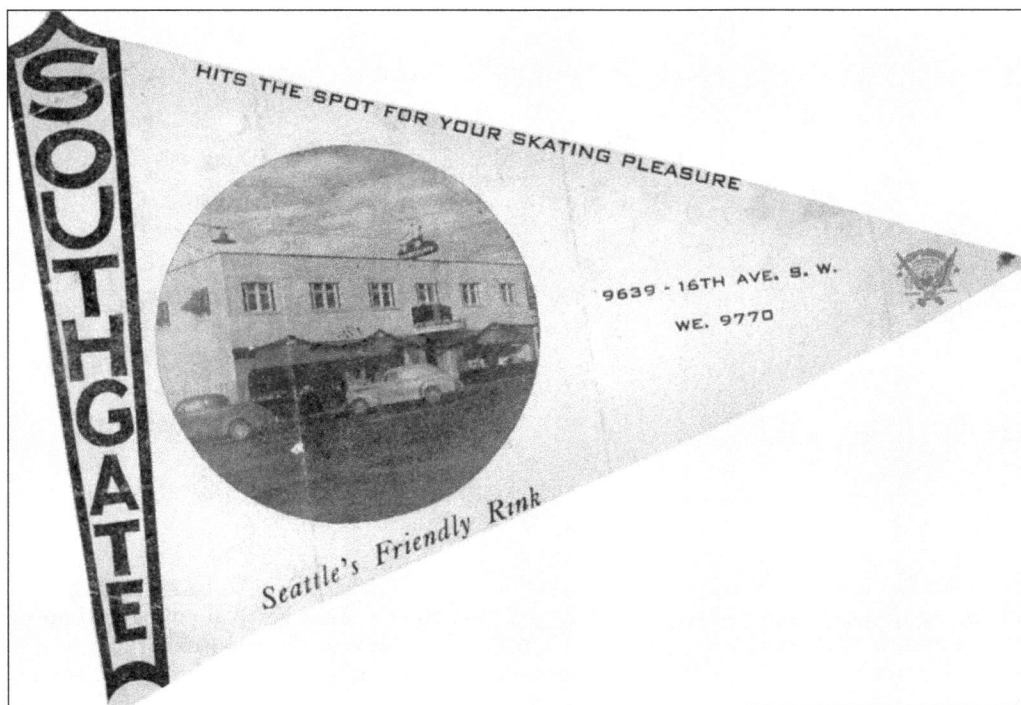

Miss Southwest Seattle and her court of local beauties are shown aboard a parade float around 1940. Several southwest neighborhoods are represented—visible sashes are White Center, Arbor Heights, and Highland Park.

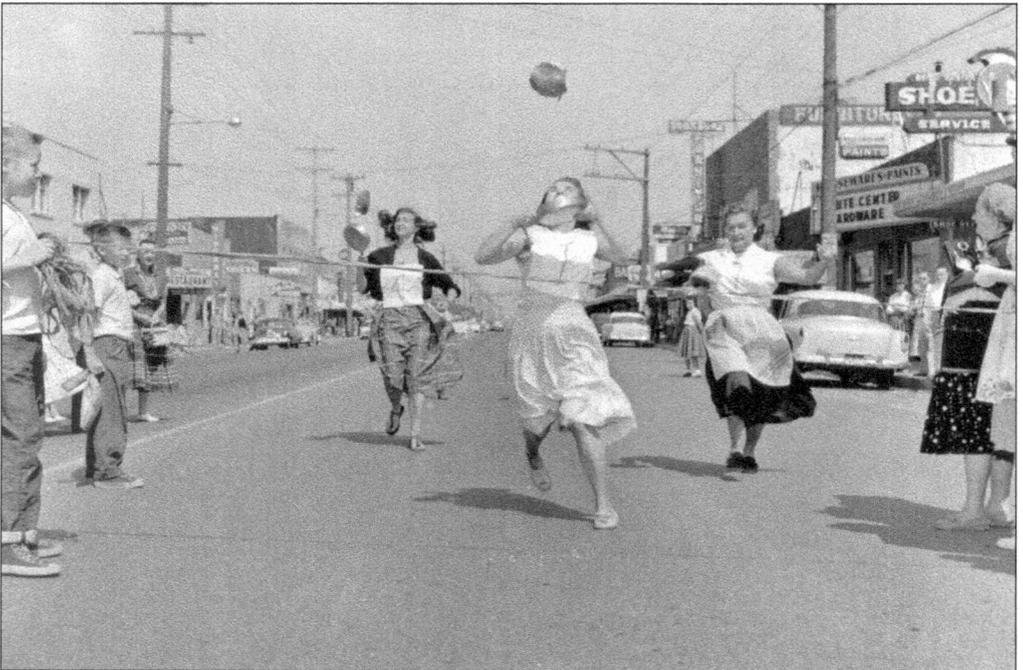

Three competitors approach the finish line during the Pancake Festival pancake flipping race at Sixteenth Avenue SW on August 11, 1956. The Hideaway Tavern, Roxbury Furniture, White Center Hardware, and White Center Shoe Service can be seen on the right. (Courtesy MOHAI, 1986.5.1662.)

The White Center Lions Club chamber music ensemble and singing youngsters, led by a conductor in clown attire, perform for the crowd during the Mardi Gras festival on July 17, 1948. Elliott Couden, White Center businessman and a founding member of the Southwest Seattle Historical Society, is visible far right, standing in the bowler hat.

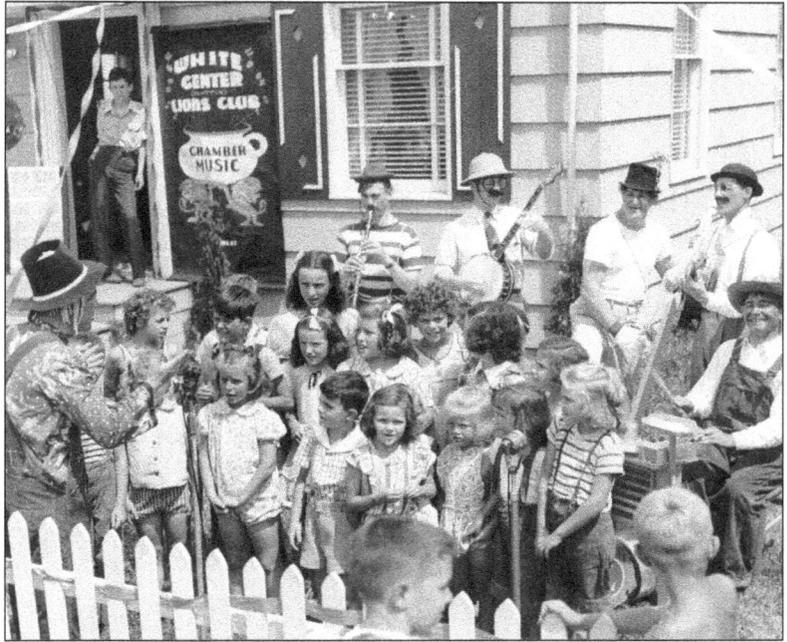

Harold Hopkins (right), a past president of the White Center Lions Club, presents the ownership papers to the lucky winner of a new Ford automobile, the prize in a White Center Boy's Club fund-raising raffle around 1948. The White Center Boys Club had 1,000 junior members ages 11 to 20 and was funded by a collaboration between the Lions Club, the Eagles, Highland Park PTA, Holy Family, and the White Center Commercial Club.

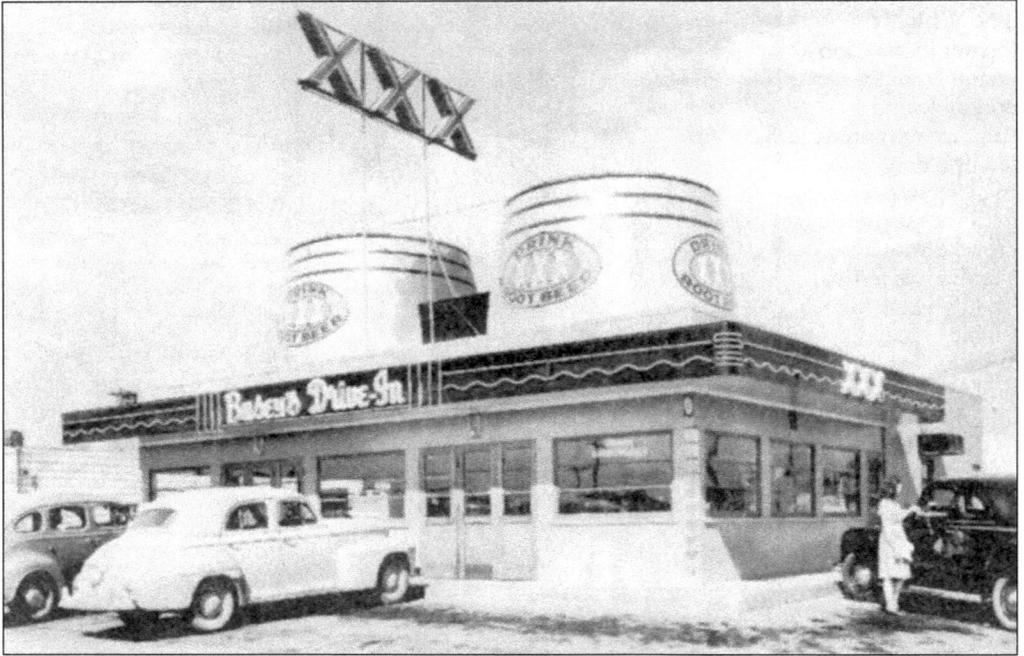

Busey's Drive-In Restaurant was built and owned by H. Richard Busey between 1941 and 1955. The Triple X drive-in, which featured carhops, was a westside favorite. The business was converted to a dine-in restaurant in 1955. It was sold to Marv Mosely in 1975 and remains as Marv's Broiler.

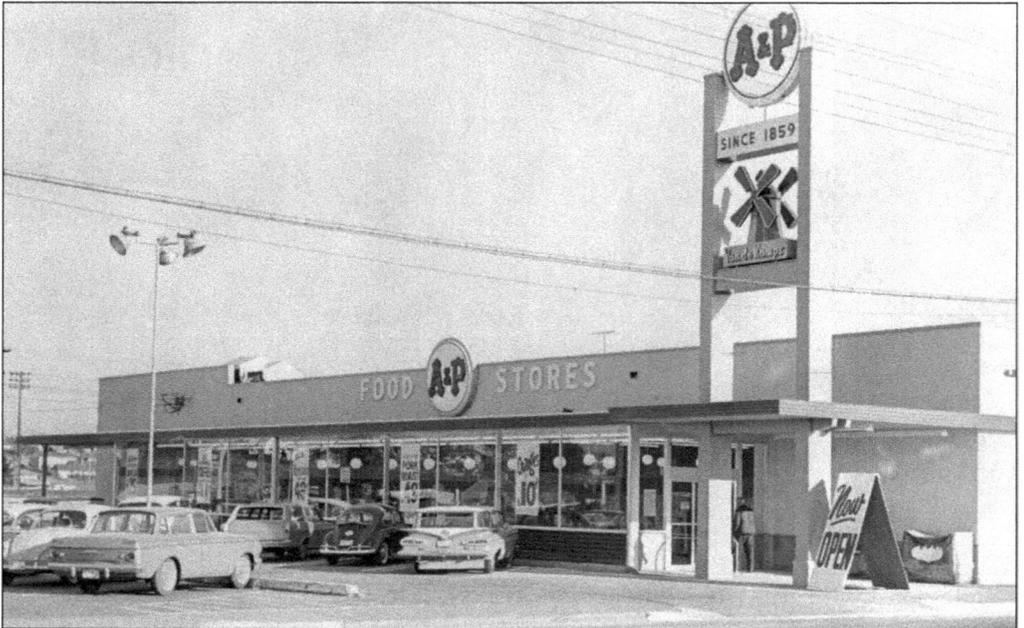

Note the food prices posted in the windows of this busy A&P food store at 10210 Sixteenth Avenue SW in 1960. Pay N' Pak Hardware later replaced the A&P. Pay N' Pak remodeled and enlarged the building considerably. It is now McLendon Hardware.

Seven

YOUNGSTOWN AND RIVERSIDE TO DELRIDGE

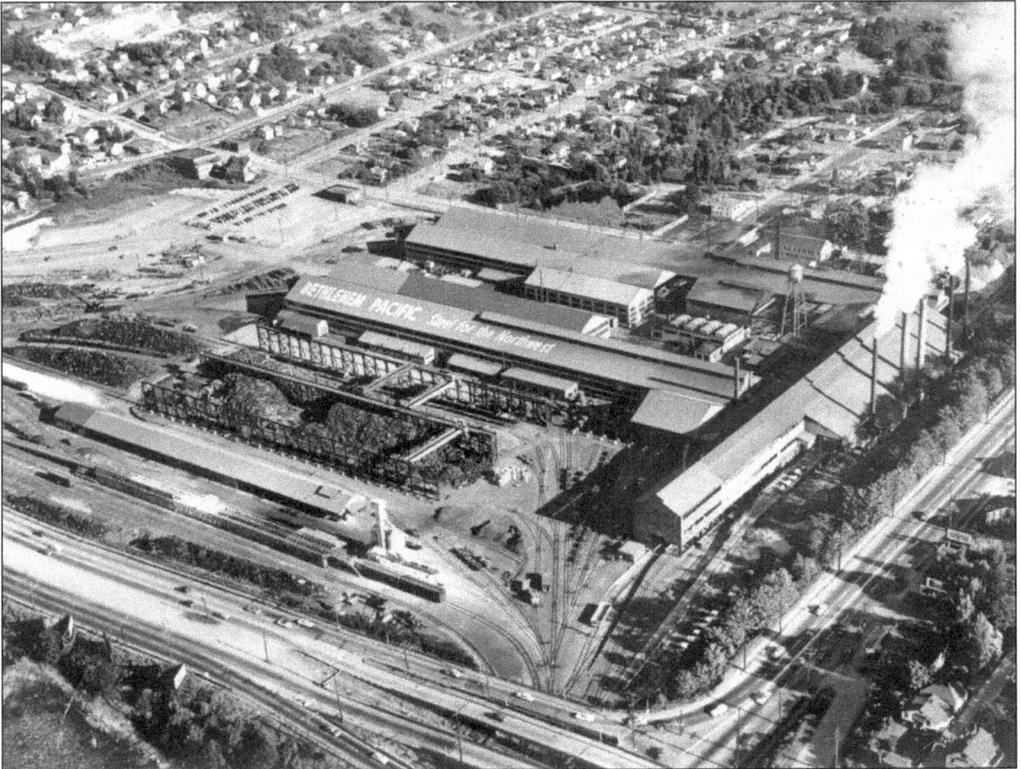

Located just south of SW Spokane Street, the Bethlehem Steel Plant opened in 1905 in the area known as Youngstown. It was originally the Seattle Steel Company and employed 140 workers. Rolling iron bars and rails, it began full steel production when an open-hearth furnace was installed in 1915. The "Youngstown" name was chosen to emulate Youngstown in Ohio, a city famous for its steel production.

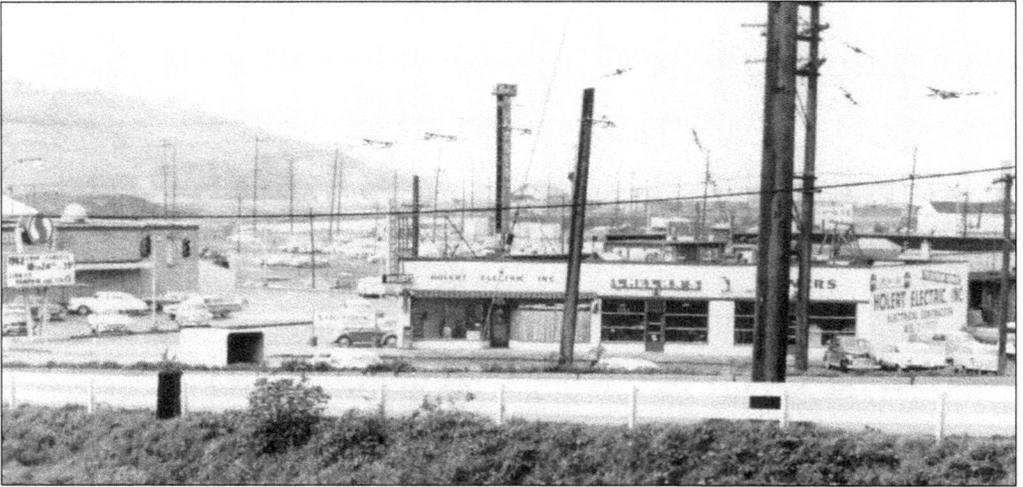

The Chelan Café, looking northwest near SW Spokane Street and Twenty-second Avenue SW around 1962, is the very last of what was once a bustling business district along SW Spokane Street. Most businesses were forced to move when the West Seattle Freeway was built in 1965. Today the Chelan Café has taken over the space shown occupied by Holert Electric.

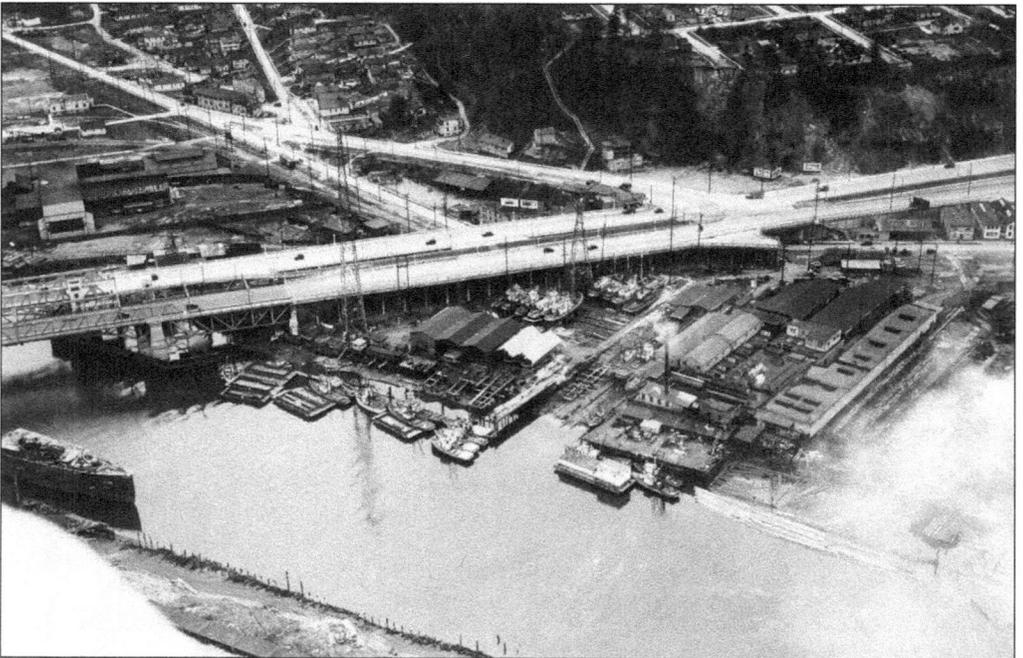

Tucked up against the east side (left on the photograph) of Pigeon Point is the community of Riverside. Started as a residential community, many of the homes have made way for industry. Riverside had a large Croatian population who fished the nearby waters and was put on the literary map by northwest author Richard Hugo.

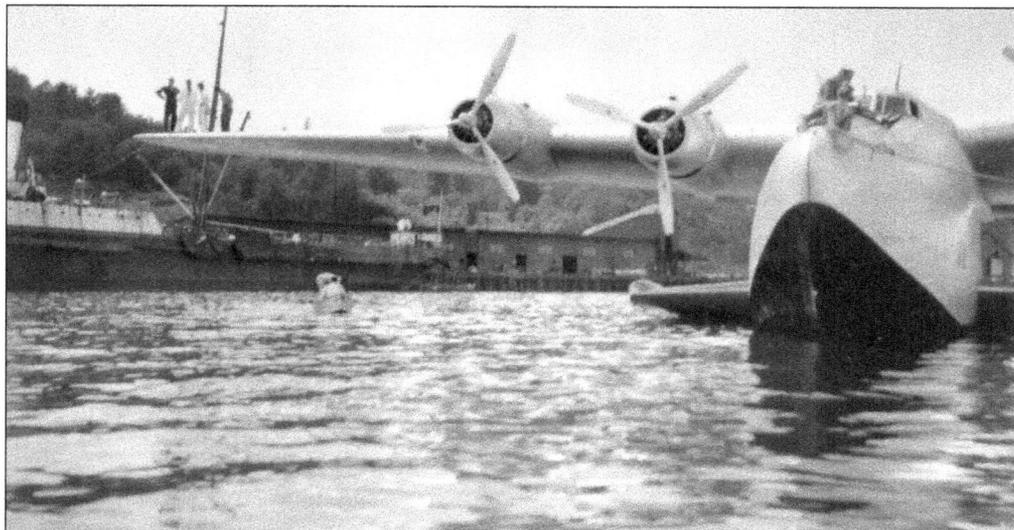

A Boeing 314 clipper flying boat is moored along Harbor Avenue SW in the 1930s. Built at Boeing's Plant 1, the clippers were barged north on the Duwamish River (barely clearing the Spokane Street Bridge piers) for engine and taxi tests on Elliott Bay.

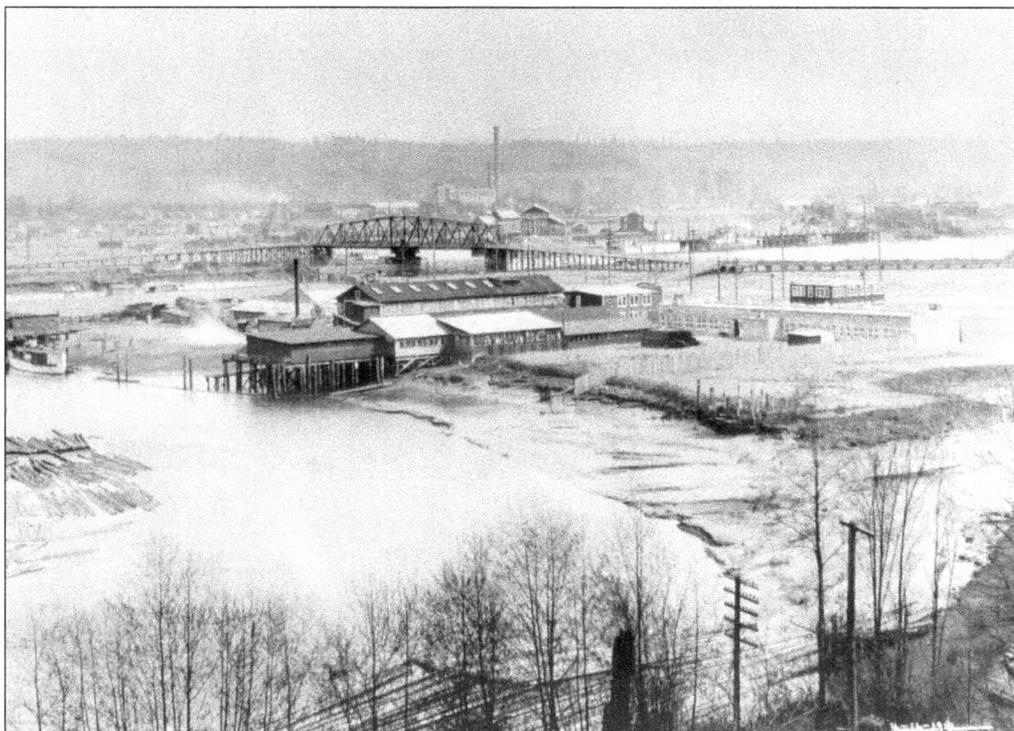

This is Boeing's first plant on the Duwamish as it appeared on April 10, 1918, looking east from "Boeing Hill." Originally the plant was called the "Oxbow" after its Duwamish River location. A World War I seaplane contract launched Boeing as a major military aircraft manufacturer. After World War I, and the loss of wartime business, non-aircraft items such as furniture and phonograph cases were manufactured to keep solvent. (Courtesy MOHAI, SHS17645.)

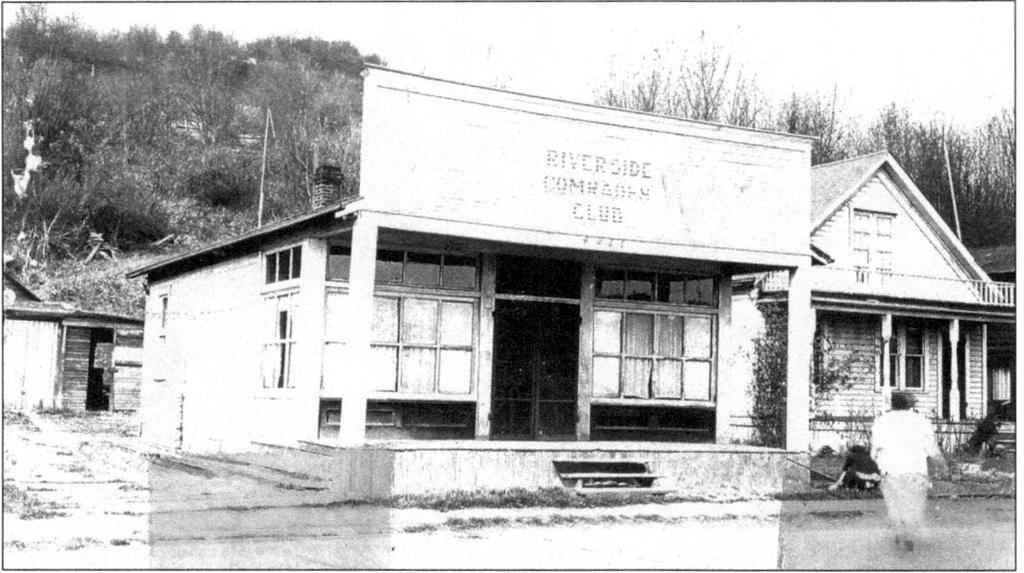

The Riverside Comrades Club was located on West Marginal Way SW. The building dates back to 1917, the time of the Russian Revolution and two years before the Seattle General Strike. This photograph is from the 1930s.

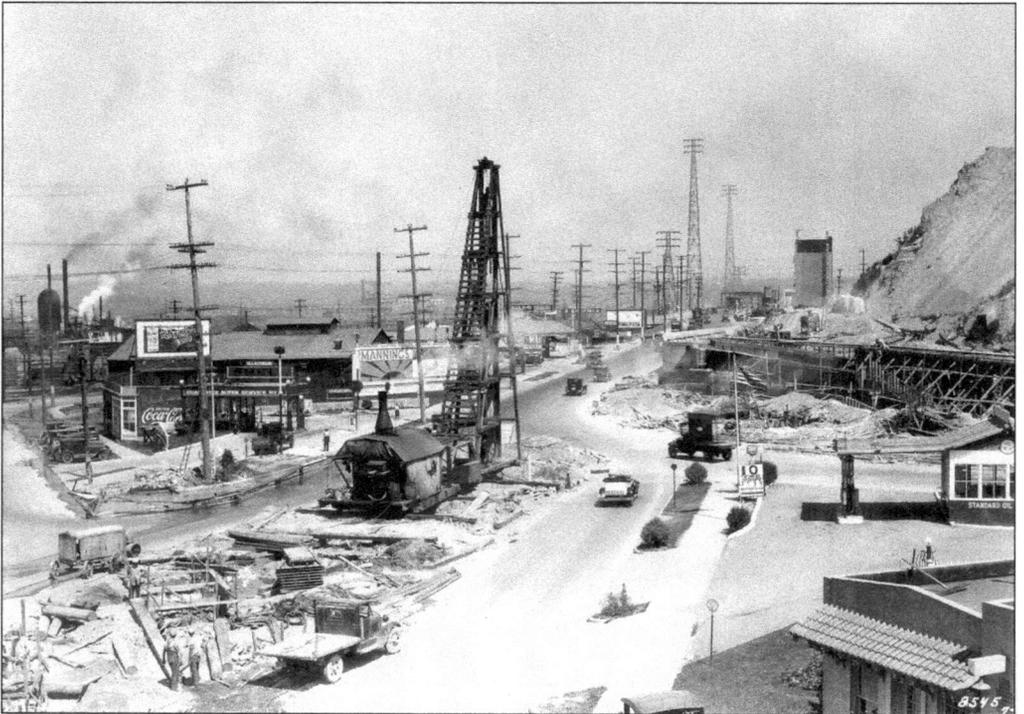

Construction on SW Spokane Street and Twenty-third Avenue SW is shown here in July 1930. On the right is the newly built Spokane Street Bridge No. 2, which was opened to vehicle traffic in September of that same year. The pile driver is constructing footings for a concrete streetcar viaduct that extended to the two Spokane Street bridges.

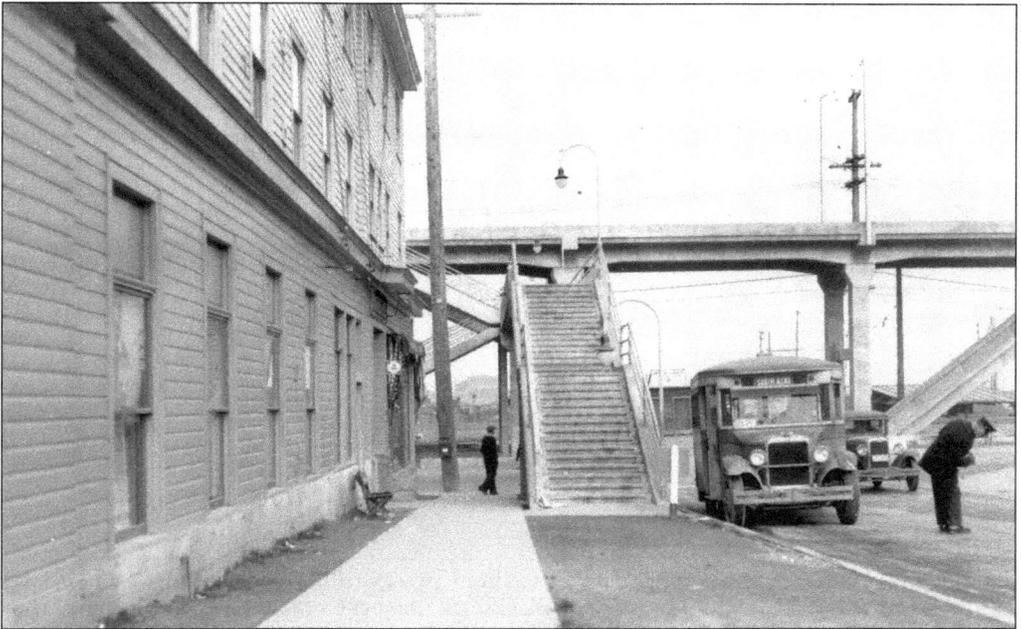

This is a view looking north on Twenty-third Avenue SW toward SW Spokane Street in November 1930. The stairs leading up to a pedestrian overpass connect to the streetcar station on the viaduct. Buses, such as the one in the photograph to South Alki, had begun transporting passengers to areas around Seattle that were not served by the streetcars.

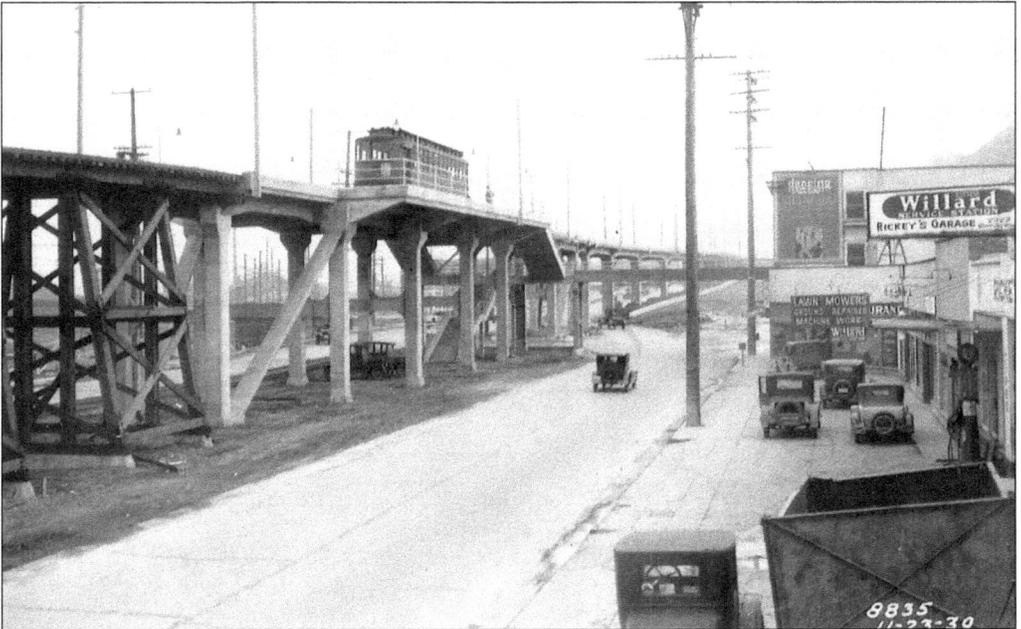

The newly completed Youngstown Place streetcar trestle is shown here in November 1930. Youngstown had a thriving business community up until the mid-1960s. The streetcar trestle avoided the traffic congestion caused by cars or trains on SW Spokane Street. In 1948, eight years after the last streetcar line serving West Seattle was discontinued, the viaduct was demolished.

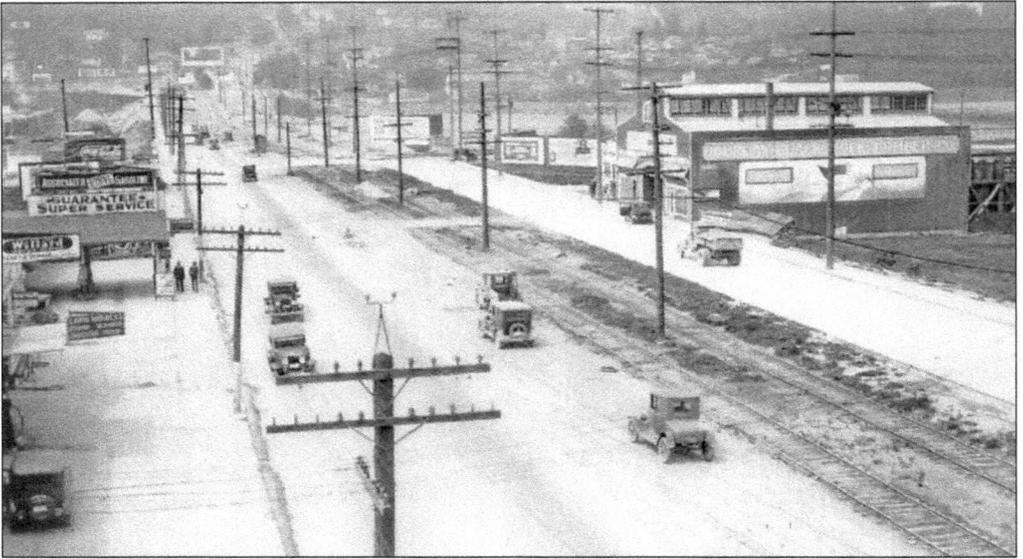

This view is looking west on SW Spokane Street from Twenty-third Avenue SW in Youngstown's business district in April 1930. The Gourlay-Blackstock Lumber Company, which advertised they had "everything in lumber that you may need here in West Seattle," is on the right.

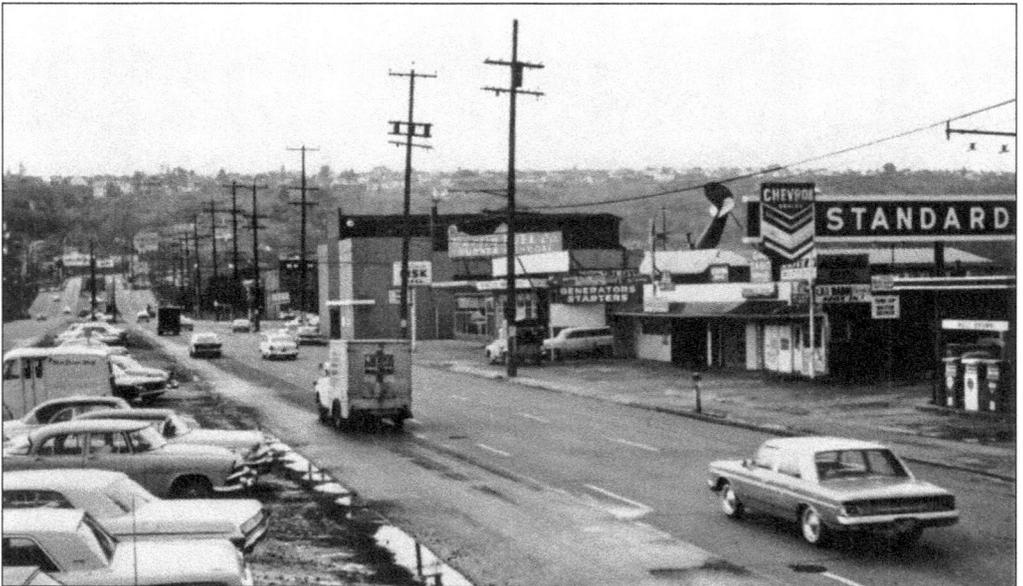

The north side of the SW Spokane Street business district is shown looking northwest in November 1962. Virtually all the businesses, such as Ace Auto Electric, Martin Fuel Company, and the Blackstock Lumber Company, no longer exist. In fact, the only business that remains from that era is the Chelan Café.

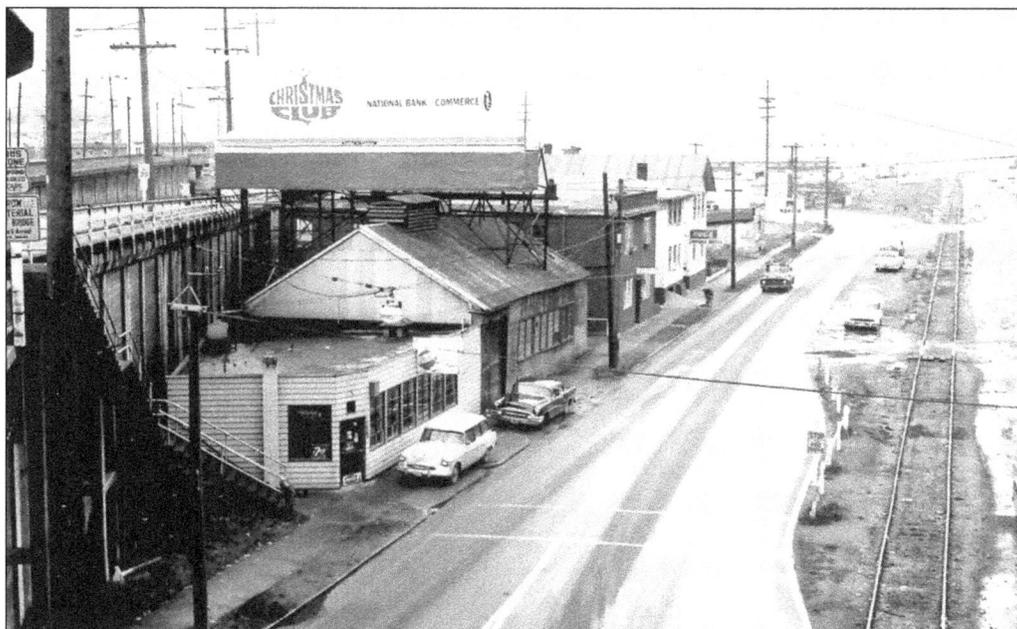

Stairs from the Spokane Street Bridge lead down to the National Tavern. In 1962, the Bridge Hotel was just up the street at 3525 SW Iowa Avenue. This business area no longer exists.

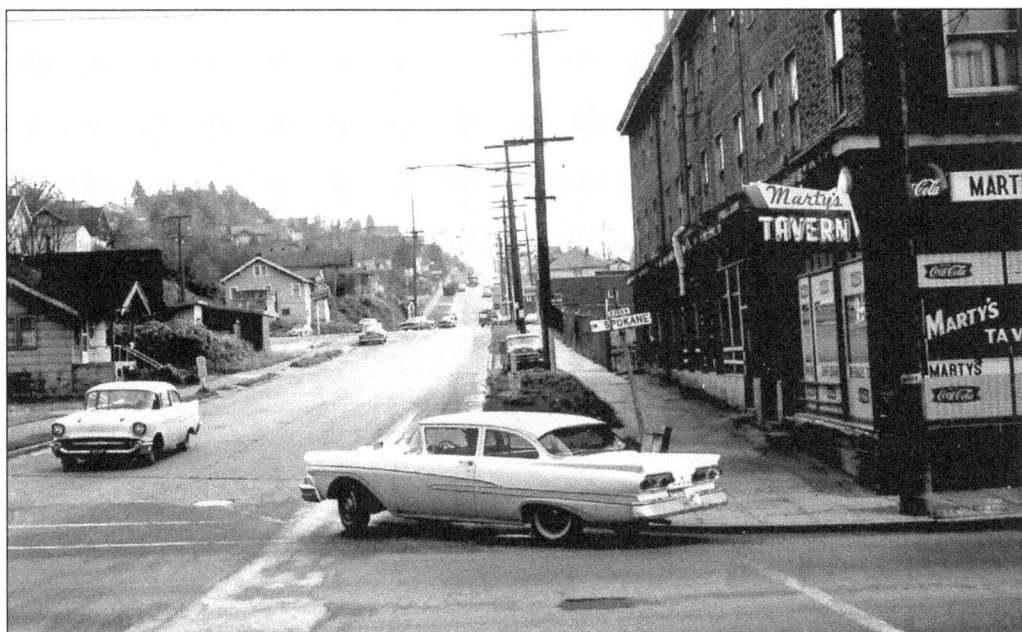

In November 1962, looking south from Twenty-third Avenue SW and SW Spokane Street, many of the businesses along SW Spokane Street, such as Marty's Tavern, were later torn down to accommodate the new, elevated West Seattle Freeway. The new roadway was completed in 1965.

The neighborhood street condition after a heavy rainstorm and landslide is shown looking south on Twenty-second Avenue SW from Charleston Place (now SW Charleston Street) on February 8, 1926. This was a strong incentive for pavement. (Courtesy Seattle Municipal Archives, No. 2588.)

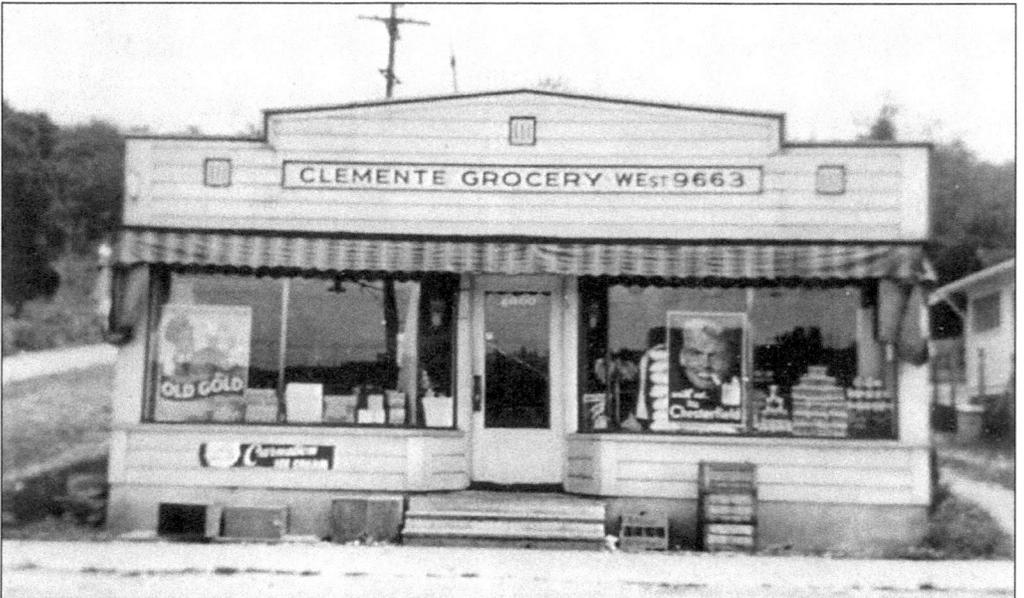

Opened by Saraca and Lydia Clemente in 1936, the Clemente Grocery was a community fixture. In 1938, they expanded their store and inventory as Depression-era waist-tightening eased. Neighborhood parents would send their children to wait for the school bus in front of the store under the watchful eye of Lydia, known affectionately by everyone as "Ma." The building still stands at 4800 Delridge Way SW.

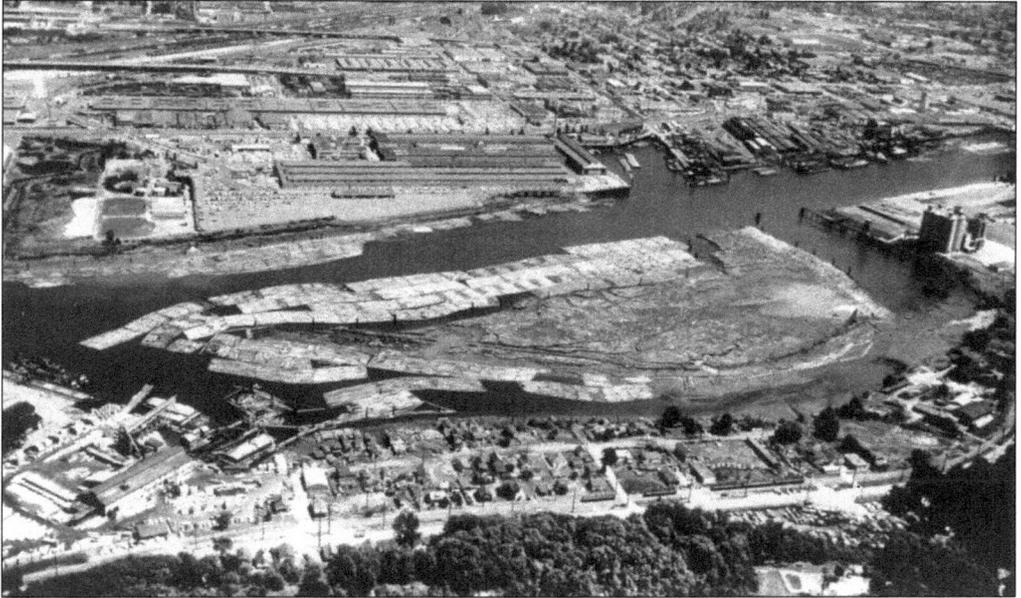

In this 1960s aerial view of south Riverside, with Kellogg Island visible in the background, the community shown along the river is now the site of T-107 Park. In the late 1970s, construction by the Port of Seattle was halted at the site when archaeological discoveries were unearthed. Several indigenous villages existed at the site from about 728 to 1758 AD, making T-107 important to the cultural heritage of the Duwamish people.

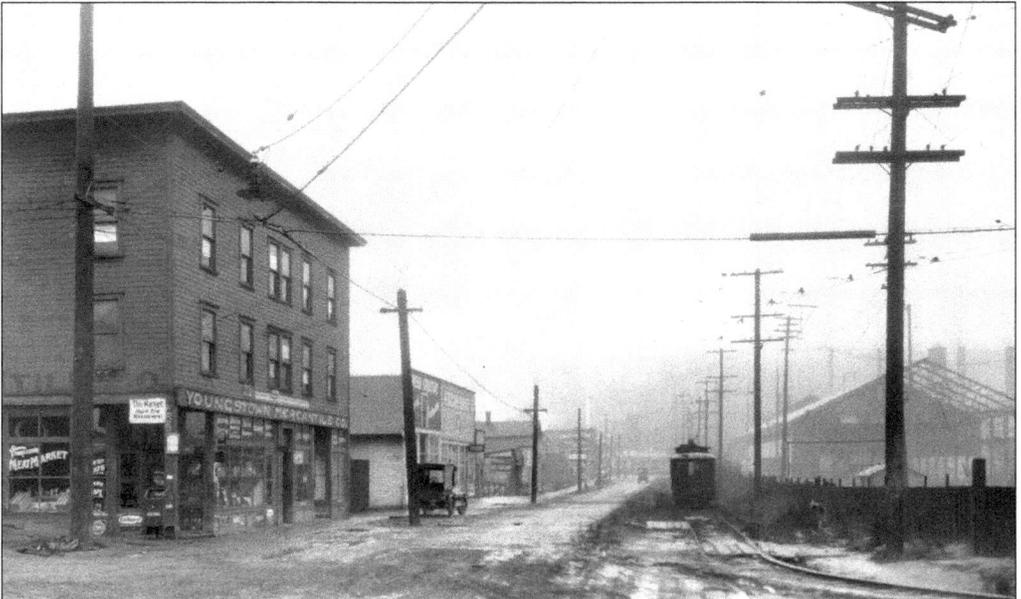

The Youngstown Mercantile Company is shown looking west on SW Andover Street from Twenty-sixth Avenue SW around 1918. It was built in 1911 and began as a general store in the Youngstown neighborhood. The streetcar on the right served the Alaska Junction to the west and ran through what is now the West Seattle Golf Course. The buildings on the right are part of the Pacific Coast Steel Mill. (Courtesy MOHAI.)

The Frank B. Cooper School, on Delridge Way SW, is shown in the photograph above in 1960. The first school in the Youngstown community opened in 1905 in a one-room building provided by the Seattle Steel Company and on its property because the majority of the children attending were from its workers' families. The photograph below shows the Youngstown School (left), which was built by the Seattle School District; it opened in 1907. The third Youngstown School, the large brick structure on the right, opened in 1917. In 1939, the school was renamed in honor of Frank B. Cooper, a past superintendent of Seattle schools. The school closed in 1989, and in 1999, the building reopened as the Youngstown Cultural Arts Center.

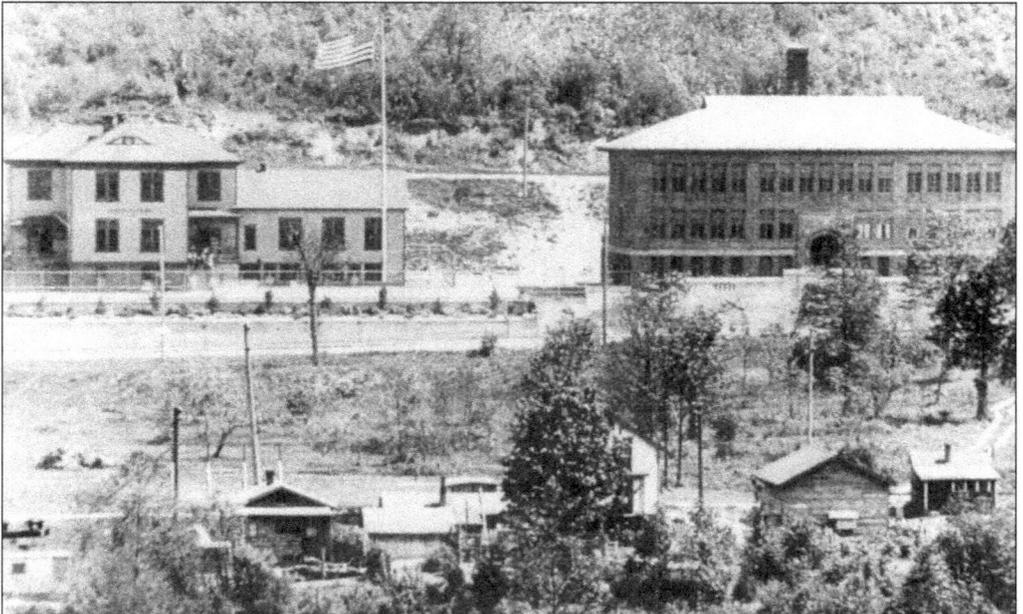

Eight

COMMUNITY

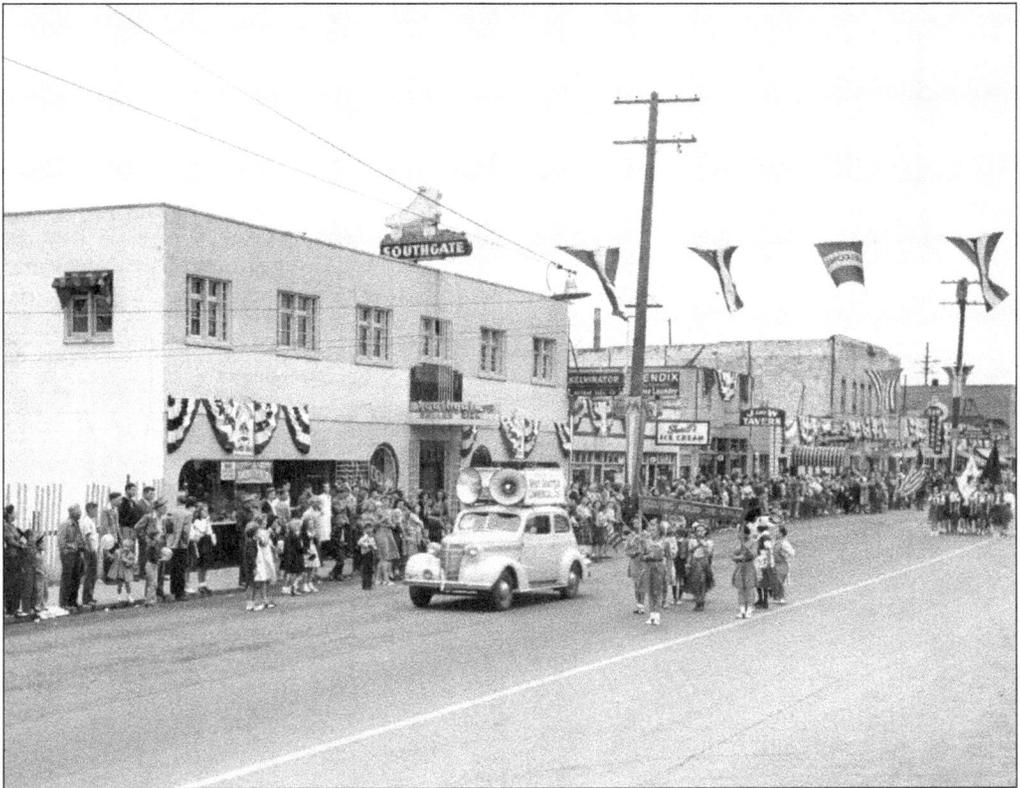

The White Center Mardi Gras parade comes back to life in 1947 after an 11-year absence. The event included flower shows, carnival rides, and Wild West horseback riding by the South Seattle Saddle Club. This view looks north along Sixteenth Avenue SW.

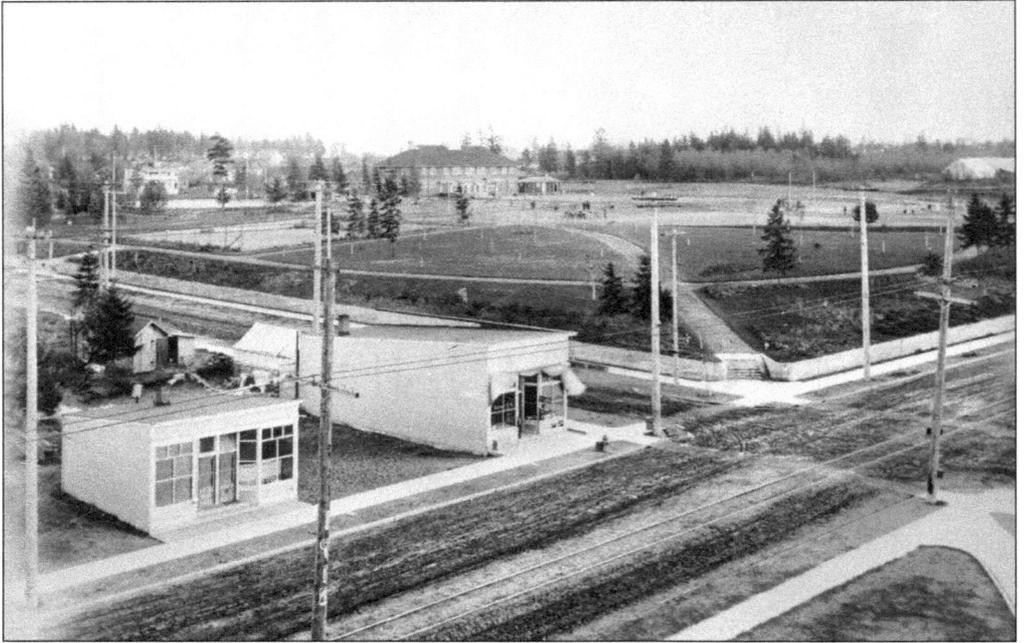

John Olmsted, the son of the famed Frederick Law Olmsted who designed New York's Central Park, laid out Hiawatha Playfield, shown in the photograph above around 1911, as part of a planned network of Seattle parks. It opened in 1910, and at the time it was the largest playfield in the city. In 1911, a field house (later renamed a community center) became the first public recreation building in Seattle. Gym classes and school dances were held at the center and playfield. The photograph below shows a May Day celebration in 1914. Students from schools all over West Seattle would attend the May fete, and girls would wind bright streamers around the maypole, wrapping it in a colorful pattern. During World War II, between 140 and 160 soldiers camped in tents on the playfield, and officers used the field house as a defense headquarters to guard against possible air attacks on Boeing and the Duwamish shipyards. (Courtesy Seattle Municipal Archives, No. 29297 and No. 29274.)

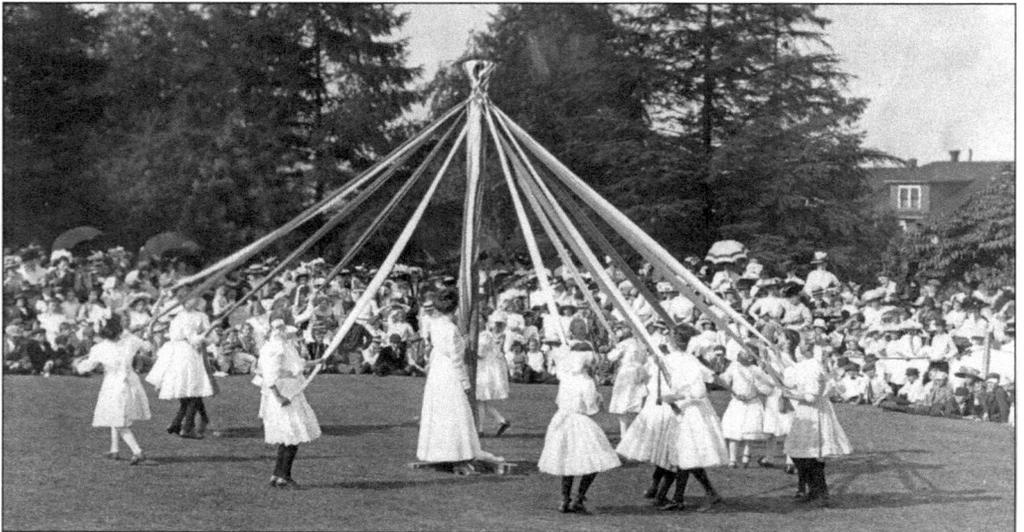

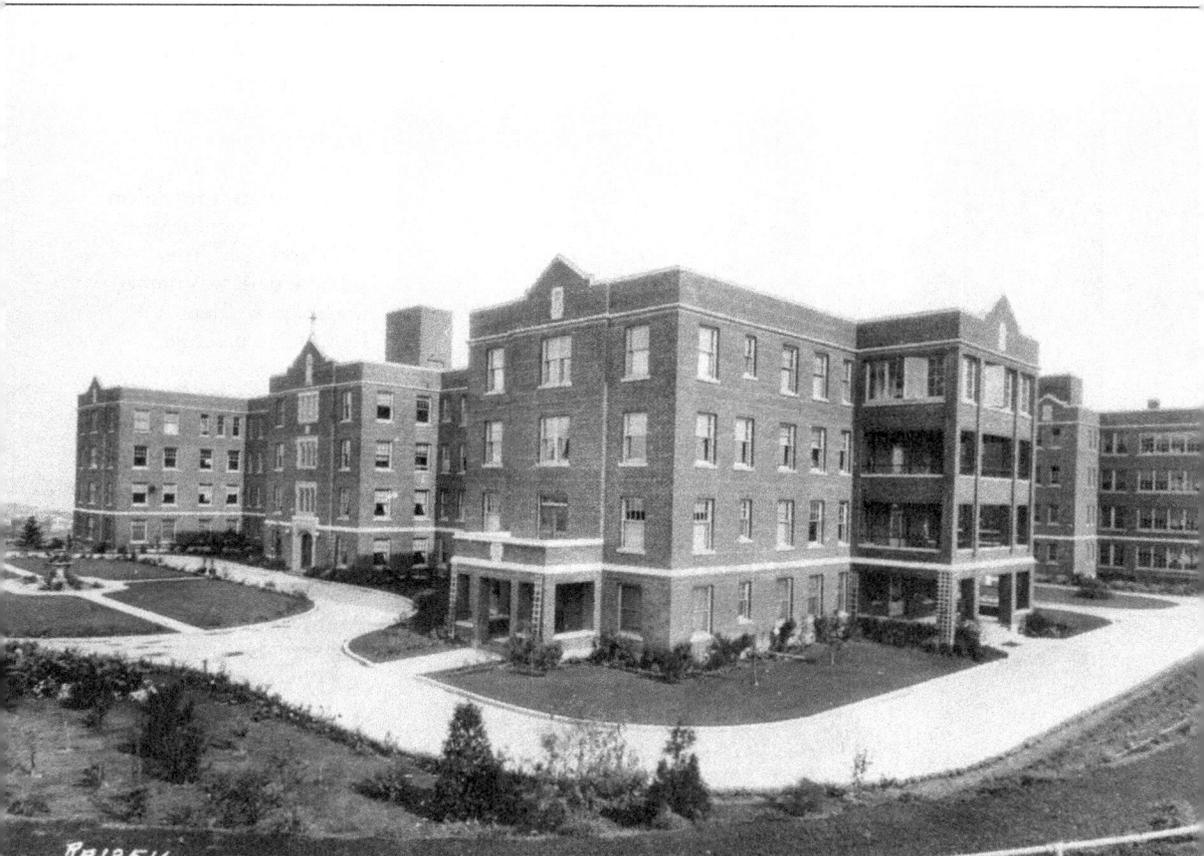

The beautiful grounds and building of Saint Vincent Home for the Elderly, now called Providence Mount Saint Vincent, are shown as they appeared around 1924. The complex had sweeping views and included an orchard and several ponds. The original home was established in Vancouver, Washington Territory, and relocated to the current location in West Seattle on January 25, 1924. (Courtesy Providence Mount Saint Vincent.)

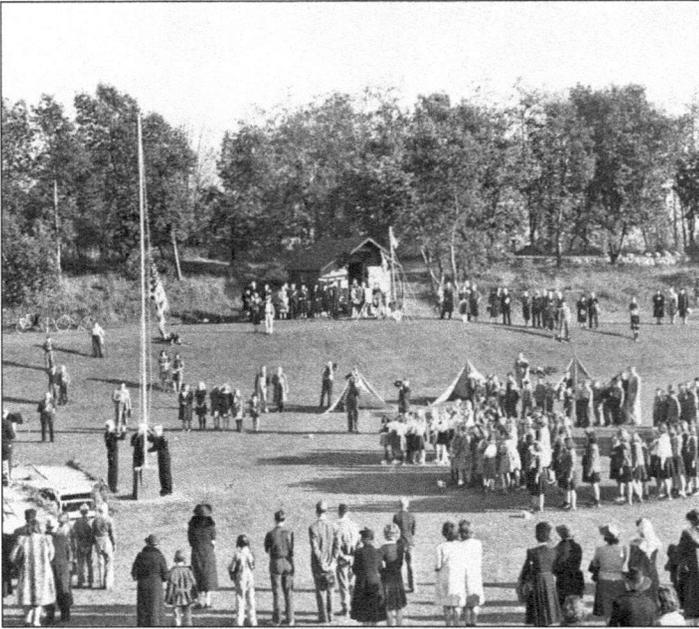

First Lady Eleanor Roosevelt attended the 1941 dedication of Camp Long after visiting it during the planning stages. Built as a Works Progress Administration (WPA) project between 1937 and 1940, the 68-acre park was named for Judge William G. Long, a juvenile court judge and strong youth advocate. Clark Schurman, a nationally known mountain climber and scoutmaster, designed the park along with Ben Evans of the Seattle Parks Department. (Courtesy Seattle Municipal Archives, No. 30573.)

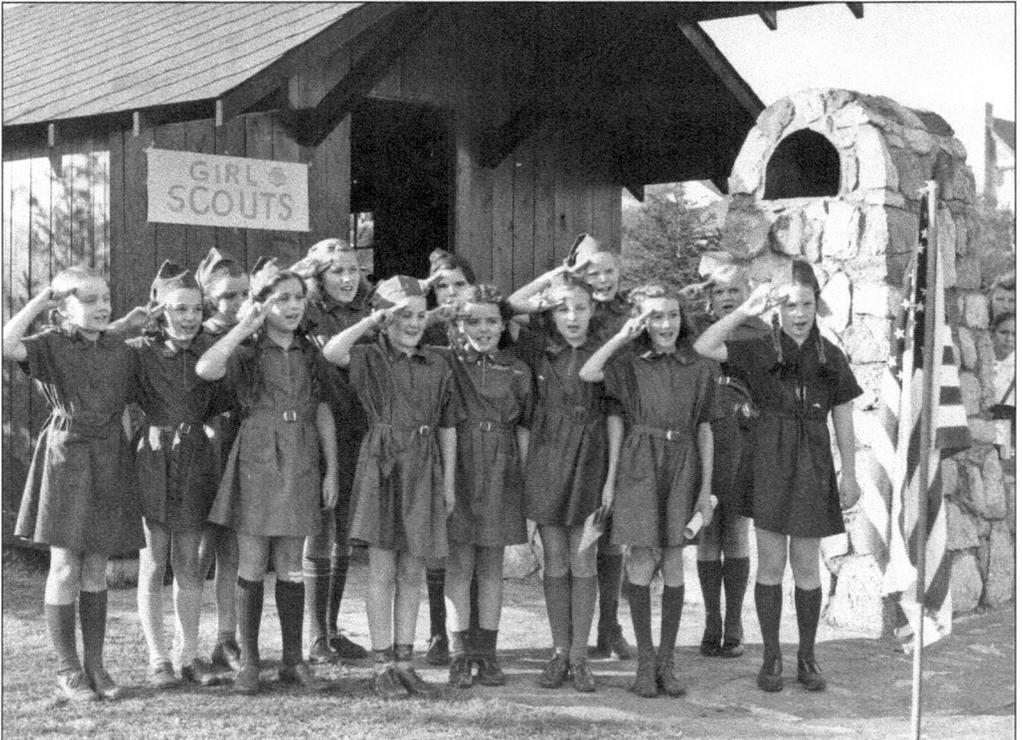

Girst Scouts salute the U.S. flag at Camp Long in the late 1950s. They stand in front of one of 10 arts and crafts rustic-style cabins that were built in 1938. Camp Long, the West Seattle Golf Course, and the West Seattle Stadium were all WPA projects. Lumber from dismantled local buildings was recycled to erect these structures.

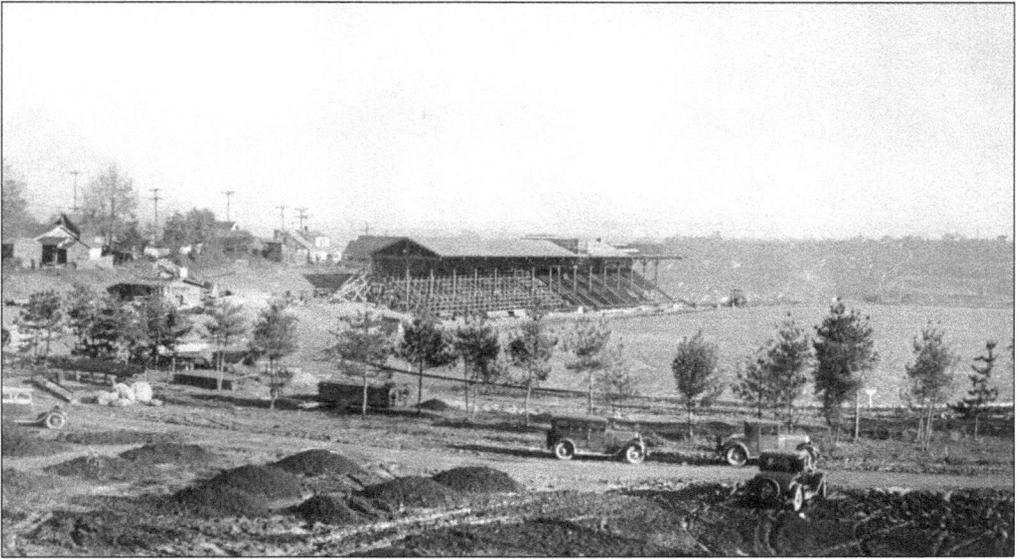

West Seattle Stadium, shown here in 1937, was originally intended for the Camp Long site. The West Seattle Athletic League played the first football game at the stadium in 1938 before its completion in 1939. The original grandstand on the north side of the field is still standing, but the wooden bleachers were replaced by concrete ones in 1961. (Courtesy Seattle Municipal Archives, No. 30646.)

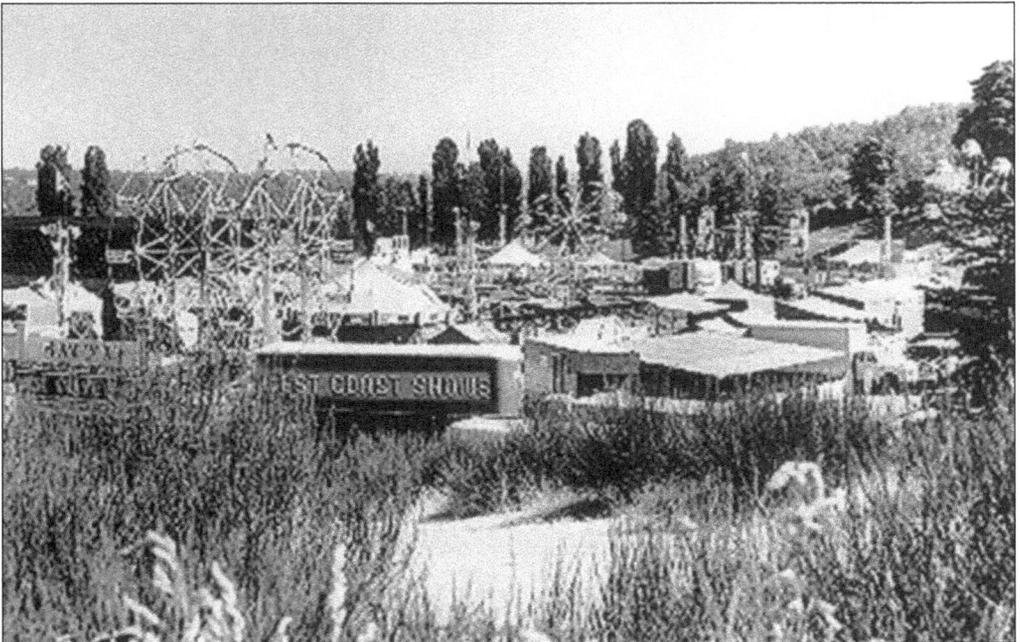

This view is of the Hi-Yu Carnival at the West Seattle Stadium in 1960. The carnival started at the West Seattle Stadium in 1951 and was an annual event until 1984. The weeklong carnival included rides, games, booths, and wrestling matches. After the grand parade, drum and bugle corps would assemble at the stadium for a competition, which was followed by a big fireworks display. (Courtesy Seattle Municipal Archives, No. 30679.)

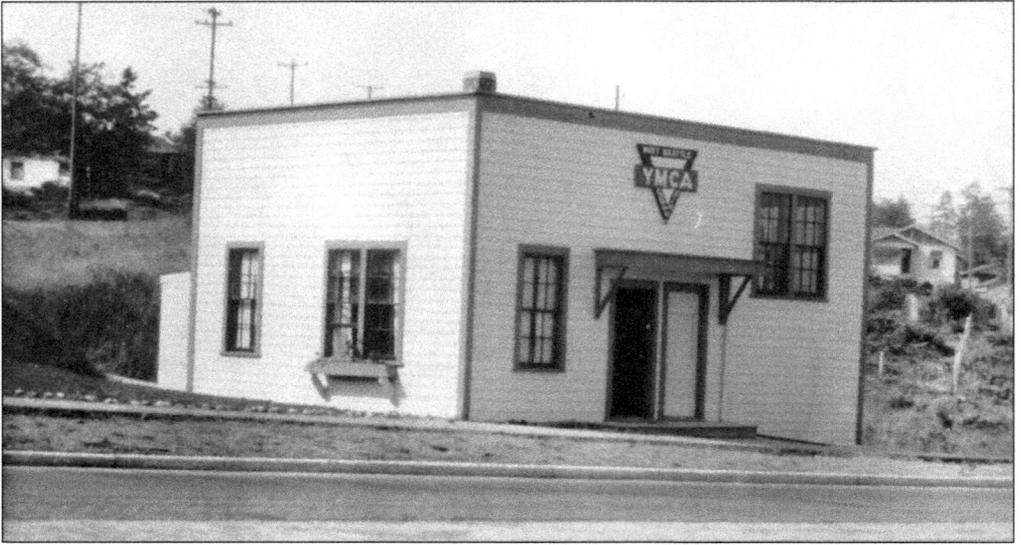

Dubbed the "Cheese Box," this YMCA building at Thirty-ninth Avenue SW and Fauntleroy Way SW is shown here around 1930 and opened on February 2, 1925. This building later expanded to include an outside playfield and tennis court.

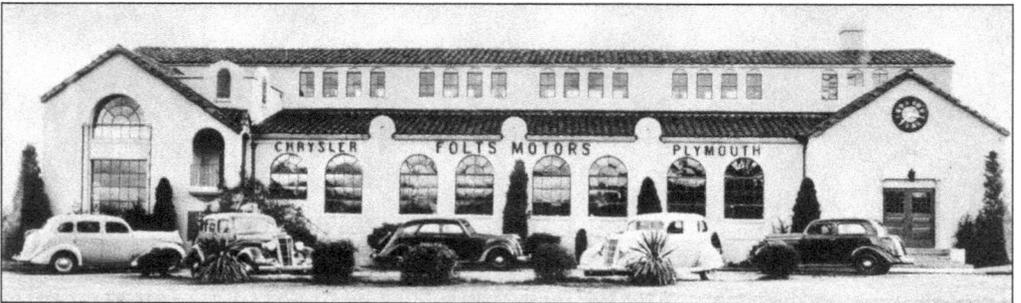

The Folts Motors building, shown here in 1935, was originally part of the West Seattle Dairy and became the home of the YMCA in 1942. The YMCA paid just $15,000 to acquire the building, though it was worth $135,000. After the building was demolished, the site would later become Huling Brothers Chrysler-Jeep.

Two young YMCA members gather bars of soap to sell and earn their way to summer camp, around 1960. The West Seattle "Y" would finally include activities for girls in 1943.

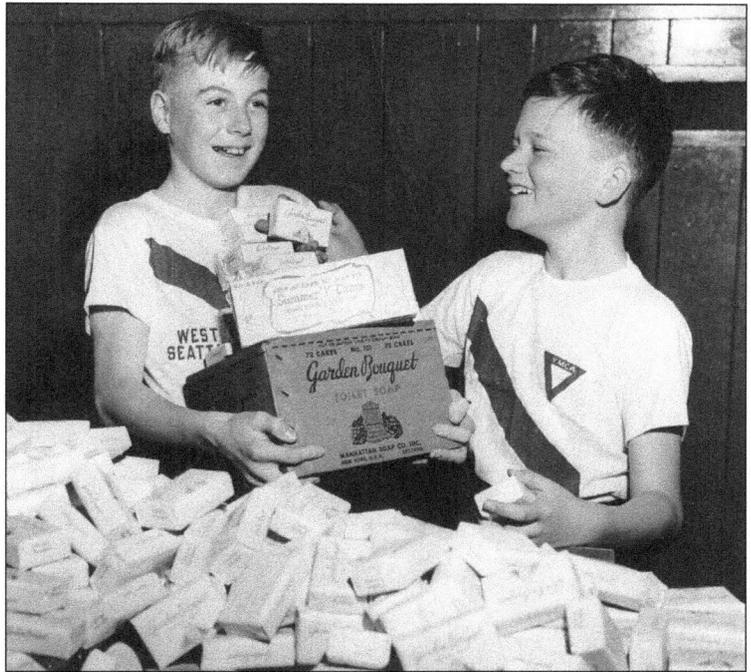

The purpose of the YMCA in 1922 was to "stimulate the growth of its youth into better manhood through clean and wholesome recreational activities." Activities would eventually include basketball, swimming, and shop classes in the 1960s.

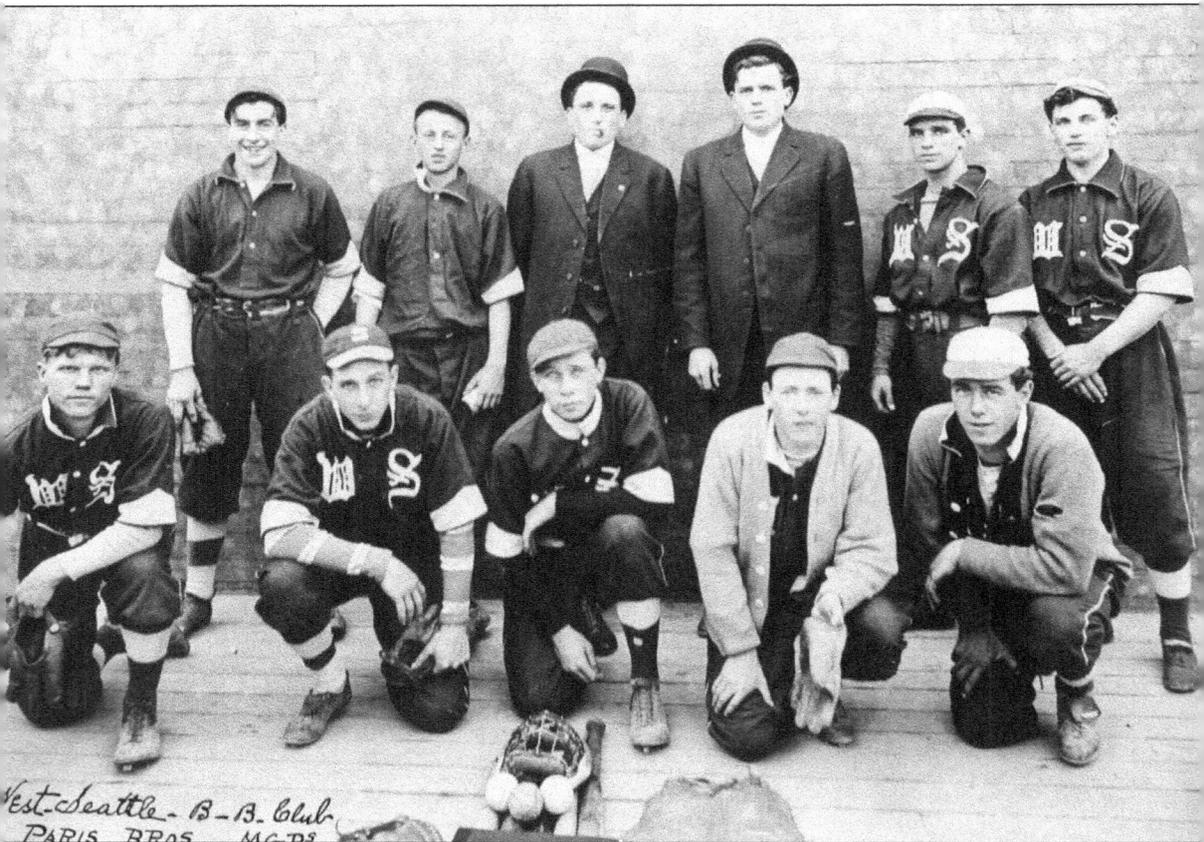

West Seattle B.B. Club
Paris Bros Mgrs

This tough-looking group of West Seattle Baseball Club players was managed by the even tougher appearing Paris brothers—Ben and Jack in the center of the second row.

This is a view looking down a trail at Schmitz Park around 1910. Ferdinand Schmitz acquired land in 1887 and saved it from being logged off. In 1908, he and his wife, Emma, donated 30 acres of their land to the City of Seattle under the provision that it be preserved to represent the original forest "cathedral" the settlers found when they first colonized the area.

The Schmitz estate home, located on the hillside now within Me-Kwa-Mooks Park, was also named *San Souci*, which is French for "without worry." Beach Drive area residents relax on the Schmitz family yacht *San Souci II* around 1920.

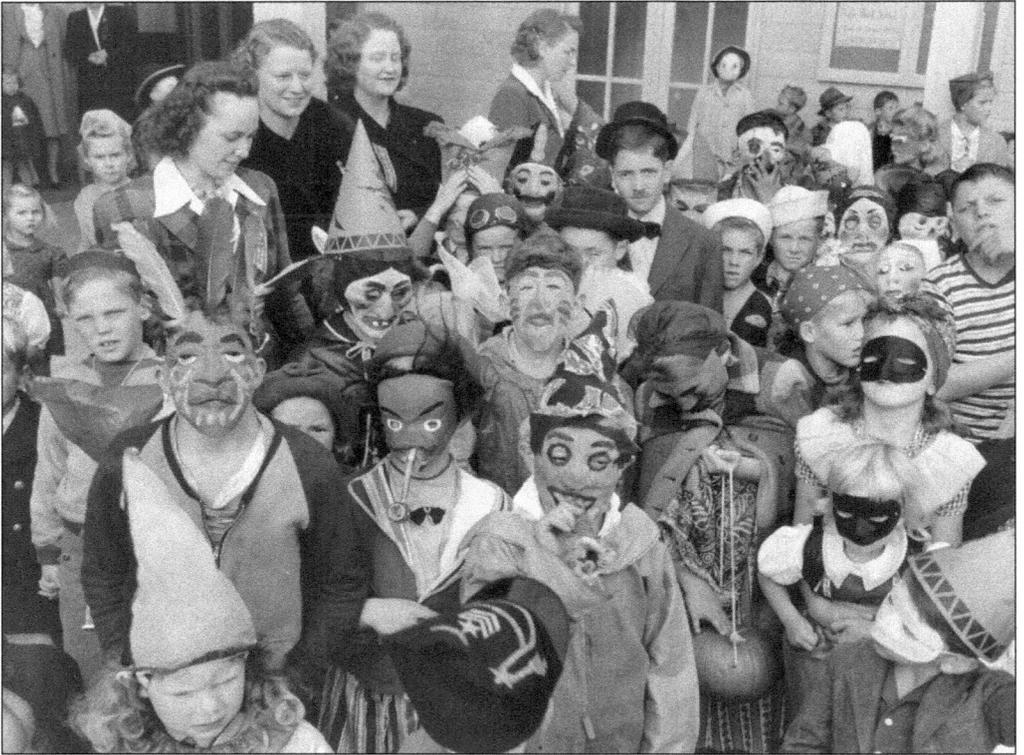

Over 700 homes, mainly duplexes, were built at High Point to provide housing for wartime defense workers and, later, returning war veterans to Seattle. In many families, both parents worked, and community residents helped one another to care for the children. The High Point Community Center was busy with events such as this 1943 Halloween party. As Seattle's needs changed, so did High Point. No longer needed for military, in 1953 High Point became public housing, and in 2003 was fully demolished to become a vibrant mixed-income community. (Above courtesy MOHAI, PI 23331; below courtesy SWSHS.)

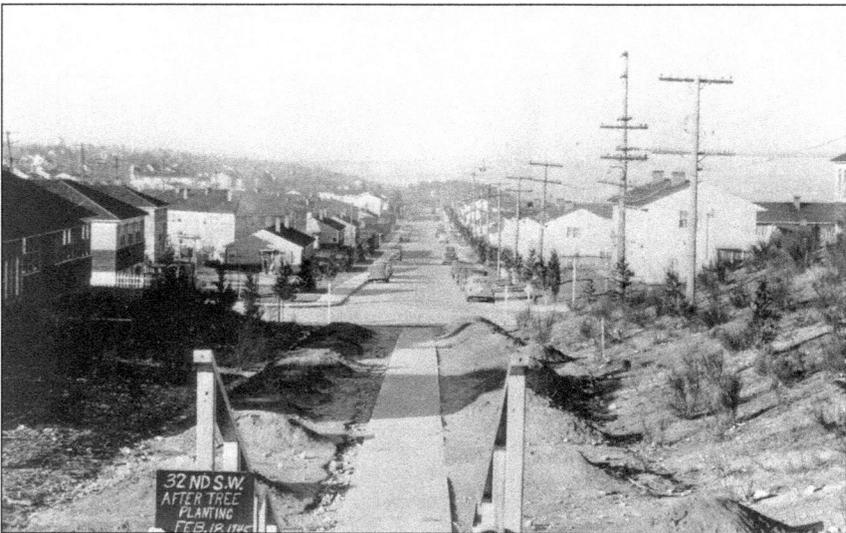

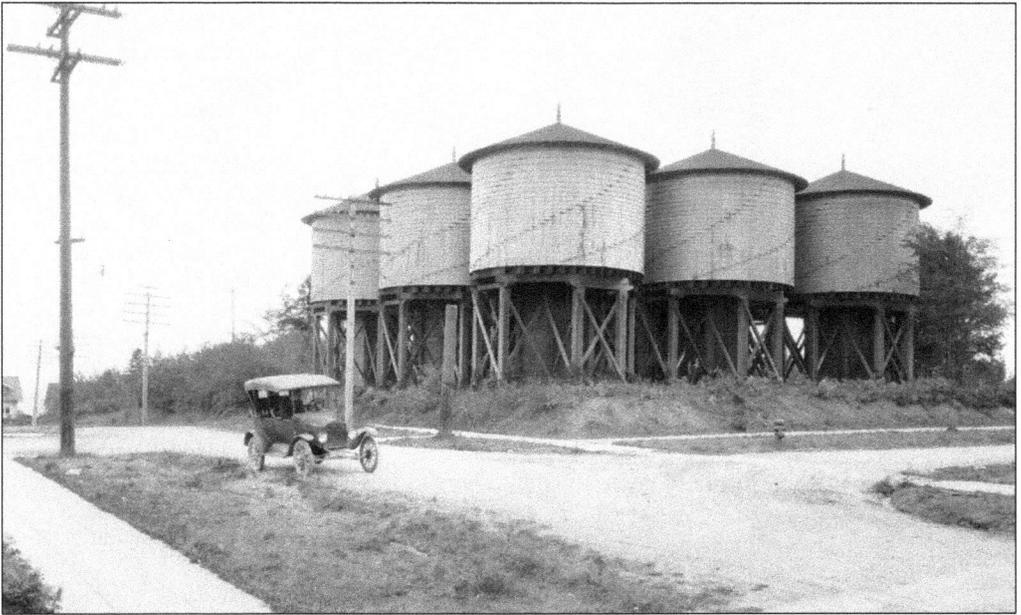

Around 1923, these nine wooden water tanks at Fortieth SW and SW Charlestown Street served the entire West Seattle area. A 1-million-gallon steel tank replaced the wooden tanks in 1927. The replacement tank remains in service today. (Courtesy Seattle Municipal Archives, No. 50562.)

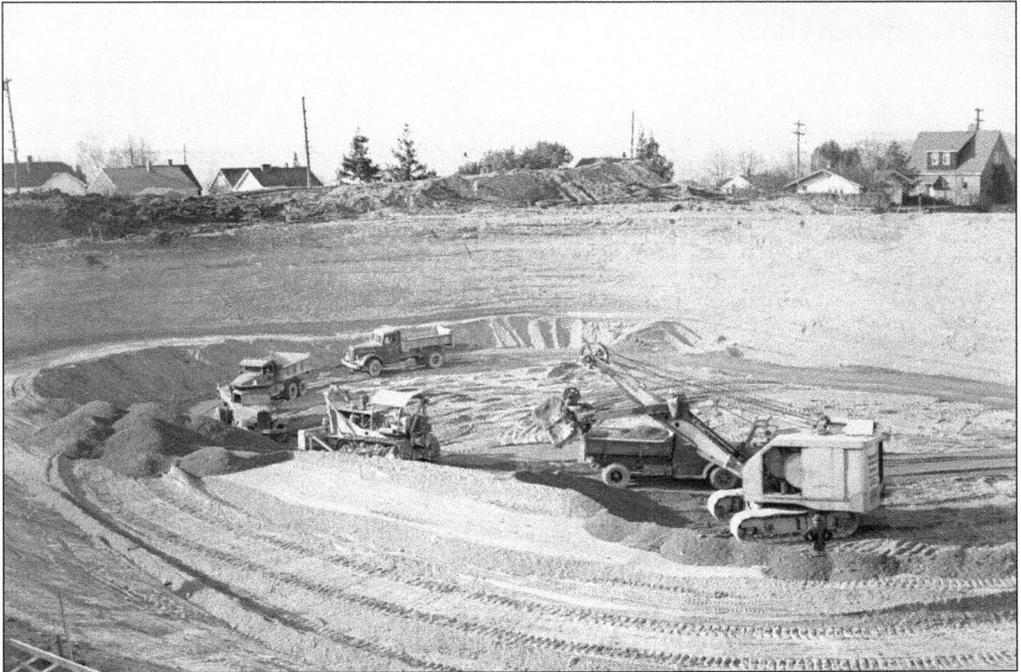

Construction of the Myrtle Street Reservoir at Thirty-fifth Avenue SW and SW Myrtle Street in the High Point neighborhood is shown in February 1947. The reservoir site is the highest point in Seattle. Current plans for a viewpoint park area include an open grass area planted over the lidded reservoir and walking paths. (Courtesy Seattle Municipal Archives, No. 40749.)

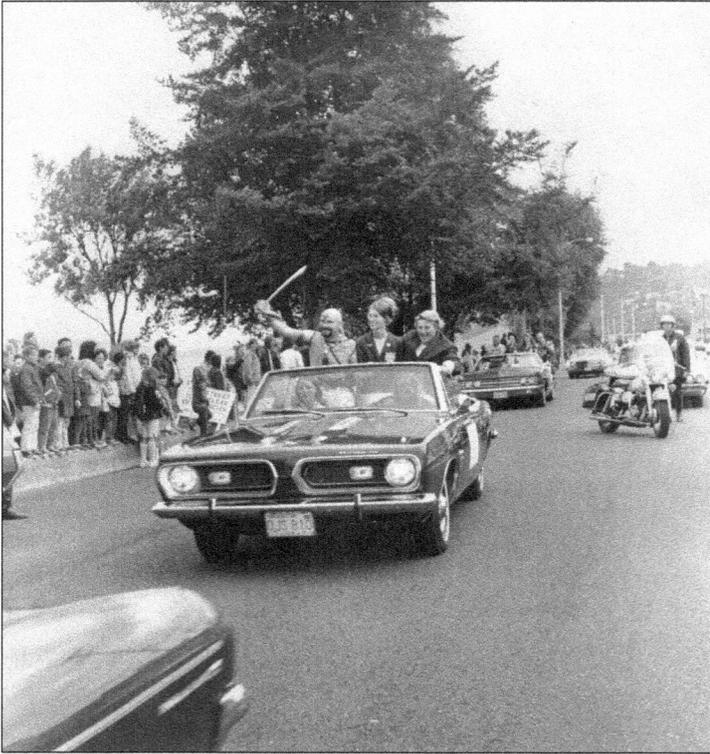

The Seafair Pirates land at Alki Beach during Hi-Yu Celebration on August 4, 1966. The first pirates were sponsored by the West Seattle Lions Club and landed at Alki around 1934 aboard the *Yankee Clipper*, which also participated in the 2001 Seattle sesquicentennial. The raucous pirates' landing continues to be a popular Seafair event today with coins and necklaces tossed to waiting children and adults.

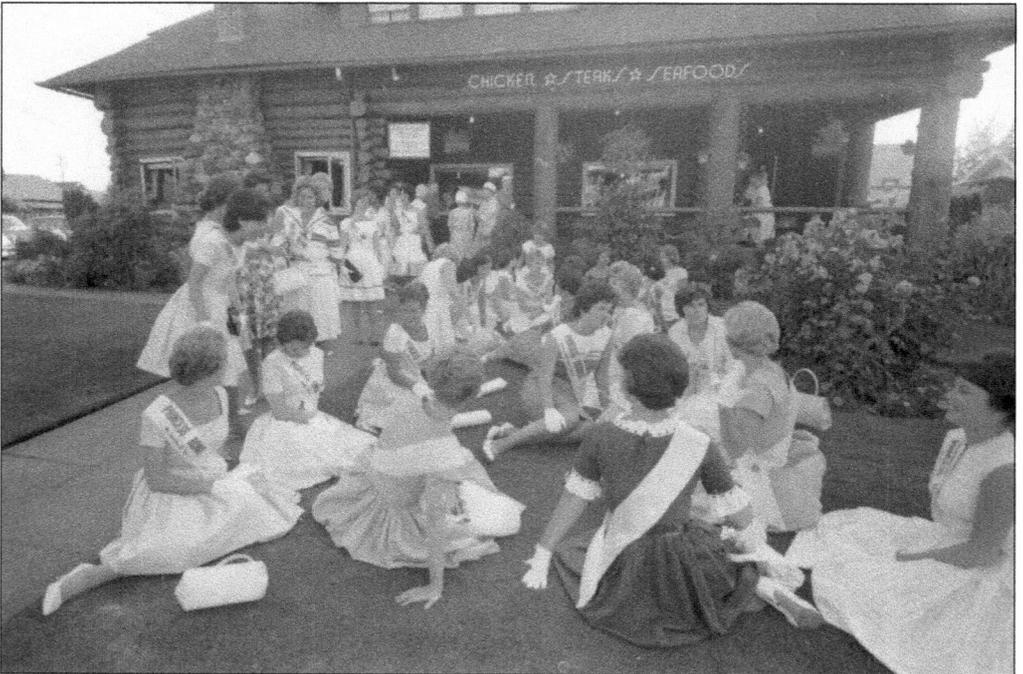

The 1962 Hi-Yu celebration court gathers on the lawn in front of the Alki Homestead Restaurant. The princesses are competing to be Miss West Seattle.

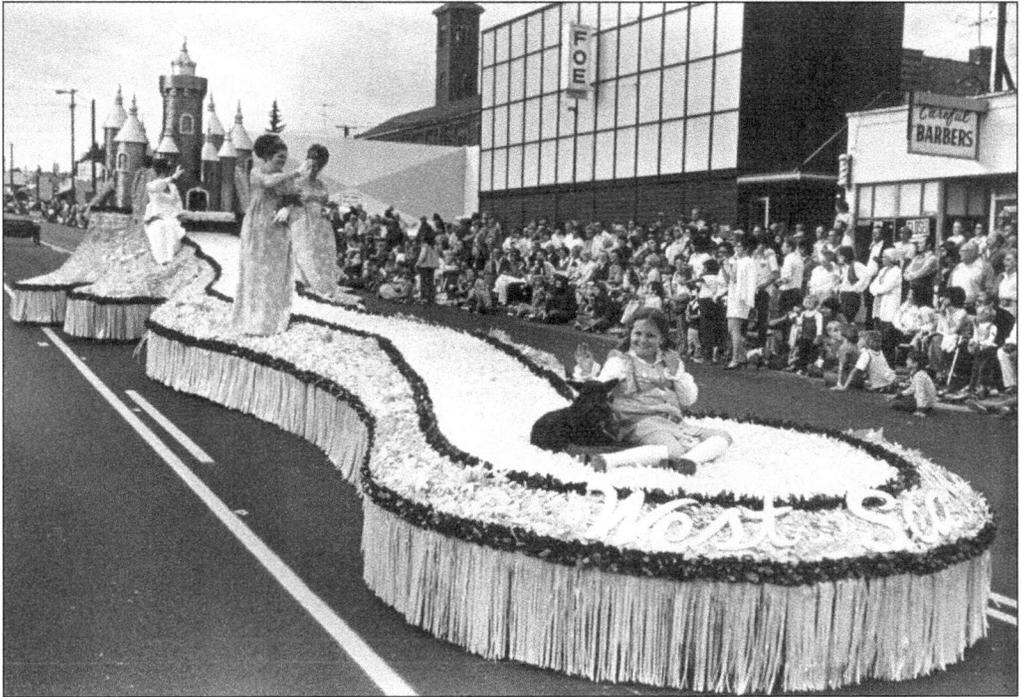

Local Moe Beerman created the standout float of 1973, "Magical Moments in the Land of Oz." The West Seattle American Legion Post No. 160 has always organized the parade. It takes true dedication some years to watch the Hi-Yu parade under gray skies with cold Seattle weather. The word *hiyu* originates from the Chinook trade jargon and means gathering or party.

Debate Team

West Seattle may well be proud of her debating season. We couldn't claim the title of champions; yet there has been discovered some excellent material for the future. Mrs. Lansing and Mr. Kimball, debate coaches, have done an admirable piece of work for the school.

The question for the first semester was "Resolved, That the jury system be abolished in civil and criminal cases." The negative team, composed of Duane Robinson and Frances Farmer, lost their debates to Roosevelt and Queen Anne. The affirmative team, George Lipsky and Joe Hunt, won both their debates, the first with Ballard, the second with Broadway.

Famed actress Frances Farmer, during her junior year at West Seattle High School in 1930, was active in debate, writing, and student government. Farmer was accepted to the University of Washington where she starred in student stage productions before being contracted with Paramount Pictures in Hollywood. She drew national attention when her high school student paper, "God Dies," won a *Scholastic* magazine award. The ensuing controversy negatively impacted her view of hometown West Seattle.

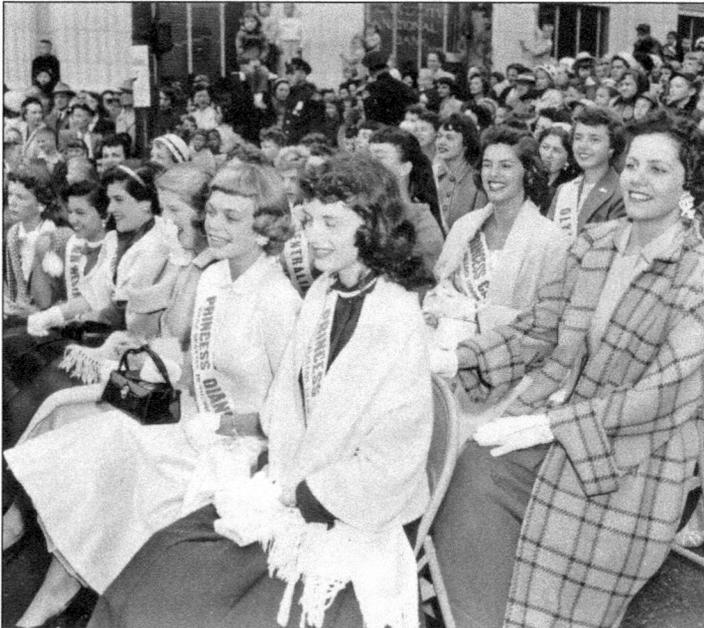

Diane Friesen was voted Miss West Seattle during the 1955 Hi-Yu. Most recognize her now as actress Dyan Cannon. She graduated from West Seattle High School in 1954.

In 1952, the Seattle Council of the Boy Scouts of America unveiled their donation to the people of Seattle—a Little Sister of Liberty. Over the following 55 years, the thin shell of metal endured salt water, weather, and vandalism until replaced in 2008 with a solid bronze Statue of Liberty. The original intent was to inspire patriotic gatherings, and since that first unveiling, it has become a landmark and meeting place. The first statue still stands nearby, inside the climate-controlled Log House Museum.

ABOUT THE
LOG HOUSE MUSEUM

The "Birthplace of Seattle" Log House Museum is located in an authentically restored 1904 log structure. The former carriage house of the Fir Lodge estate was purchased by the Southwest Seattle Historical Society in 1995, restored, and converted into the Log House Museum. The surrounding gardens are filled with Northwest native plants. Museum exhibits reflect the heritage of the Duwamish Peninsula from 1851 to current times. A project of the Southwest Seattle Historical Society, the Log House Museum is a place to discover and celebrate the history of the Duwamish Peninsula and the birthplace of Seattle. A city of Seattle landmark, the award-winning facility is a community treasure. Volunteers and businesses donate skills, time, and funds to maintain and operate this local museum interpreting the history of southwest Seattle. We invite you to visit, tour, volunteer, and become a member!

CONTACT

Southwest Seattle Historical Society
Log House Museum
3003 61st Ave SW
Seattle, Washington 98116

WEST SEATTLE AND WHITE CENTER HISTORY
ONLINE RESOURCES

The Log House Museum
www.loghousemuseum.info

History Link
www.historylink.org

University of Washington Libraries Digital Collection
http://content.lib.washington.edu/

City of Seattle Archives
www.cityofseattle.net/CityArchives/

Don Sherwood Park History Files
www.seattle.gov/parks/history/sherwood.htm

Washington State Archives, Puget Sound Region
www.secstate.wa.gov/archives/archives_puget.aspx

The Museum of History and Industry
www.seattlehistory.org

Historic Seattle
www.historicseattle.org

Visit us at
arcadiapublishing.com

www.ingramcontent.com/pod-product-compliance
Lightning Source LLC
Chambersburg PA
CBHW050610110426
42813CB00008B/2517